THE MIGHTY FALLEN

OUR NATION'S GREATEST WAR MEMORIALS

Larry Bond and *f*-stop Fitzgerald

Collins

An Imprint of HarperCollinsPublishers

On the endpapers:

FREEDOM WALL

Part of the WW II Memorial in Washington, D.C. is the Freedom Wall. The wall contains twenty-three panels, each with eleven columns and sixteen rows of stars, a total of 4048 gold stars, approximately one for each 100 American deaths during the war. Gold stars were a symbol of sacrifice during WW II. Families who had lost a member would hang a gold star in their window. A plaque on front of the wall declares, "Here we mark the price of freedom."

THE MIGHTY FALLEN. Compilation copyright © 2007 Larry Bond and f-stop Fitzgerald, Inc. Text copyright Larry Bond, 2007. Photographs copyright f-stop Fitzgerald, 2007. All rights reserved. Printed in the China.
No part of this book may be used or reproduced in any manner whatsoever without written permission except in the case of brief quotations embodied in critical articles and reviews. For information, address HarperCollins Publishers, 10 East 53rd Street, New York, NY 10022.

HarperCollins books may be purchased for educational, business, or sales promotional use. For information please write: Special Markets Department, HarperCollins Publishers, 10 East 53rd Street, New York, NY 10022.

FIRST EDITION

The name of the "Smithsonian," "Smithsonian Institution," and the sunburst logo are registered trademarks of the Smithsonian Institution.

Designed by David Perry

Produced by BAND-F Ltd.
www.BAND-F.com
www.f-stopfitzgerald.com

Custom prints from this collection may be ordered online.

Library of Congress Cataloging-in-Publication Data has been applied for.

ISBN: 978-0-06-117090-4
ISBN-10: 0-06-117090-9

07 08 09 10 11 TP 10 9 8 7 6 5 4 3 2 1

TABLE OF CONTENTS

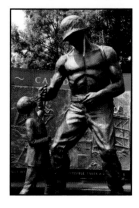

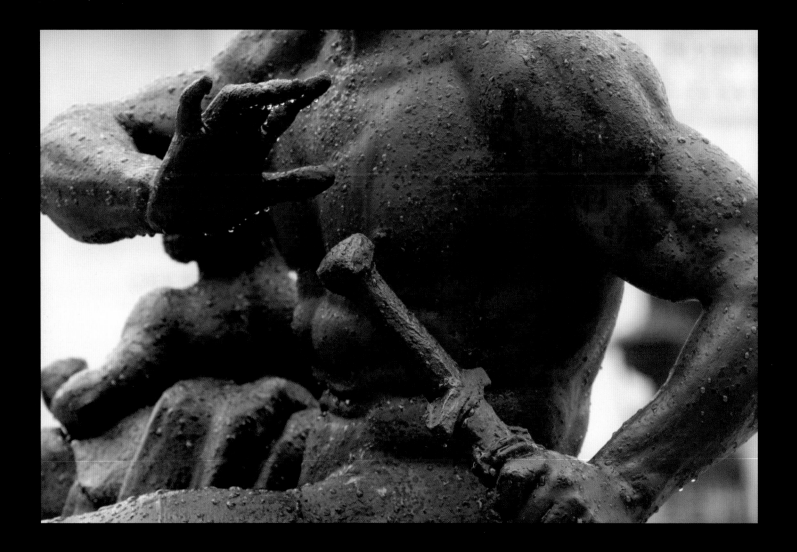

WAR AND PEACE

Monument Park in Baltimore, Maryland began as a single memorial to our recently-deceased President George Washington. A 160-foot-tall marble column was no less than the first president deserved, but city residents were worried about it falling, so the work was erected north of town. As time passed, the city grew toward and around the park, and the park became a place for other memorials. A statue of Lafayette honors the ties between France and America in WW I. A philanthropist, a Supreme Court justice, and others were all honored.

French sculptor Antoine-Louis Barye created four statues depicting War (see detail above), Peace, Order, and Force. They were donated to the city in the 1880s.

INTRODUCTION
BY LARRY BOND

An old battlefield gives no hint of the struggle that took place there. A great campaign might have been won or lost, but human affairs make little impression. Defensive works or scars from shellfire are quickly softened by nature. The land may even be returned to its original use. Even in carefully preserved national parks, like Gettysburg, the land alone will not tell the story.

The passage of time is even harder on human memory. The moment the battle is over, actions begin to fade in the participants' minds. Once the debris is cleared away, only people can preserve the events. Paper records, photos, audio, and video recordings can help, but to someone who has been there, they are a pale fraction of the real thing.

Memories of a war or battle are unpleasant, but few veterans would want them erased. That part of their life was important, serving an end larger than themselves. And the goals always require sacrifice. Their hardships and their friends' suffering are meaningless without some goal or purpose. Victory obviously provides that validation, as does defeat—though perhaps less so—if their cause was worthy.

Veterans have always known that their deeds and the sacrifice of their comrades would be lost with their own passing. Each wartime generation has commissioned memorials and monuments. Many are built on the battlefield. Some are built in the homes they left. Their very name, "memorial," hints at their first purpose—to make sure the events that took place are kept in our memories. But beyond information, they also want us to remember that there was a cost. That is their second goal.

Losses are felt deeply by those who fought together. They know each other well, and have shared much, often more than those at home understand. A wartime death also takes away someone before their time, and their death may be hard. Even in triumph, a veteran's first thoughts will be of those who didn't live to see it.

So when veterans erect a memorial, they include names. In fact, one of the most recent and most famous of memorials, the Vietnam Veterans Memorial on the National Mall in Washington, D.C., is nothing but a list of names—the name of every American who was lost fighting in that conflict. It is a moving experience to visit that place, and it should be.

The third and most important purpose of a monument is to move us, to evoke emotions. Those feelings can only be hinted at by a book, a photo, a film or a video. They can be grief, fear, anger, or pride, or other more complex emotions, but the people who create a memorial want us to know what they knew, and feel what they felt.

A memorial is almost always the work of an artist; while few people describe war memorials as beautiful, they do describe them as powerful or moving. Art evokes emotion, and good art creates strong ones.

The Mighty Fallen uses photographs to show what the memorials' designers wanted us to know about their creations. We have selected images of monuments from all of North America, both in the United States and Canada. They cover wars in three centuries, the eighteenth, nineteenth, and twentieth. The memorials presented are arranged in an approximate, chronological order by conflict within each century.

It is not a history of military monuments or a complete survey of North American memorials. The images in the book were chosen for their artistic significance and their effectiveness at communicating their creators' message. Some images show the complete monument, some only a detail. Each is an interpretation of that memorial's spirit and message from its creators to us. It is only one interpretation.

The need for remembrance has been a constant. Sometimes groups or individuals have been overlooked or shortchanged; others will hopefully receive their fair share.

Our way of building memorials has not changed much, either. Both the Revolutionary Monument—the first war monument built in this country—and the Vietnam Veterans Memorial are simple shapes listing the names of the dead. Individual honors usually rate a statue, and those dedicated two hundred years ago look as modern as ones cast today.

It should be comforting that the way we memorialize our heroes hasn't changed: memorials built centuries ago still perform their purpose; those we erect tomorrow will honor the mighty fallen for generations to come.

We owe it to them to remember.

18TH CENTURY
CONFLICTS

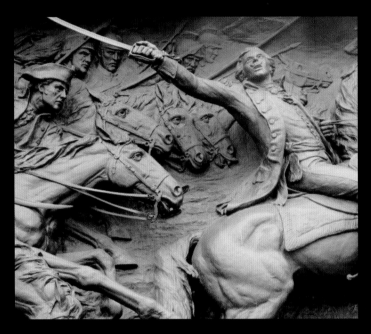

ON LEXINGTON GREEN

Americans have always had a special relationship with their fighting men and women. In eighteenth-century Europe, professional armies fought the wars. They were relatively small, but extremely disciplined. Troops needed discipline to stand in tightly-packed ranks while enemies within shouting range fired murderous volleys and their companions fell around them. That discipline was iron-hard. It was better to be shot at than risk punishment for breaking ranks.

Discipline was also necessary because most European professional soldiers were either the dregs of society or mercenaries. Many would desert, given the chance. A lot of staff work was devoted to preventing opportunities for desertion, and rounding up the inevitable stragglers. Often the soldiers and sailors were criminals.

During the Revolutionary War, General Washington would work to create a regular army, with the help of expert European officers like Casimir Pulaski and the Marquis de Lafayette. The result was not a European-style army. European tactics didn't work on American battlefields, and American soldiers hadn't been press-ganged.

In addition to regular troops, American colonial soldiers were local men who served either in the volunteers or militia. Volunteers wore uniforms and had names like "First Pennsylvania" or "Third Massachusetts." They were expected to join the line of battle and fight as regular troops. Militia were local folk mustered in an emergency i.e. The Minutemen. They acted as scouts and skirmishers, and usually wore civilian clothes. Neither type was as well-trained or disciplined as "regular" army units, and professional soldiers didn't bother hiding their contempt.

Militia and volunteer units drilled on the village commons, and many had no combat experience before the American Revolution began. Unlike regular army soldiers, these men fought to protect their homes and families, their own towns and friends. They served because they wanted to, not because they'd been press-ganged or paid as a mercenary. While there was discipline, it rested more lightly on these men because they were willing to serve.

Colonial towns were proud of their volunteers. They made drills into social events, and ladies' groups embroidered flags. They cheered when their boys marched by. British Army soldiers usually weren't so welcome. European armies were hard on the towns they passed through, even ones on their own side. One of the grievances of the American colonists was the forced housing of British troops in citizens' homes. These were not just unexpected houseguests. For many, it was like having a biker gang invade their home.

Citizen soldiers served this country from colonial times until the mid-twentieth century. Our small peacetime regular army was never meant to fight wars by itself. When the need arose, the country would mobilize. Until the advent of pushbutton wars, there was usually time to recruit and train an army, then send it to war. This was a sensible economic measure, but it also kept the military close to those it defended. That colonial heritage is still strong. Daniel Chester French's statue of a Lexington Minuteman is the emblem of the National Guard.

When America broke away from England, communities across the thirteen colonies sent their friends and relatives to stand against the world-class British Army and Navy. There were many people who believed they didn't have a chance. Even if they won, they would face hardship. There would be losses from disease, even if there were no combat. Out of touch, with letters that could bear bad news as well as good, service was almost as hard on the towns at home as on the men in the field.

But winning, they wanted to remember. The first war memorial raised in America stands on the Battle Green in Lexington, Massachusetts. Dedicated on July 4, 1799, the Revolution had only ended in 1783 with the Treaty of Paris.

Imagine veterans of Lexington visiting the Battle Green, trying to retrace their steps and the spots where their friends and family had died. With the passing of time their memories, so vivid, must have seemed in danger of fading completely. The American Revolution gave the United States more than a few heroes. The memorials in this section honor battles and individuals that created the United States and Canada.

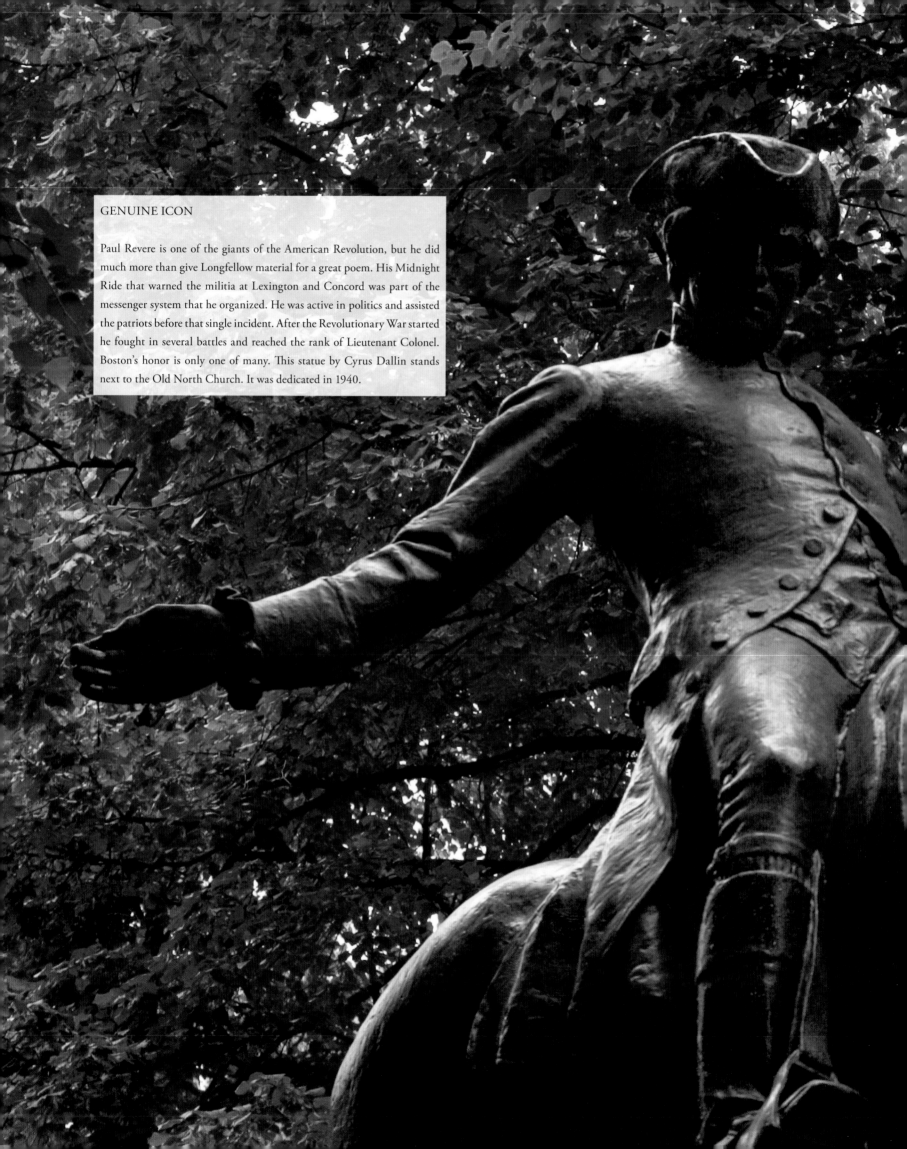

GENUINE ICON

Paul Revere is one of the giants of the American Revolution, but he did much more than give Longfellow material for a great poem. His Midnight Ride that warned the militia at Lexington and Concord was part of the messenger system that he organized. He was active in politics and assisted the patriots before that single incident. After the Revolutionary War started he fought in several battles and reached the rank of Lieutenant Colonel. Boston's honor is only one of many. This statue by Cyrus Dallin stands next to the Old North Church. It was dedicated in 1940.

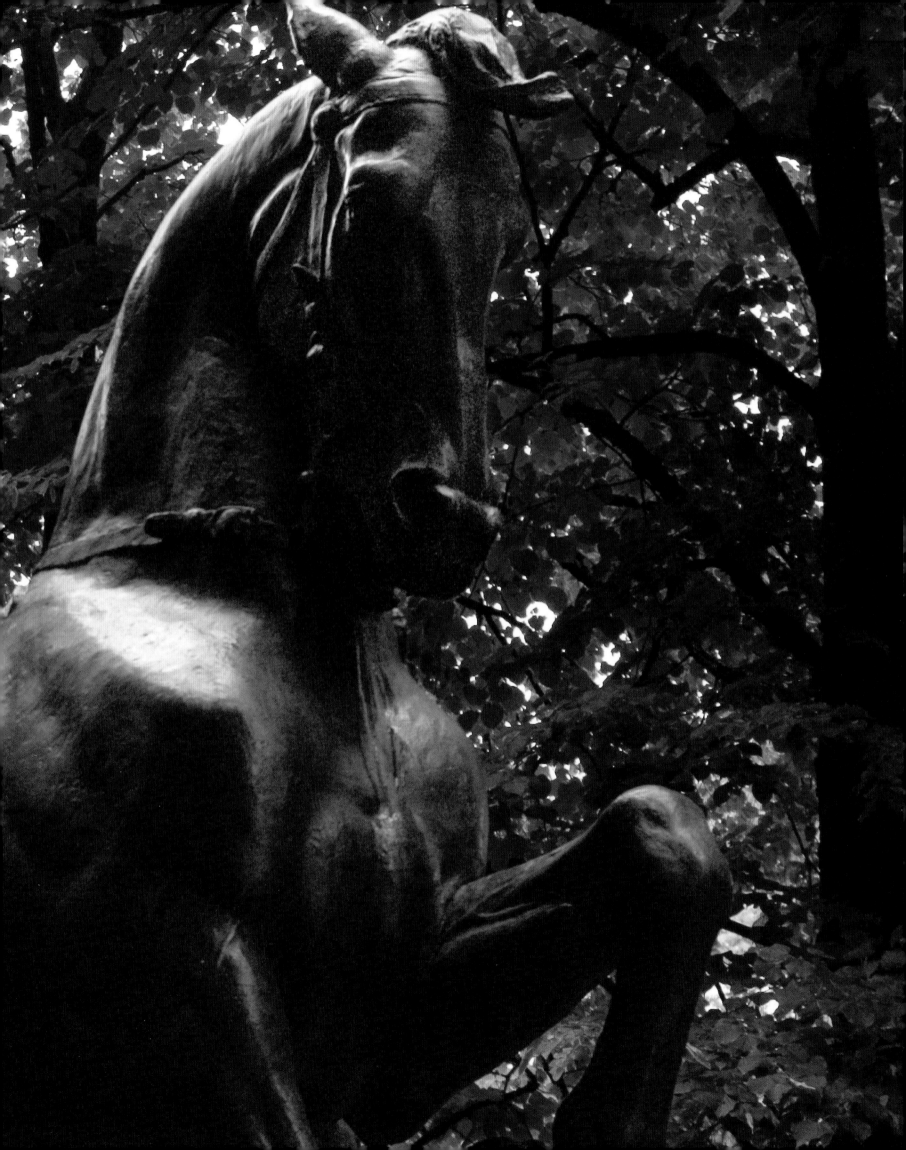

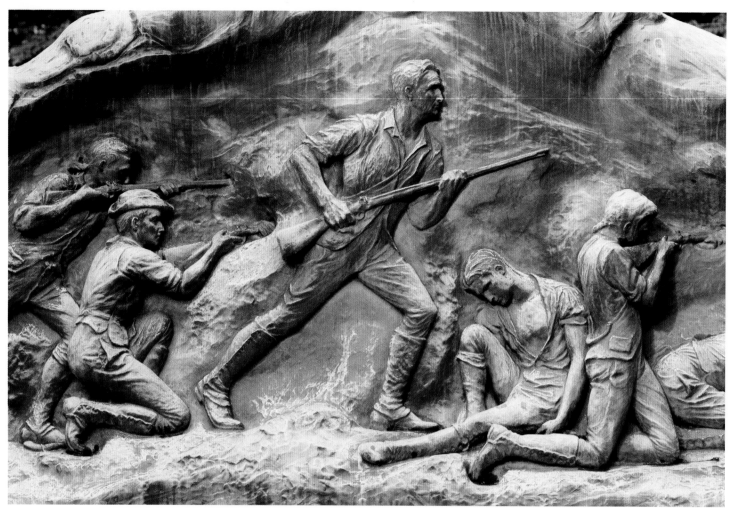

THE SEVENTY-SEVEN

This frieze, The Lexington Memorial by Bashka Paeff, stands in front of Buckman's tavern in Lexington, Massachusetts. It memorializes "...all the Lexington men who confronted the British."

LET IT BEGIN HERE

John Parker led the Massachusetts militia at Lexington and Concord, but died of tuberculosis a few months after the battle. Although his service was short, his quote before the battle made him immortal: "Stand your ground. Don't fire unless fired upon, but if they mean to have a war, let it begin here." Henry Hudson Kitson's sculpture of Parker was dedicated in Lexington in 1900.

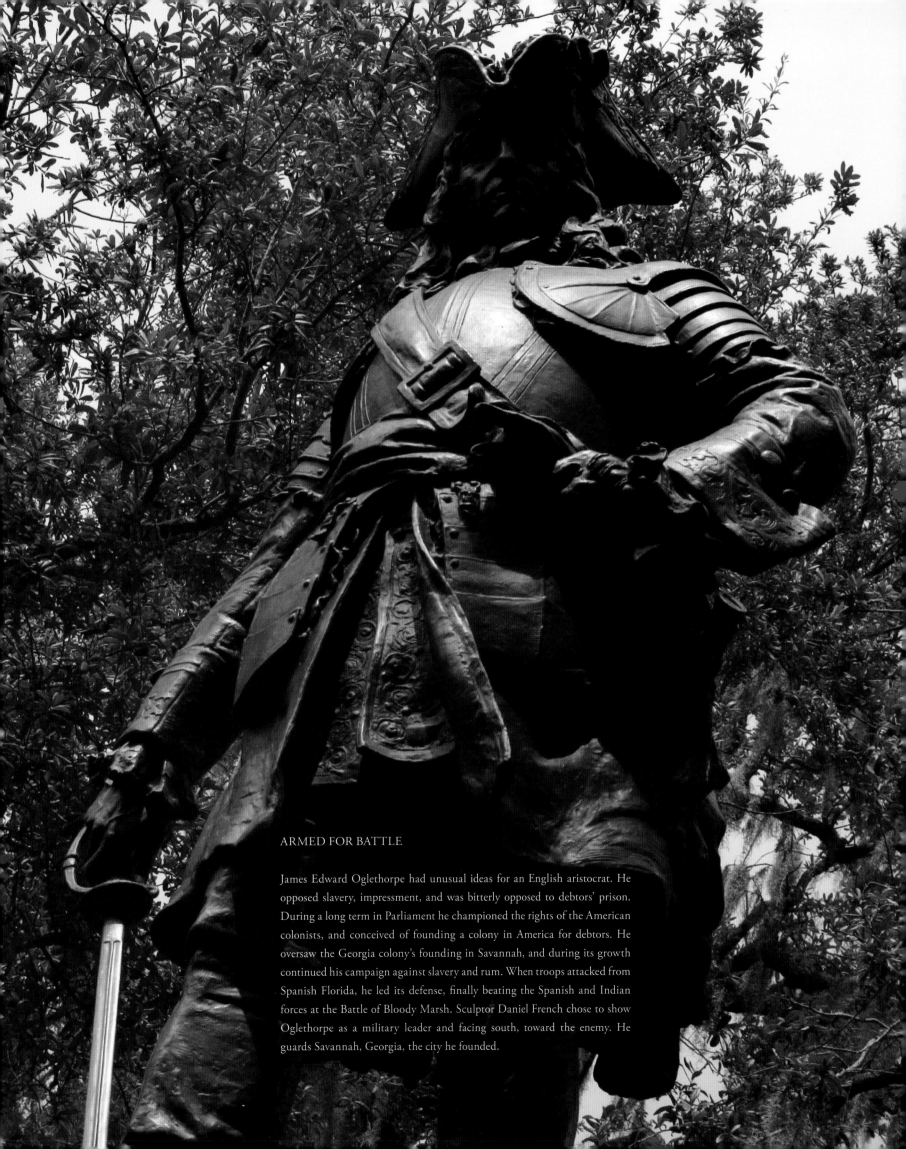

ARMED FOR BATTLE

James Edward Oglethorpe had unusual ideas for an English aristocrat. He opposed slavery, impressment, and was bitterly opposed to debtors' prison. During a long term in Parliament he championed the rights of the American colonists, and conceived of founding a colony in America for debtors. He oversaw the Georgia colony's founding in Savannah, and during its growth continued his campaign against slavery and rum. When troops attacked from Spanish Florida, he led its defense, finally beating the Spanish and Indian forces at the Battle of Bloody Marsh. Sculptor Daniel French chose to show Oglethorpe as a military leader and facing south, toward the enemy. He guards Savannah, Georgia, the city he founded.

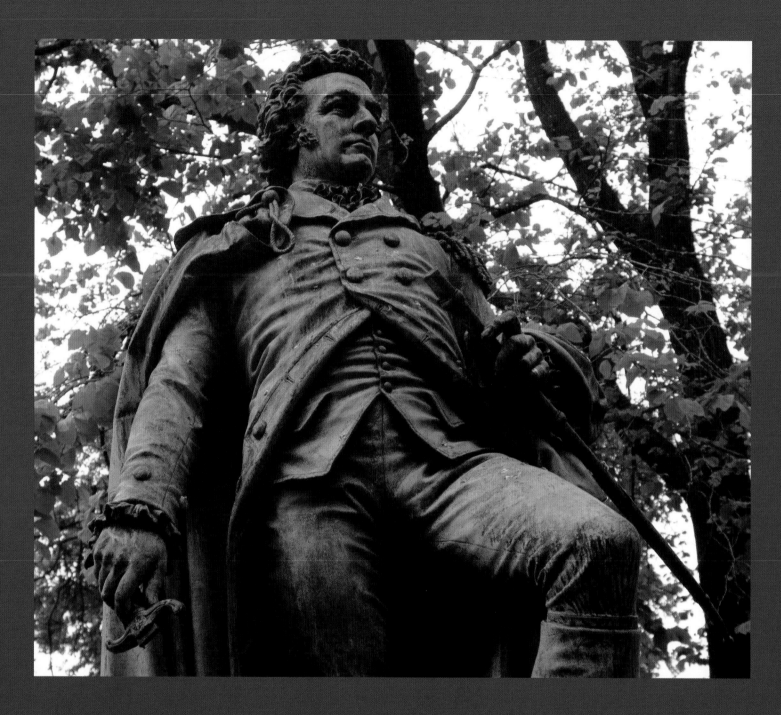

BY LAND OR SEA

John Glover, the first American to be promoted to the rank of Brigadier General, served his country before, during, and after the American Revolution with energy and intelligence. Glover's Marblehead regiment was an unusual group. Comprised of Maine fishermen, it was as comfortable on water as land. Because of their expertise, he and his regiment were ordered to commission two small vessels, the beginning of a Continental Navy. They took Washington and his troops across the Delaware, pioneering amphibious warfare. And they held off a British force five times their size. Glover's statue, sculpted by Martin Milmore, was erected in Boston in 1875.

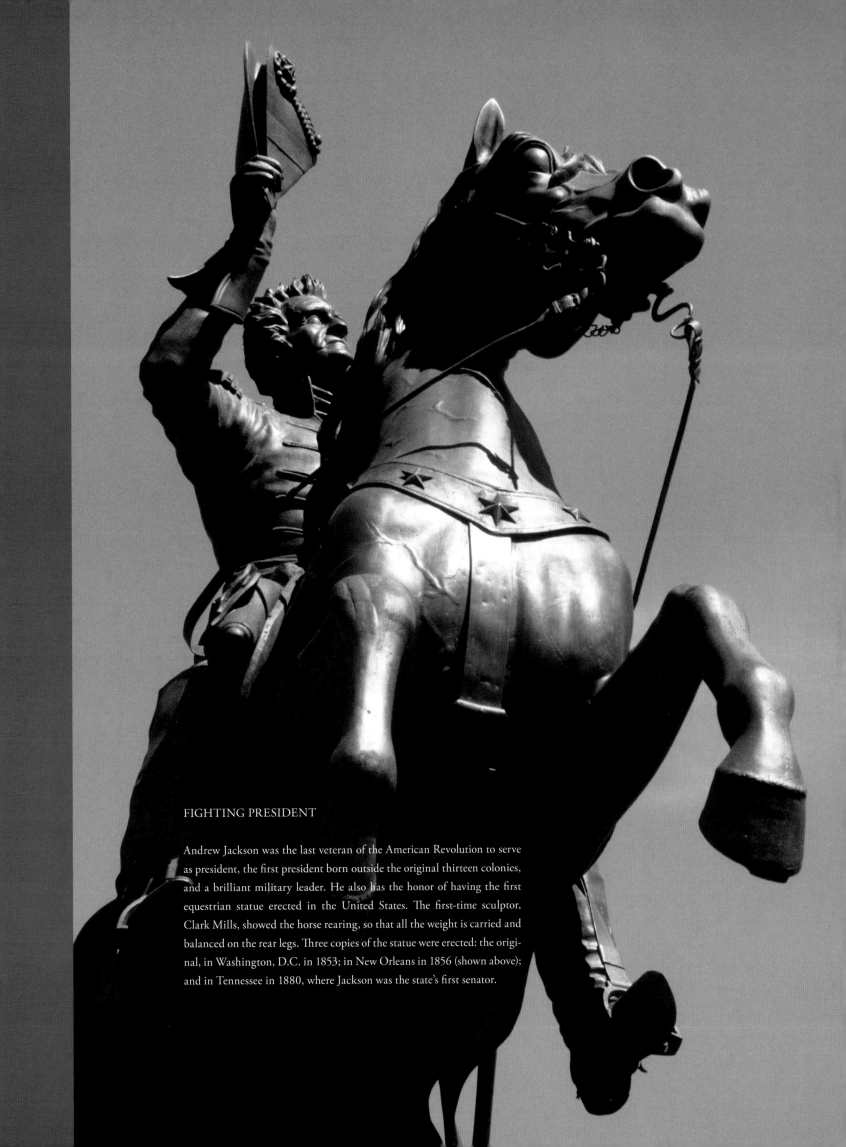

FIGHTING PRESIDENT

Andrew Jackson was the last veteran of the American Revolution to serve as president, the first president born outside the original thirteen colonies, and a brilliant military leader. He also has the honor of having the first equestrian statue erected in the United States. The first-time sculptor, Clark Mills, showed the horse rearing, so that all the weight is carried and balanced on the rear legs. Three copies of the statue were erected: the original, in Washington, D.C. in 1853; in New Orleans in 1856 (shown above); and in Tennessee in 1880, where Jackson was the state's first senator.

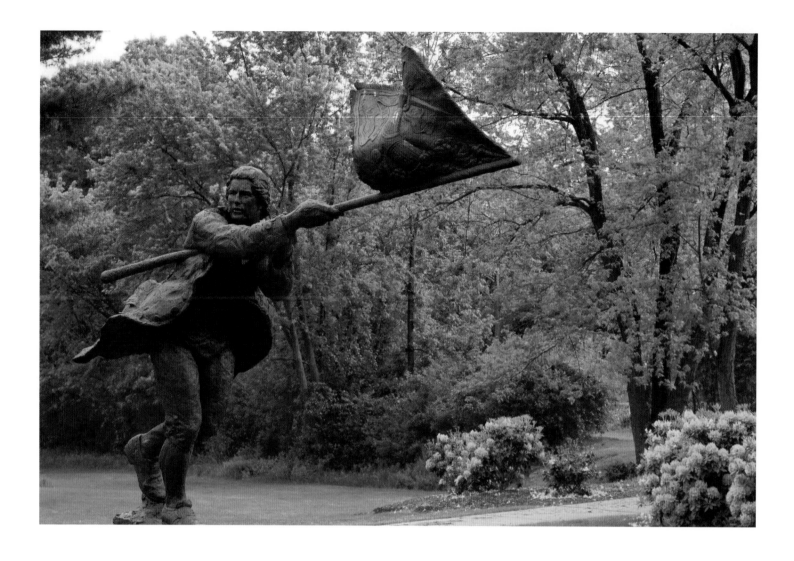

THE BEDFORD FLAG

At the Battle Green in Lexington, Massachusetts, the Bedford Cultural Council commissioned this statue of a Minuteman carrying a flag into battle. Tradition says that the flag was carried by Nathaniel Page, elected flag-bearer of his militia company. The same tradition says that he carried the Bedford Flag, a standard that predates the first American flag. Artist Bruce Pappito finished "The Patriot" and it was dedicated in 2000. The Bedford Flag is kept in the Bedford Public Library in Bedford, Massachusetts.

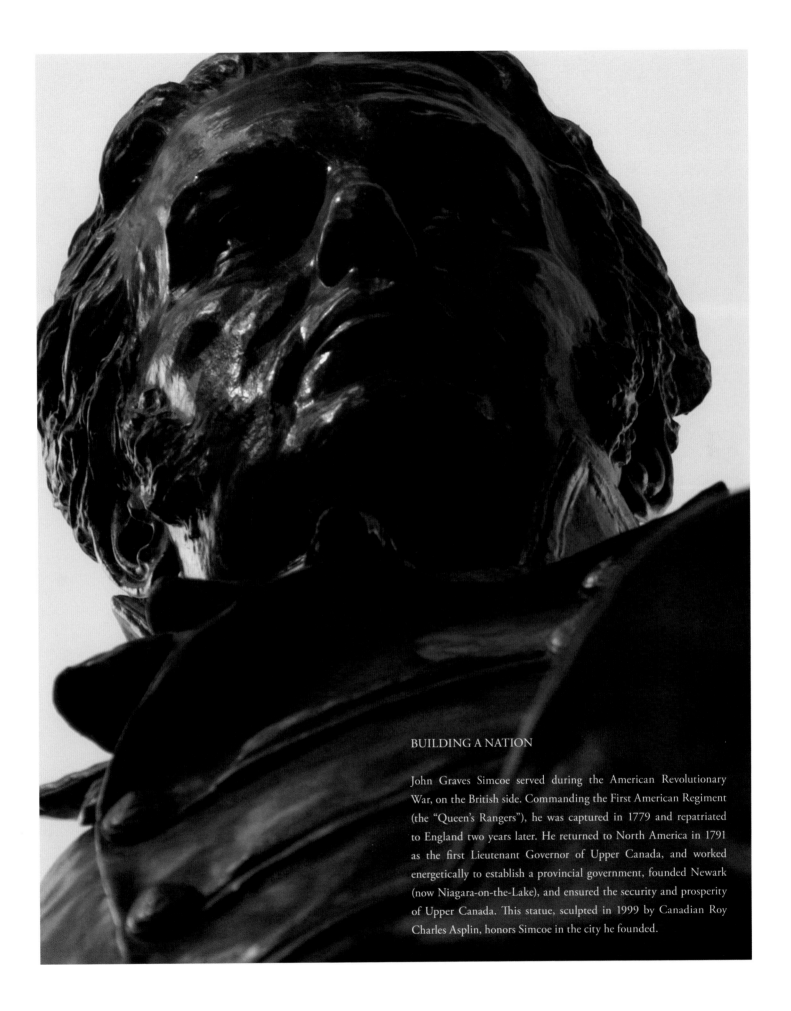

BUILDING A NATION

John Graves Simcoe served during the American Revolutionary
War, on the British side. Commanding the First American Regiment
(the "Queen's Rangers"), he was captured in 1779 and repatriated
to England two years later. He returned to North America in 1791
as the first Lieutenant Governor of Upper Canada, and worked
energetically to establish a provincial government, founded Newark
(now Niagara-on-the-Lake), and ensured the security and prosperity
of Upper Canada. This statue, sculpted in 1999 by Canadian Roy
Charles Asplin, honors Simcoe in the city he founded.

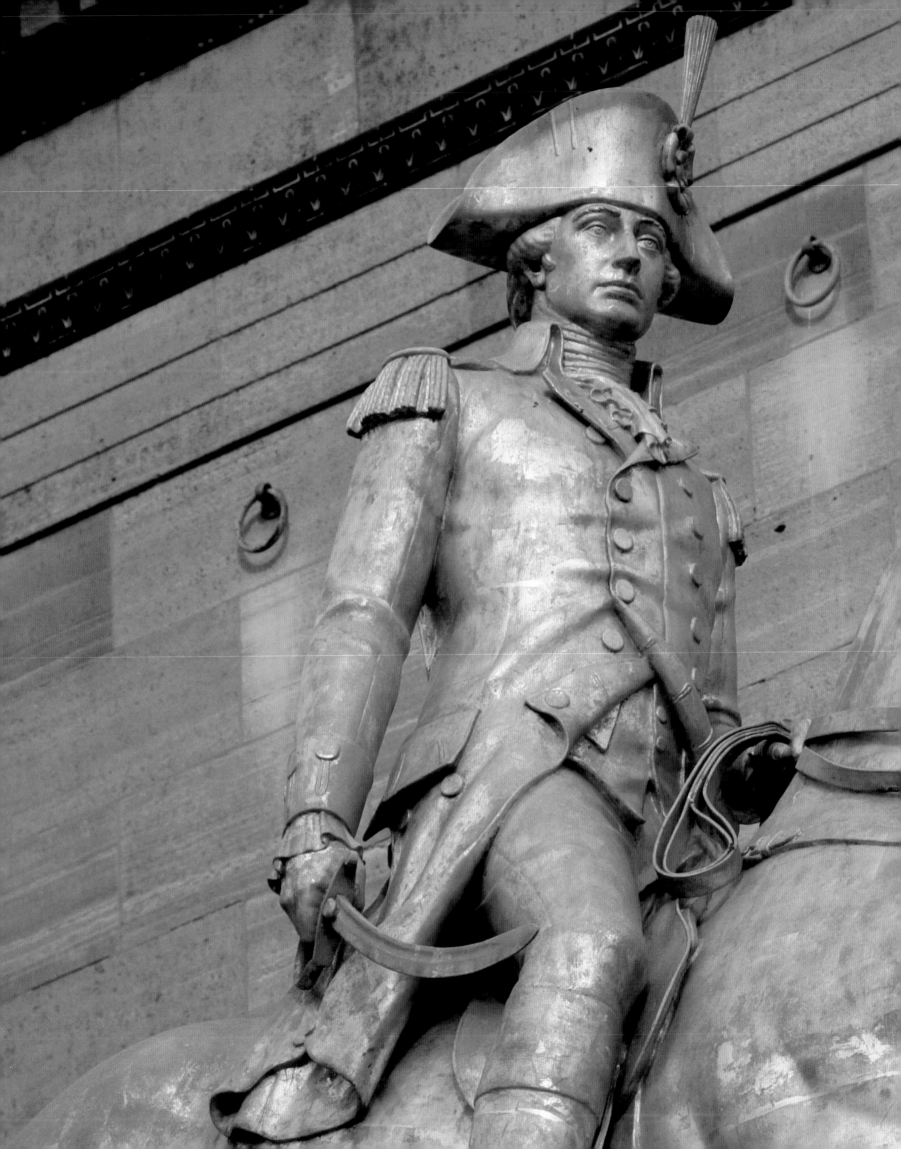

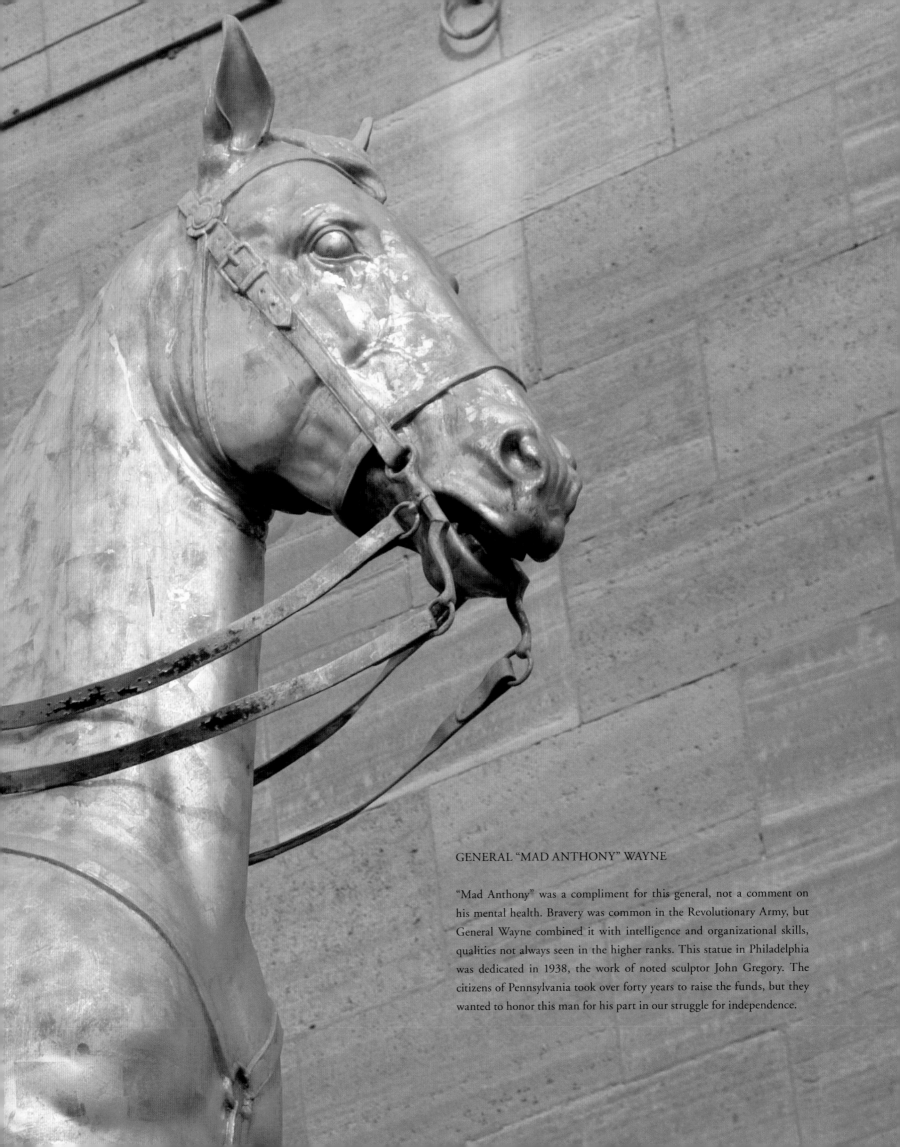

GENERAL "MAD ANTHONY" WAYNE

"Mad Anthony" was a compliment for this general, not a comment on his mental health. Bravery was common in the Revolutionary Army, but General Wayne combined it with intelligence and organizational skills, qualities not always seen in the higher ranks. This statue in Philadelphia was dedicated in 1938, the work of noted sculptor John Gregory. The citizens of Pennsylvania took over forty years to raise the funds, but they wanted to honor this man for his part in our struggle for independence.

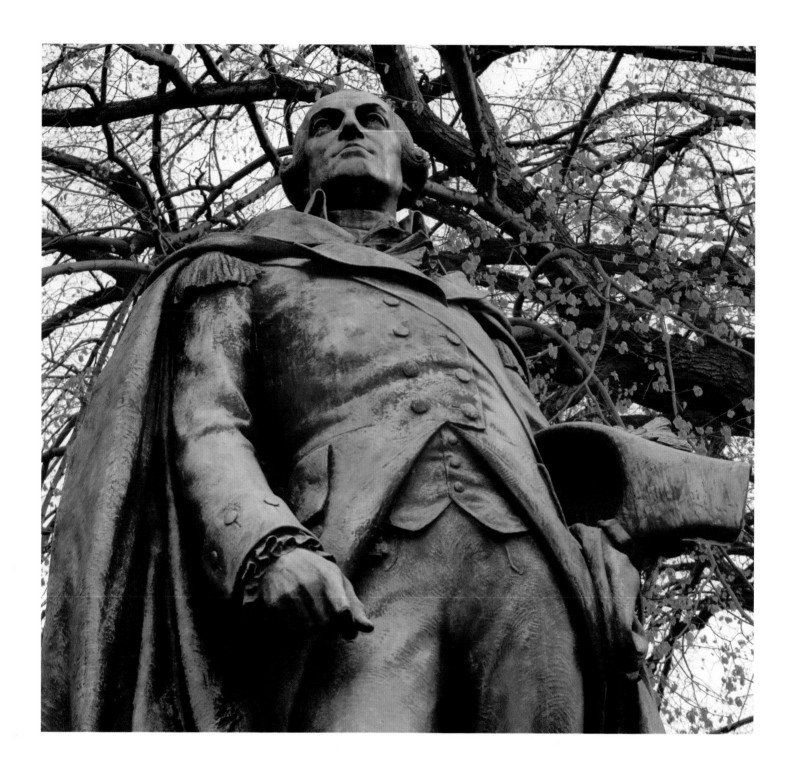

A GOOD SON

Philadelphia honored one of its Revolutionary heroes in 1910 when this statue to Peter Muhlenberg was sculpted by J. Otto Schweizer. Muhlenberg was born and educated in Pennsylvania. He then served both as a clergyman and a Virginia delegate before being asked to raise a regiment in that colony. He served throughout the Revolutionary War, then settled in Pennsylvania. He represented the state in Congress, and then was appointed to federal posts by President Jefferson.

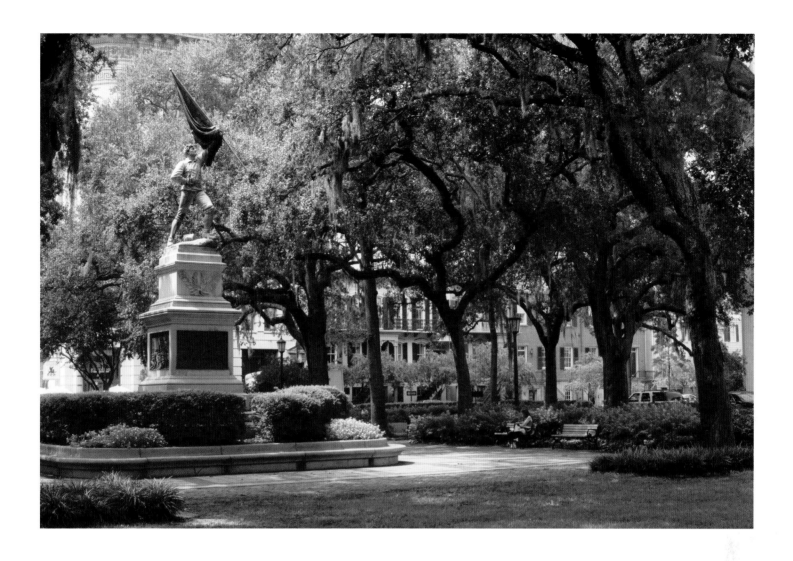

THE FLAGBEARER

William Jasper was personally recruited by Francis "Swamp Fox" Marion to serve in the 2nd South Carolina Regiment in the Revolutionary War. Jasper was quickly promoted to sergeant. At the Battle of Fort Moultrie in 1776, after the fort's colors were shot away, Jasper braved a storm of fire to recover them and rig a substitute. His heroism continued throughout the war, acting as a scout for the Continental Army and rescuing prisoners held by the British. His luck ran out two years later, at the Siege of Savannah. Jasper carried the colors and was mortally wounded. Savannah memorialized him with this statue dedicated in 1888.

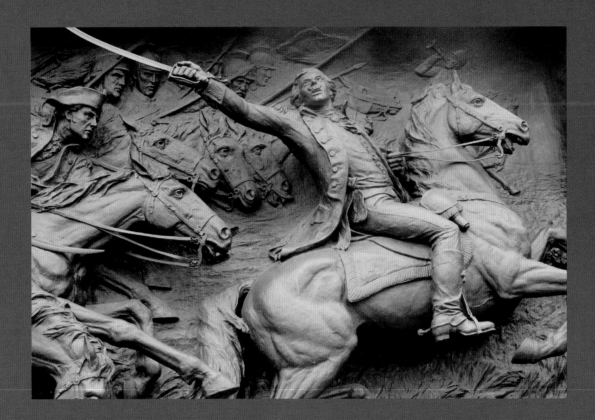

THANKING A FRIEND

A memorial often says "thank you." Casimir Pulaski was already an experienced military officer in Poland when he came to America in 1777. He'd fought hard against the Russians, but when Poland lost, he continued his fight here. He distinguished himself in several battles and contributed his own funds to help equip the men he led. Two years after arriving, he gave one last gift, dying at the Siege of Savannah while leading his men. This frieze in Baltimore is one of many tributes to this friend of freedom. It shows him leading that fatal charge, and was sculpted by Hans Schuler and dedicated in 1951.

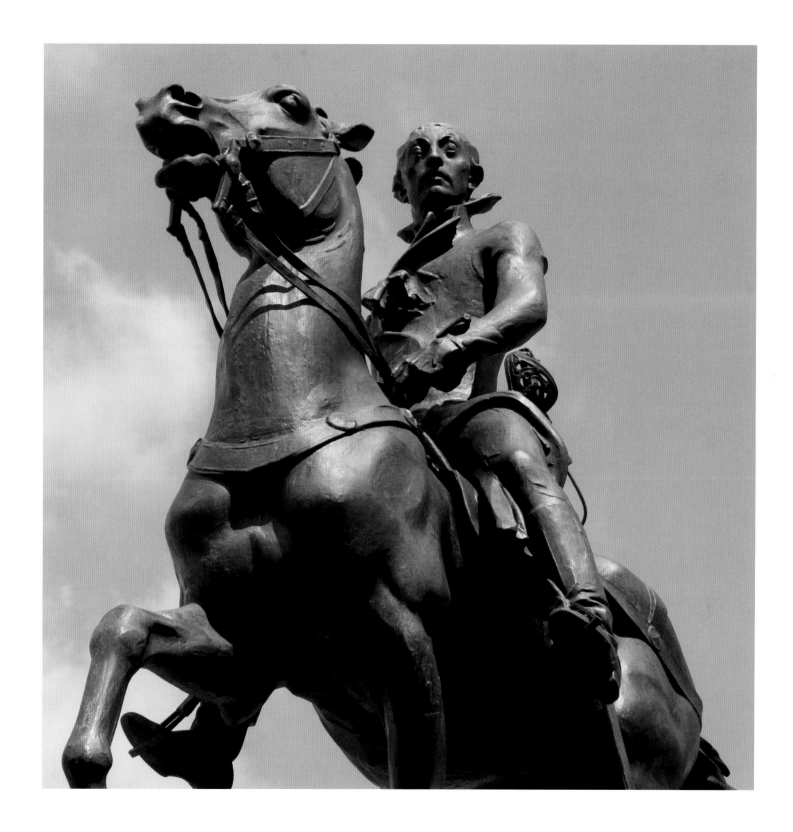

ADOPTED CAUSE

During the Revolutionary War, the Marquis de Lafayette's friendship for the American cause was vital to its success. His commitment to liberty both in America and in France earned him universal admiration. When U.S. troops arrived in France in 1918, that French-American friendship was honored again: "Lafayette, we are here!" This statue in Baltimore celebrates the French-American friendship, and was dedicated in 1924.

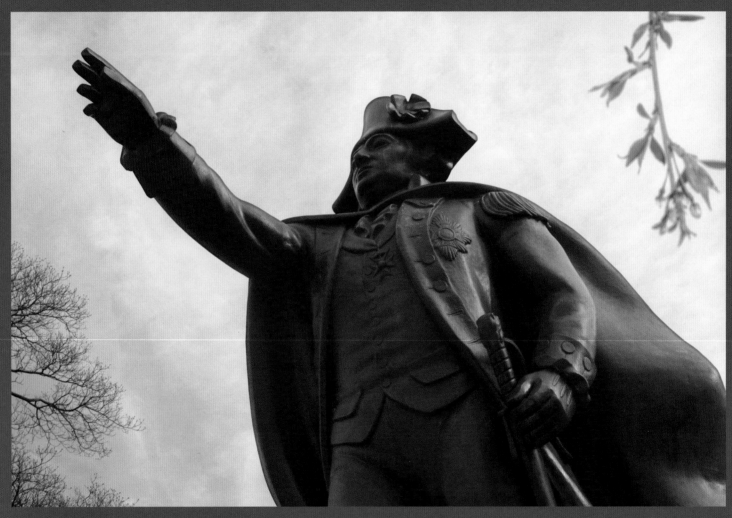

THE DRILLMASTER

"General" Friedrich Von Steuben was really only a captain, but he was a combat veteran and an experienced staff officer of the Prussian Army. The Continental Congress was glad to have his services, and his knowledge of how to organize a professional army was vital to the American Revolution. His attention to mundane-sounding details like drill and sanitation vastly improved the firepower and the health of the American soldiers. The Continental Congress gave him the rank of inspector general and after the war he became an American citizen. He is honored throughout the U.S. This statue in Philadelphia by Warren Wheelock was dedicated in 1947.

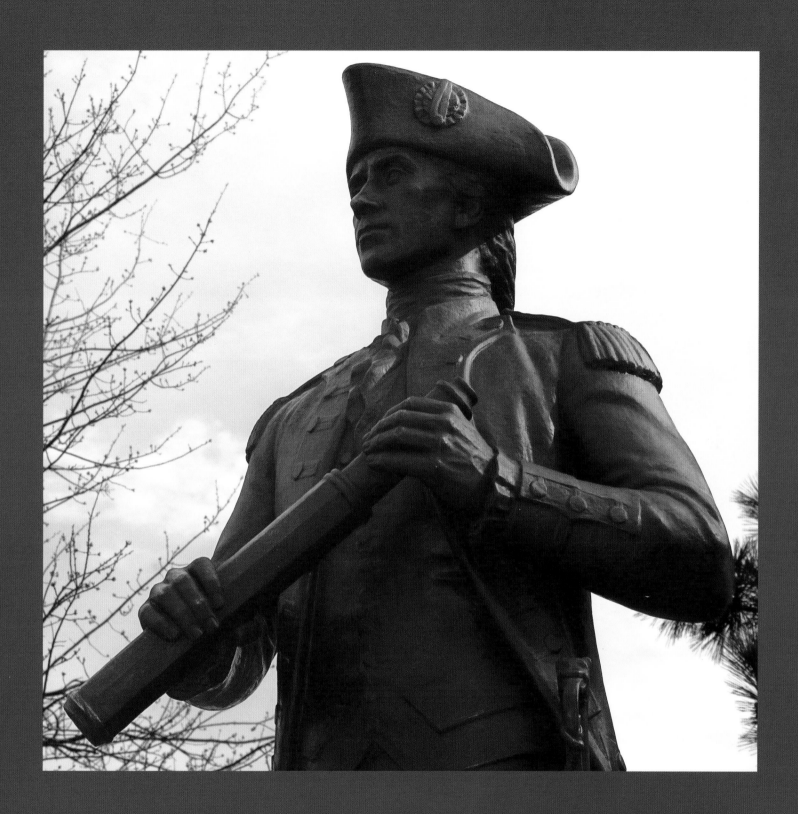

FIRST NAVAL HERO

When John Paul arrived in Philadelphia in 1775, the Scotsman was on the run. He'd killed a sailor during a mutiny, and so he added "Jones" to his name. He joined the Revolution, and his victory over HMS *Serapis* helped define the new country's navy. Philadelphia honored Admiral John Paul Jones in 1957 with a statue by Walker Hancock.

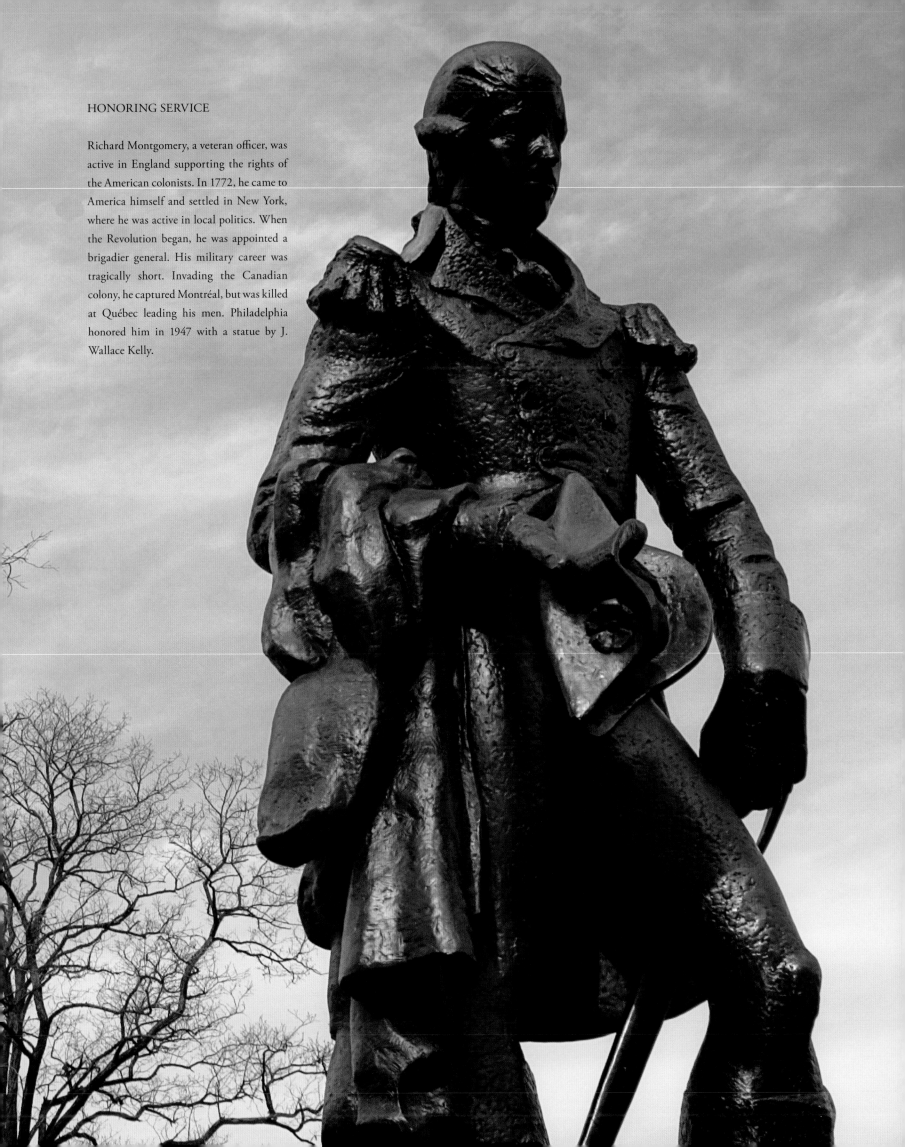

HONORING SERVICE

Richard Montgomery, a veteran officer, was active in England supporting the rights of the American colonists. In 1772, he came to America himself and settled in New York, where he was active in local politics. When the Revolution began, he was appointed a brigadier general. His military career was tragically short. Invading the Canadian colony, he captured Montréal, but was killed at Québec leading his men. Philadelphia honored him in 1947 with a statue by J. Wallace Kelly.

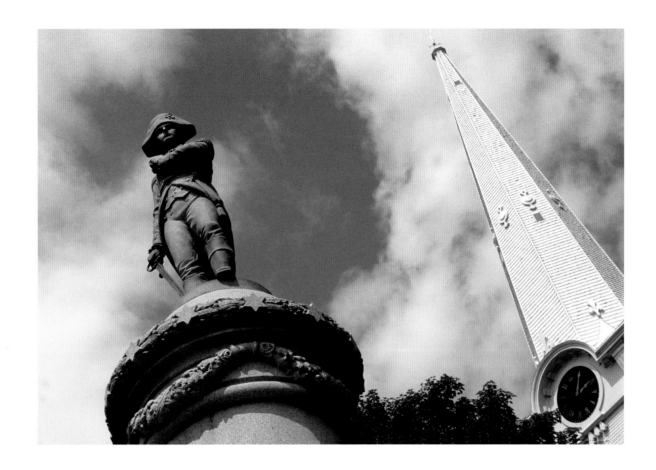

GREEN MOUNTAIN BOYS

When W.H. Fullerton was born in 1833, the Revolutionary War was a living memory for many. He grew up hearing stories and anecdotes from his father's and grandfather's generations. A successful stonemason and local businessman, acclaimed for his work, he was commissioned to fashion a monument for his town square in Manchester, Vermont, in front of the First Congregational Church. Fullerton's statue depicts one of the Green Mountain Boys, a legendary Vermont unit. It is possible he had met members of the band. By the time the statue was erected in 1879, that generation had passed, but the face of that soldier could have been a grandfather or uncle. People were proud to count one of them in their family, and still are today.

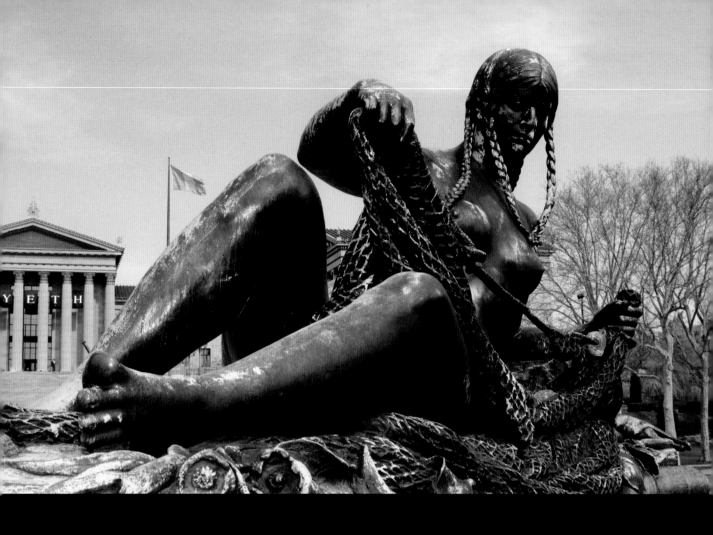
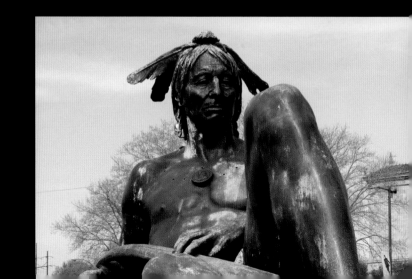

WASHINGTON AND AMERICA

In 1824, the Marquis de Lafayette visited Philadelphia, and the city fathers were embarrassed that there was no monument to his former commander, General George Washington. It took until 1897 for the city to properly honor the first President. Artist Rudolph Siemering was not content to simply sculpt a statue of Washington. Siemering's creation honors Washington by reminding us of the nation he helped create. Like an ancient chieftain, Washington's statue is surrounded by representations of the Revolution, and beyond them, emblems and symbols of American peoples and wildlife. These three images show details of the Revolution and the Native American peoples.

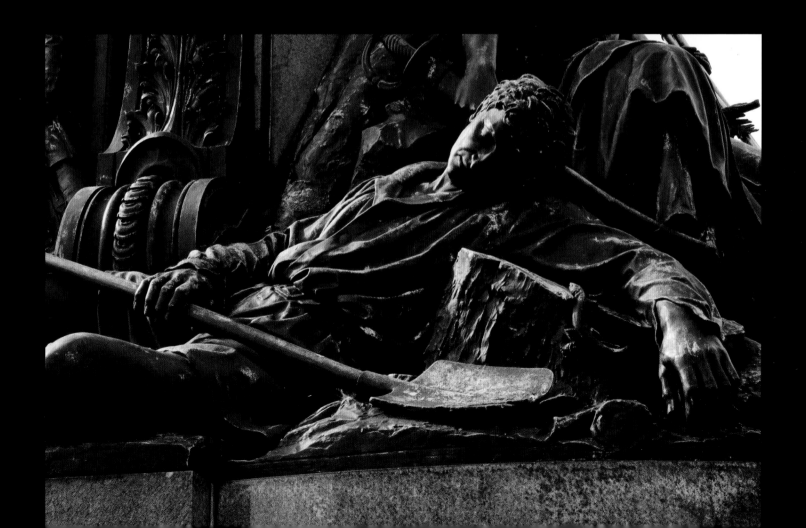

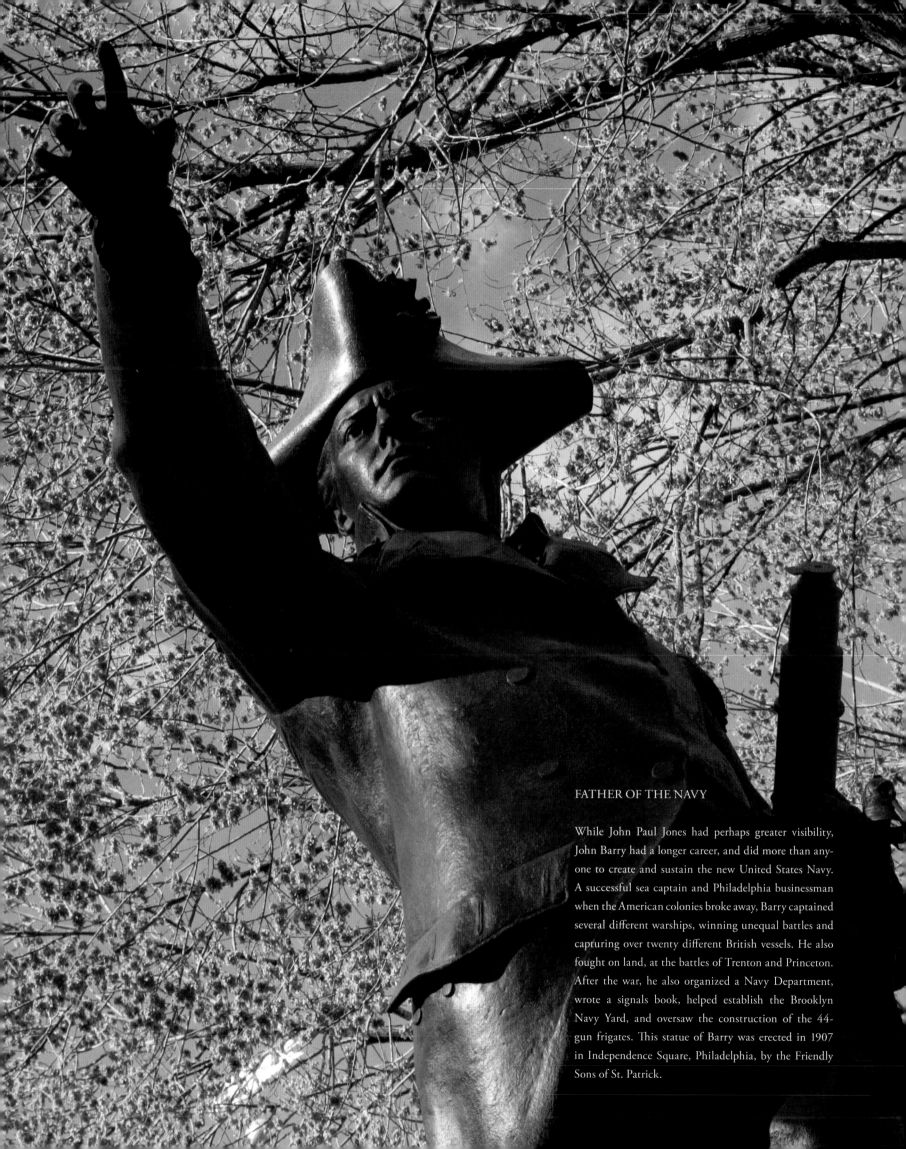

FATHER OF THE NAVY

While John Paul Jones had perhaps greater visibility, John Barry had a longer career, and did more than anyone to create and sustain the new United States Navy. A successful sea captain and Philadelphia businessman when the American colonies broke away, Barry captained several different warships, winning unequal battles and capturing over twenty different British vessels. He also fought on land, at the battles of Trenton and Princeton. After the war, he also organized a Navy Department, wrote a signals book, helped establish the Brooklyn Navy Yard, and oversaw the construction of the 44-gun frigates. This statue of Barry was erected in 1907 in Independence Square, Philadelphia, by the Friendly Sons of St. Patrick.

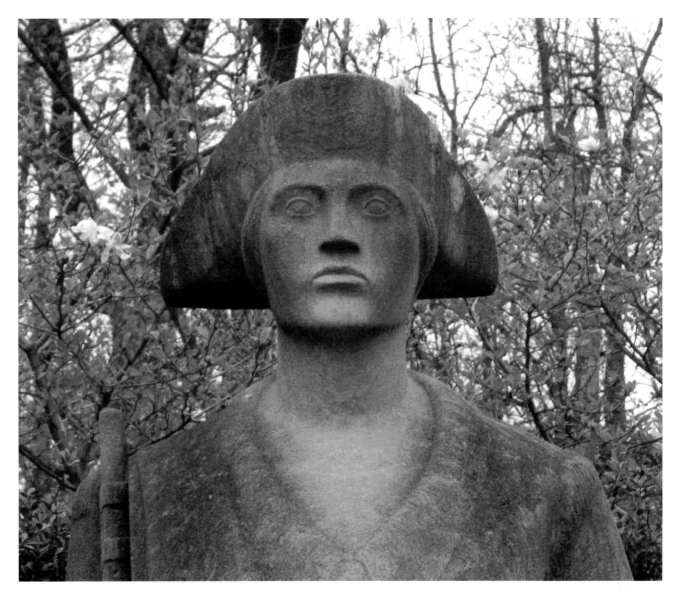

A SOLDIER'S PART

The South Terrace of the Ellen Phillips Samuel Memorial in Philadelphia is one of three terraces that make up the memorial. In the 1940s, sculptors offered designs in a competition whose theme was the birth and growth of the United States as a democracy. Erwin Frey's "A Revolutionary Soldier," above, was one of two pieces he sculpted; the other was "The Statesman."

Harry Rosin sculpted "The Puritan," shown here, as part of the same competition. Its companion piece was "The Quaker."

Other sculptors contributed works titled "The Settling of the Seaboard" and "The Birth of a Nation."

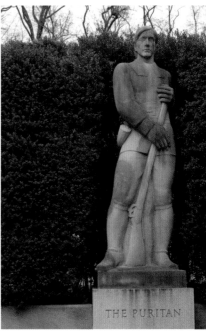

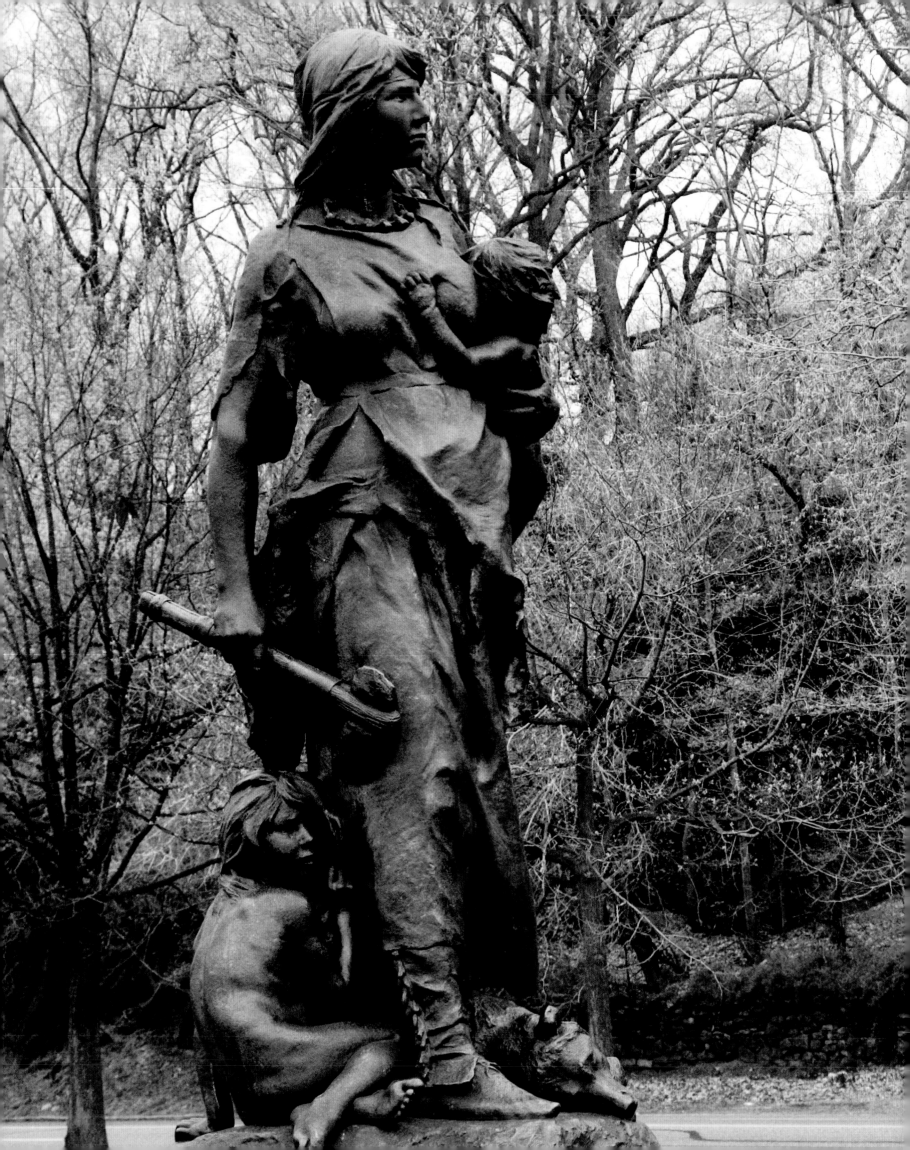

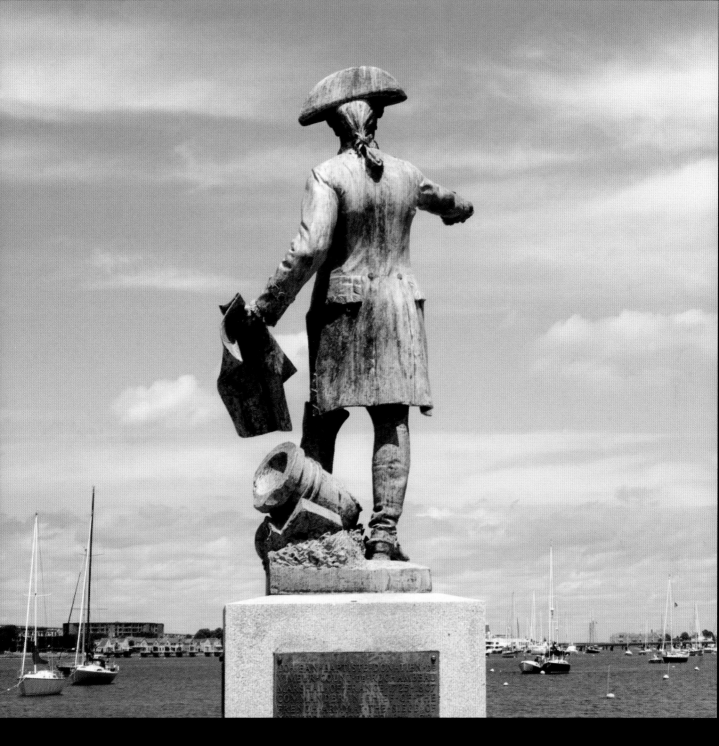

ANCIENT STRUGGLE

The oldest fight of all is the fight to survive. John J. Boyle's "Stone Age in America" brings that conflict to life. A Native American woman with a stone axe stands ready to fight, while her children cling to her for safety. The dead bear cub at her feet hints at her enemy, or possibly at her own ferocity in defending her children. Installed in Philadelphia in 1887, it has been called Boyle's greatest work.

HONORING FRIENDSHIP

When France sent troops to assist the American colonists in their struggle against England, they chose Jean-Baptiste Donatien de Vimêur, comte de Rochambeau, to command them. An experienced military officer, he was a valuable ally, and participated in the Battle of Yorktown. This statue marks the spot in Newport, Rhode Island, where he landed with his troops on July 10, 1780. Sculpted by J.J. Ferrand Hamar, similar statues stand in Washington, D.C. and Paris. This one was dedicated in 1933.

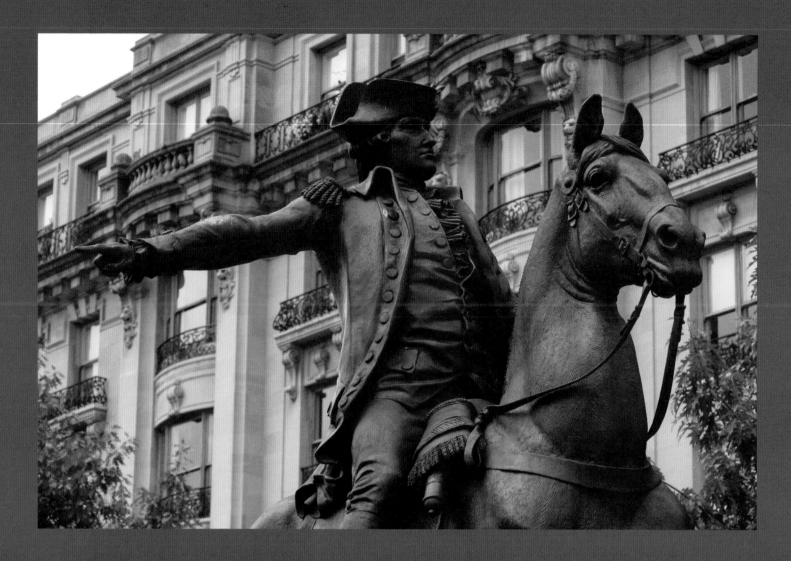

APPROPRIATE HONOR

Monument Park in Baltimore was dedicated in 1815 as a home for the Washington Monument, which was finished in 1829. At that time, it was well outside the Baltimore city limits, on land donated by Baltimore native John Eager Howard. Howard had served as a colonel in the Continental Army, and then as a congressman and one term as governor. As the city grew, the park changed, with more statues and public art installed. Revolutionary hero Lafayette, philanthropist Peabody, and Supreme Court Justice Taney were all honored. Finally and appropriately, in 1904, sculptor Emmanuel Frémiet's statue of John Eager Howard was added to the park. It's his land, after all.

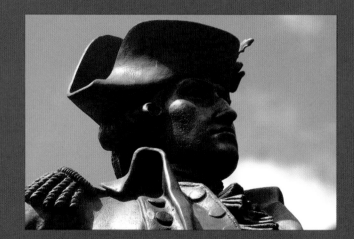

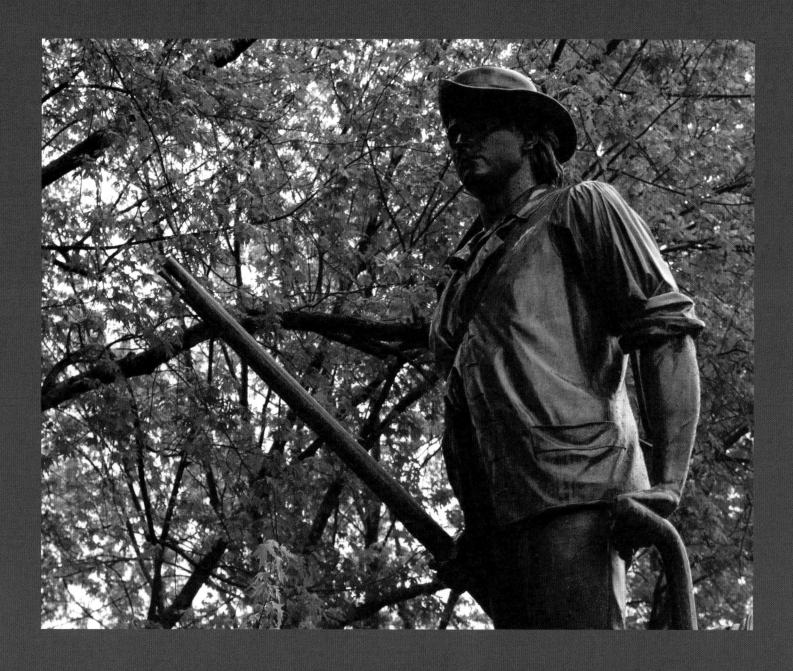

REVOLUTIONARY ICONS

The famous Minuteman statue at Concord, Massachusetts, was sculpted by Concord native Daniel Chester French, and was dedicated in 1875 as part of the Centennial of the Revolution. Nearby, the Old North Bridge is itself a monument, the fifth to stand there since the battle, but now designed to mimic the appearance of the "Battle Bridge" first built in 1760. French's statue is one of the most famous symbols of the Revolution, used and copied for postage stamps and insurance logos.

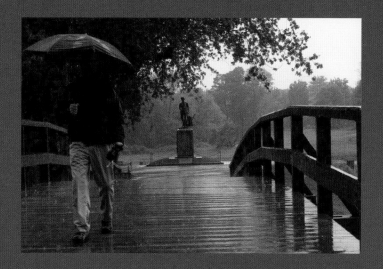

FIRST FALLEN

The Revolutionary Monument in Lexington, Massachusetts is the oldest war memorial in the United States. It was built to honor the first casualties in the War of Independence, and marks their gravesite. Constructed in 1799, it is the resting place of the eight men killed at Lexington.

PERSONAL PRICE

Lorado Taft created this sculpture of George Washington clasping hands with Robert Morris and Haym Salomon. Morris and Salomon were the two greatest financial backers of the American Revolution. Although neither ever saw battle, it is likely that the Revolution would have failed without their financial expertise and their personal contribution to support the war. They paid a high price, though, and both died bankrupt. This 1941 sculpture in downtown Chicago also celebrates the unity of people of different faiths in common purpose.

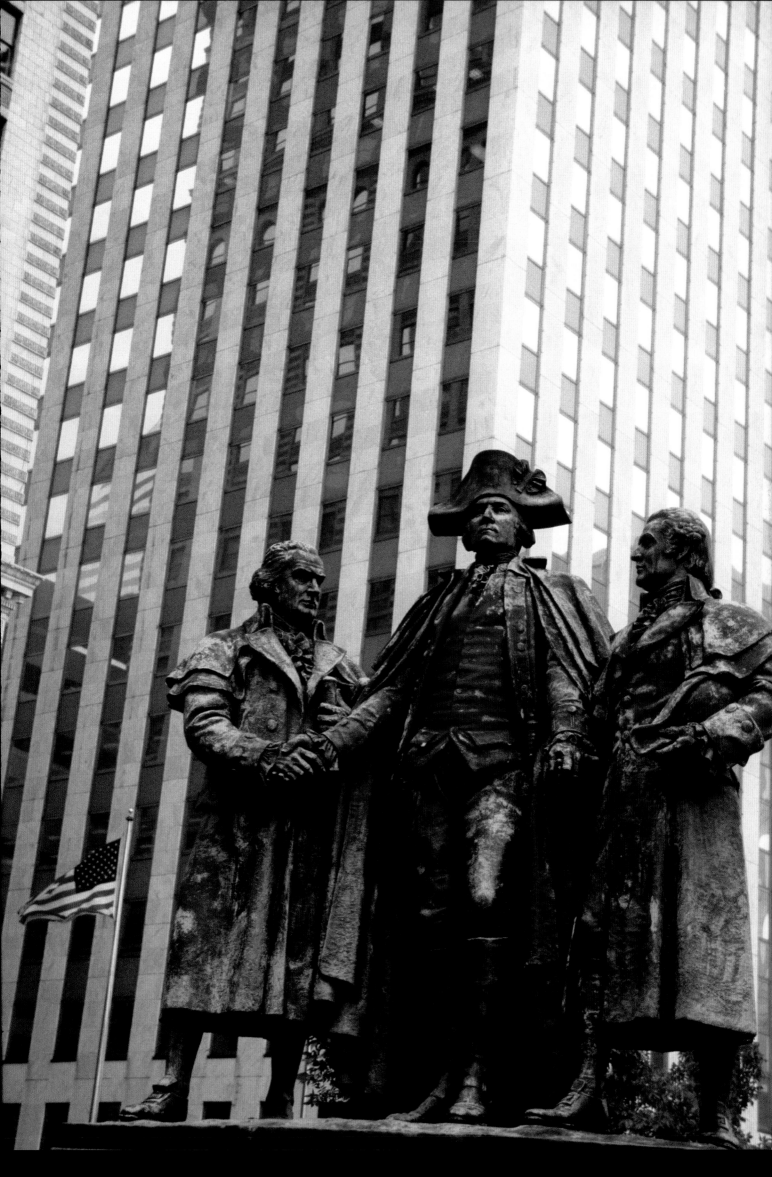

19TH CENTURY
CONFLICTS

SHAPING A NATION

America fought two major wars in the nineteenth century. The War of 1812 helped establish the United States as a sovereign power, able to act on the world's stage. Although we were not clear victors, there were plenty of heroes.

The larger Civil War consumed and transformed America, making it a single nation. With both sides American, every battle was a victory and a defeat, and in the end all the losses were ours. All the heroes were as well.

The Civil War may have forged the United States into a single nation, but for its citizens it was a small-town war. Citizens may have known they were Americans, but they thought of themselves first by their state, as Virginians or Pennsylvanians. Sometimes their thoughts never left the county where they were born. Communications and transportation were both just beginning to let people treat longer distances casually. Even if someone lived in a city, they still lived in small-town terms. Neighborhoods or boroughs formed small communities within the larger metropolis.

So when the locally-raised militias and regiments went off to fight for the Union or Confederate cause, everyone in that small town knew not just their own men, but everyone in the unit. Friends and neighbors watched each other's fathers, brothers, and sons go to faraway places like Florida and Maryland. They worried not only about their own kin, but boys they had watched grow up, with whom they had shared their lives.

Everyone who served was a hero. Leaving behind their livelihoods and their loved ones would have been enough, but they also accepted the certainty of hardship and the possibility of death. The army of the 1860s was a much simpler thing than today. Regular meals and decent medical care (even by the standards of the day) were problematic, and if a soldier wanted warm clothing, the folks back home might have to provide it.

They fought for an abstract concept—either to preserve a Union or be separate from it. These were not local issues. Later, the Southern boys could say they were fighting to protect their homes, but not in April of 1865. Devoting their lives to a distant, larger-than-life cause also marked them all as heroes.

Because the men often stayed together as a unit, they formed their own community in that far-off place, an extension of their home town. When the notices started to come back, whether their deaths were from dysentery or shellfire, the word was often sent by a friend, someone they had grown up with. Each loss was known to all, and felt by all.

The losses could be devastating, cutting the heart out of a community. Receiving one or two notices in a small town was bad enough, but because their men often fought as a unit, bad fortune on the battlefield could be devestating back home. Front-line units could sustain casualty rates of fifty percent or more. The effect on a town's population and its prospects for the future can hardly be imagined.

These days, we would say that the towns as well as the soldiers needed "closure," a way to recognize their grief and their men's sacrifice. "Decoration Day" was first celebrated on May 30, 1868 by Civil War veterans as a day to decorate the graves of fallen soldiers with flowers. The name was later changed to "Memorial Day." They also erected plaques, obelisks, and statues to individual or community contributions to the recent conflict. Some were raised by state governments, others by towns, many by popular subscription. They wanted the sacrifices of their relatives and friends to be understood and remembered long after their generation had passed away.

It worked.

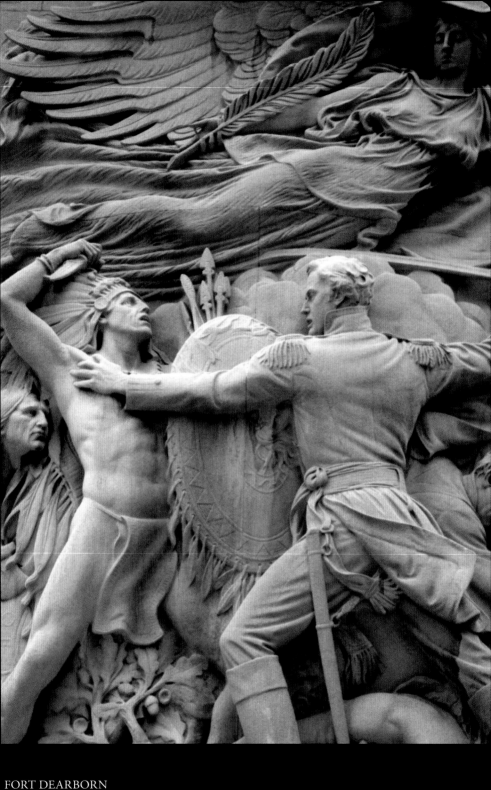

FORT DEARBORN

Fort Dearborn was built at the mouth of the Chicago River from 1803-1808. It was a lonely outpost, and when war broke out in 1812 in nearby Fort Macinac, Dearborn was ordered evacuated. As the soldiers and civilians were traveling to Fort Wayne, they were attacked by Potawatamie Indians, who were allied with the British. The Battle of Fort Dearborn is memorialized on a tower of the Michigan Avenue Bridge, which crosses the River at the site of the old fort, now downtown Chicago.

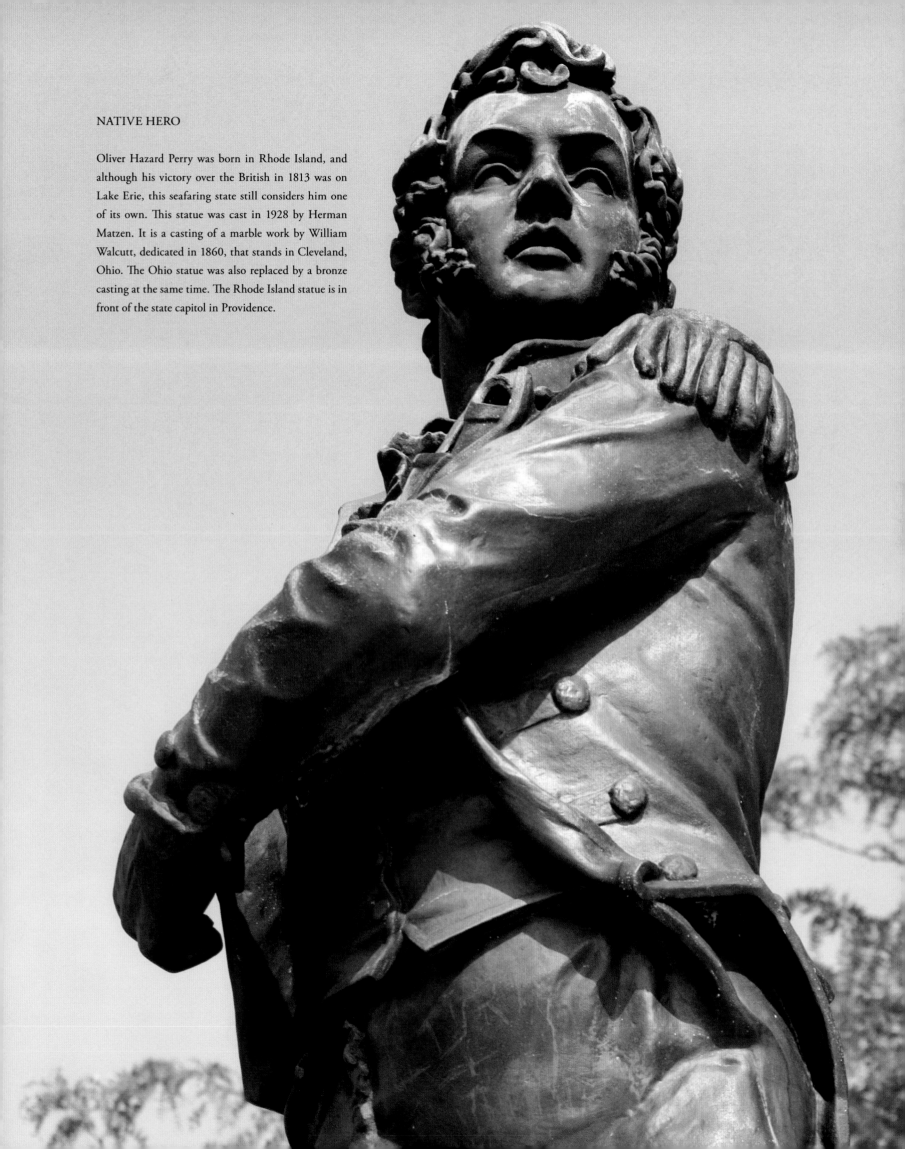

NATIVE HERO

Oliver Hazard Perry was born in Rhode Island, and although his victory over the British in 1813 was on Lake Erie, this seafaring state still considers him one of its own. This statue was cast in 1928 by Herman Matzen. It is a casting of a marble work by William Walcutt, dedicated in 1860, that stands in Cleveland, Ohio. The Ohio statue was also replaced by a bronze casting at the same time. The Rhode Island statue is in front of the state capitol in Providence.

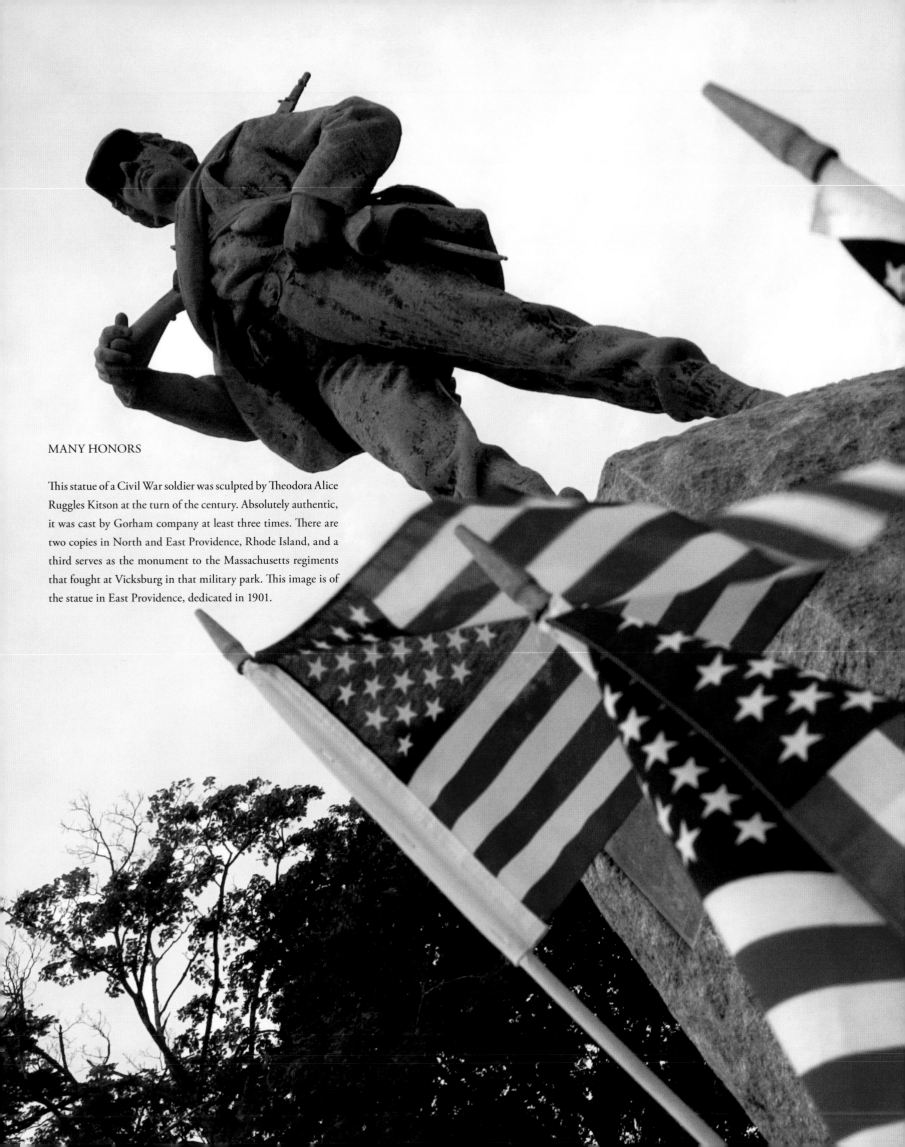

MANY HONORS

This statue of a Civil War soldier was sculpted by Theodora Alice Ruggles Kitson at the turn of the century. Absolutely authentic, it was cast by Gorham company at least three times. There are two copies in North and East Providence, Rhode Island, and a third serves as the monument to the Massachusetts regiments that fought at Vicksburg in that military park. This image is of the statue in East Providence, dedicated in 1901.

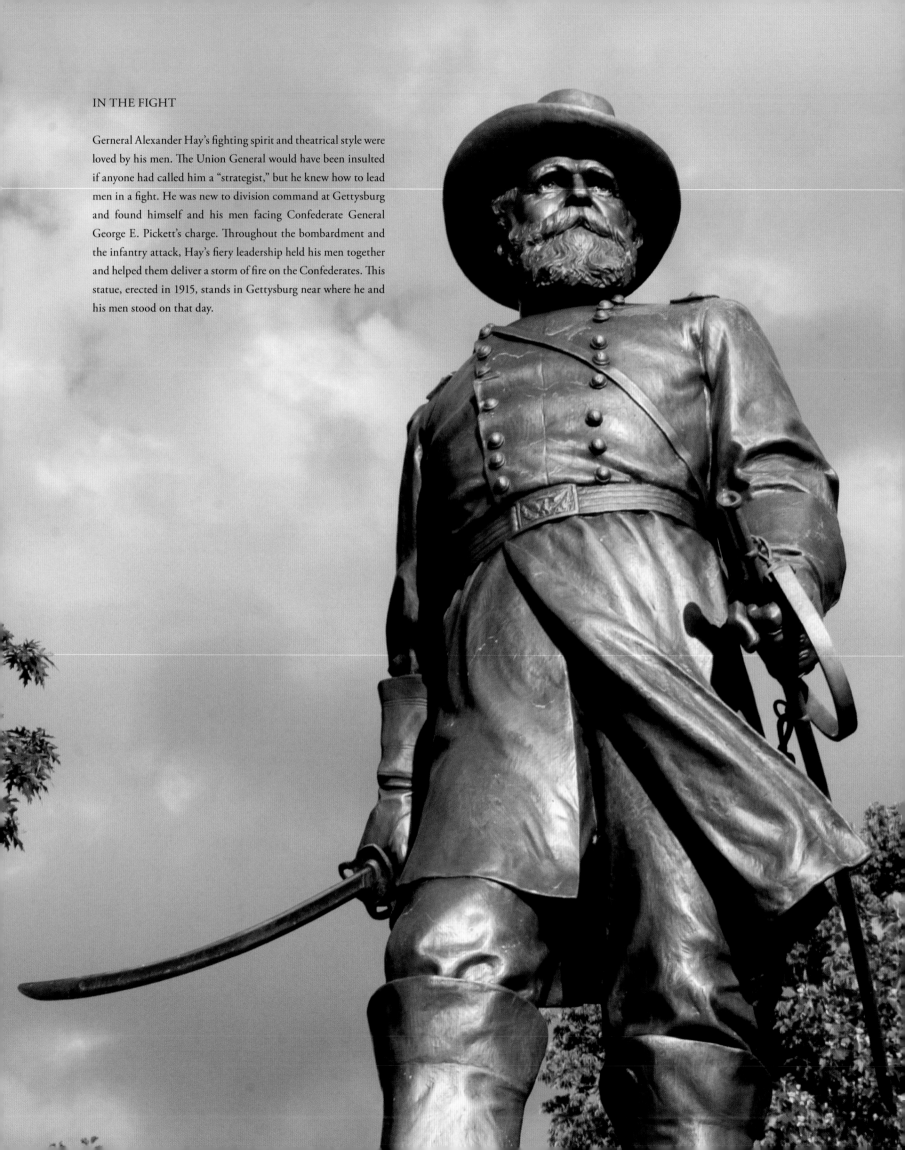

IN THE FIGHT

Gerneral Alexander Hay's fighting spirit and theatrical style were loved by his men. The Union General would have been insulted if anyone had called him a "strategist," but he knew how to lead men in a fight. He was new to division command at Gettysburg and found himself and his men facing Confederate General George E. Pickett's charge. Throughout the bombardment and the infantry attack, Hay's fiery leadership held his men together and helped them deliver a storm of fire on the Confederates. This statue, erected in 1915, stands in Gettysburg near where he and his men stood on that day.

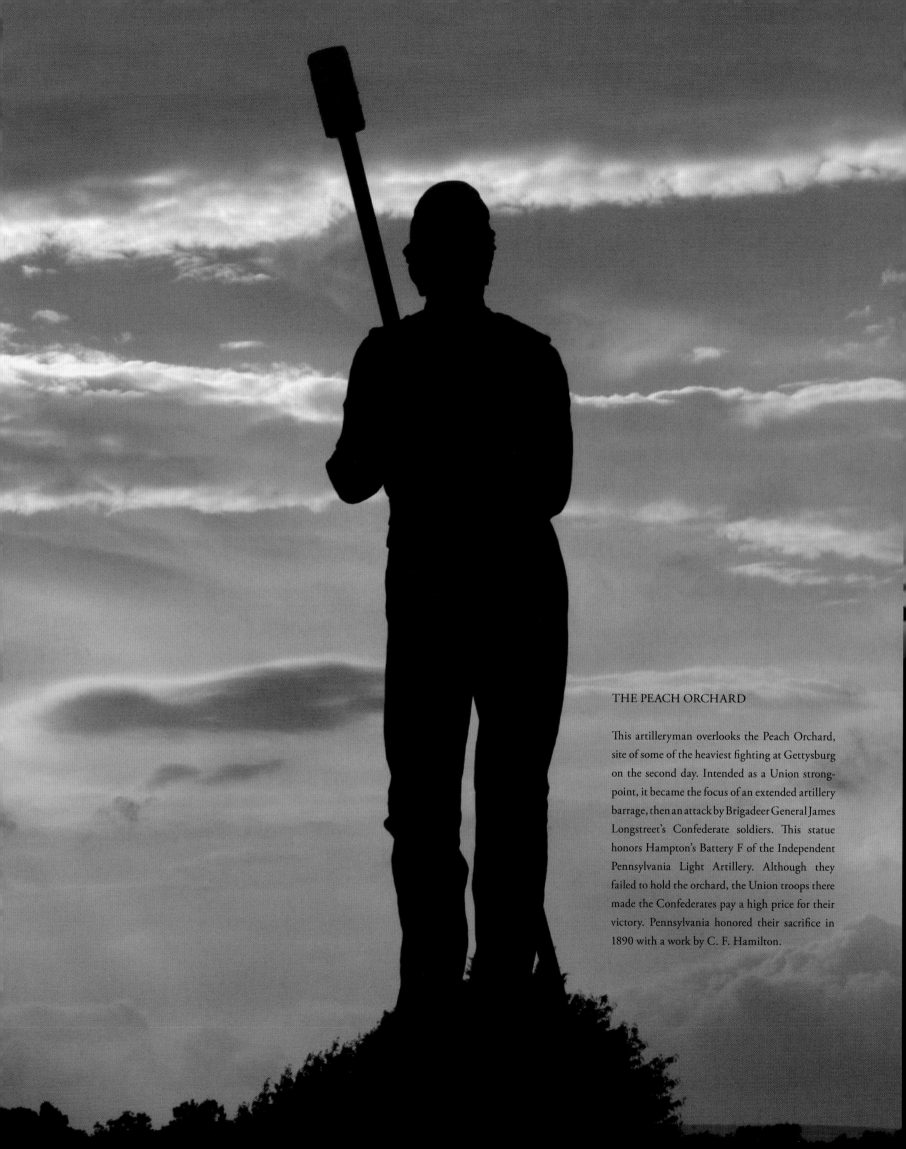

THE PEACH ORCHARD

This artilleryman overlooks the Peach Orchard, site of some of the heaviest fighting at Gettysburg on the second day. Intended as a Union strongpoint, it became the focus of an extended artillery barrage, then an attack by Brigadeer General James Longstreet's Confederate soldiers. This statue honors Hampton's Battery F of the Independent Pennsylvania Light Artillery. Although they failed to hold the orchard, the Union troops there made the Confederates pay a high price for their victory. Pennsylvania honored their sacrifice in 1890 with a work by C. F. Hamilton.

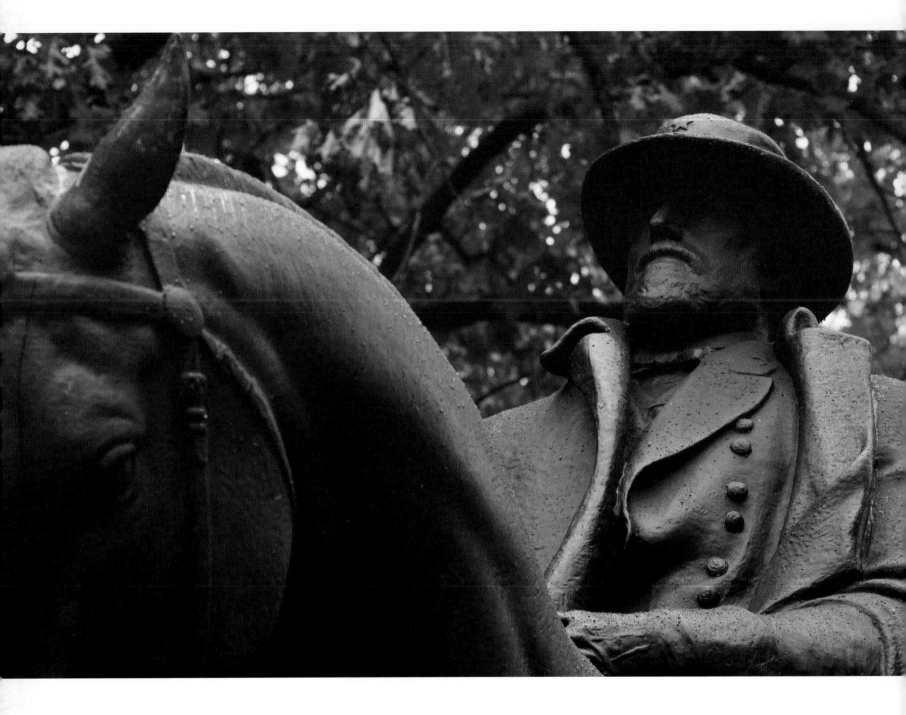

LAST PARTING

Although they may have fought on the losing side, Generals Robert E. Lee and Stonewall Jackson are icons of brilliant generalship and exemplary conduct. This detail of General Lee is part of a double equestrian statue that depicts their last meeting, just before the Battle of Chancellorsville. This Baltimore statue was dedicated in 1948. During the fight, General Jackson was accidentally shot by Confederate pickets, and died shortly thereafter. The work by artist Laura Gardin Fraser commemorates not only their virtues, but the loss of a great leader, and, like the cause they fought for, the sad waste of any war.

SAD HOMECOMING

In 1914, Colonel Ashley Horne, a veteran of the Civil War, presented North Carolina with a sculpture by Augustus Lukeman titled "Women of the Confederacy." Meant to honor and remember their sacrifices during the Civil War, it has two plaques on the base, depicting the wastefulness of war. It stands on the Statehouse grounds in Raleigh, North Carolina.

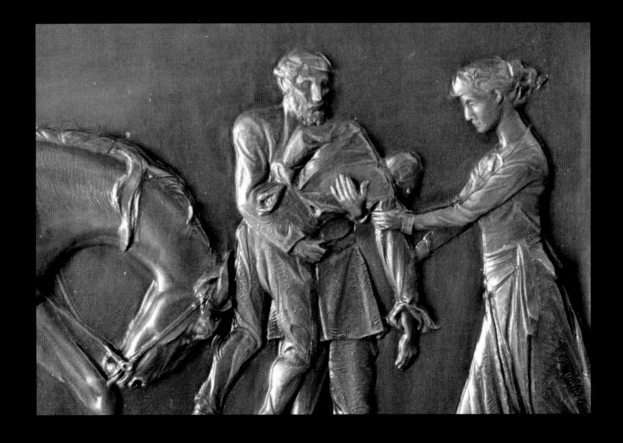

WEATHERED REMEMBRANCE

This marble memorial was erected by the Women's Relief Corps, an auxiliary of the Grand Army of the Republic, in 1885. J.M. Dibuscher sculpted a reclining soldier that after a hundred years still evokes peace and rest. The pedestal reads "In Memory of the Unknown Dead." Battered by the elements, it faithfully performs its task. It is located in the Loudon Park Military Cemetery in Maryland.

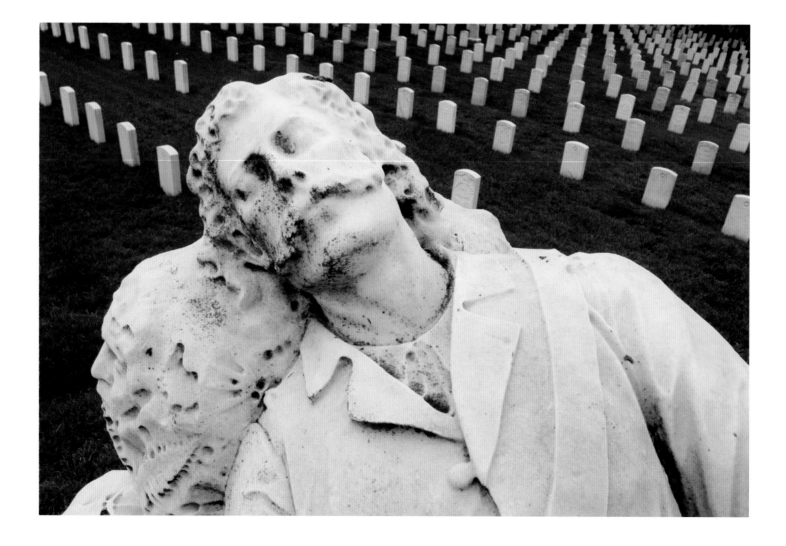

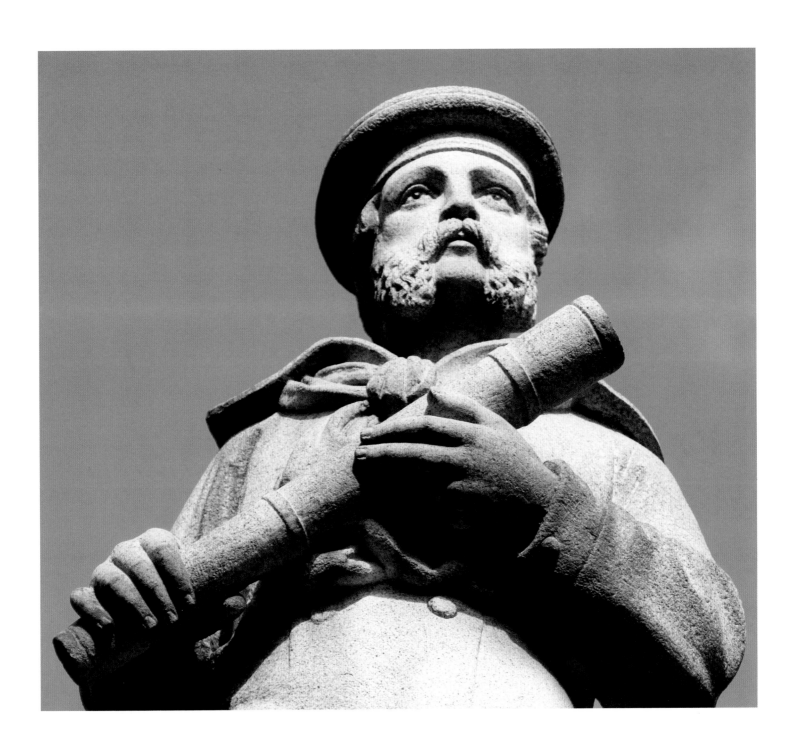

REMEMBERING THEIR OWN

Maryland's Naval Veterans' Association commissioned this granite statue in 1896. The Loyal Sons of Maryland Naval Monument stands in the Loudon Park Military Cemetery, honoring the over 4000 Marylanders who served at sea in the Civil War.

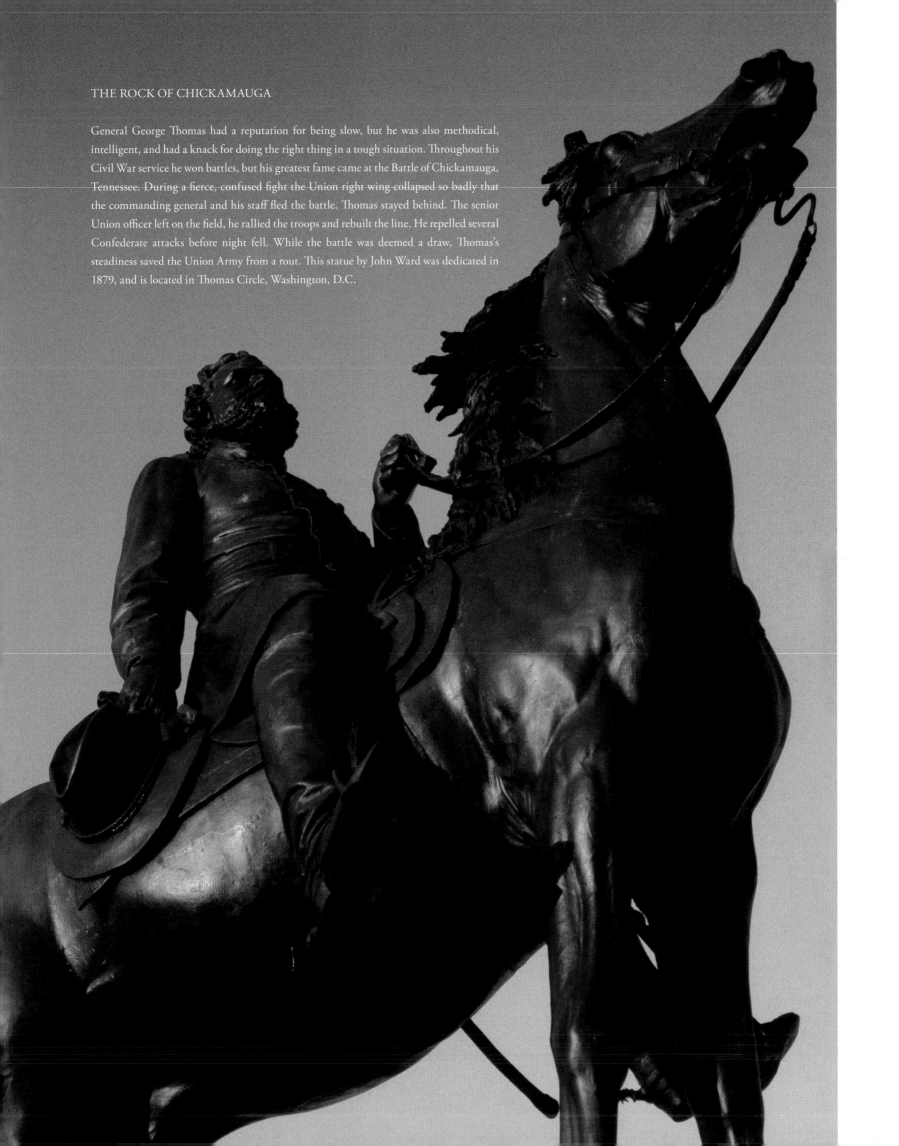

THE ROCK OF CHICKAMAUGA

General George Thomas had a reputation for being slow, but he was also methodical, intelligent, and had a knack for doing the right thing in a tough situation. Throughout his Civil War service he won battles, but his greatest fame came at the Battle of Chickamauga, Tennessee. During a fierce, confused fight the Union right wing collapsed so badly that the commanding general and his staff fled the battle. Thomas stayed behind. The senior Union officer left on the field, he rallied the troops and rebuilt the line. He repelled several Confederate attacks before night fell. While the battle was deemed a draw, Thomas's steadiness saved the Union Army from a rout. This statue by John Ward was dedicated in 1879, and is located in Thomas Circle, Washington, D.C.

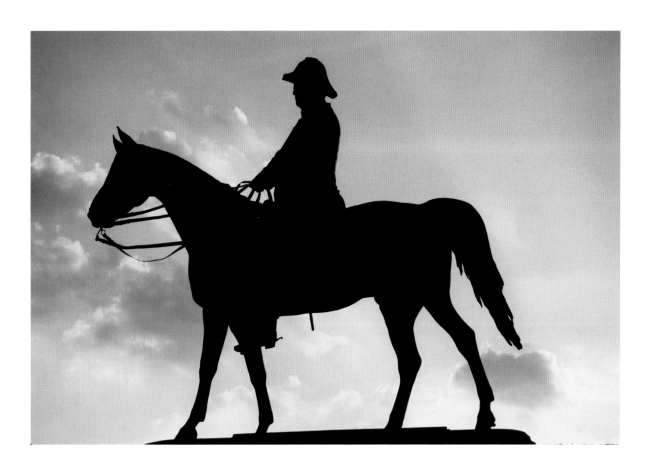

LONG-SERVICE HERO

Winfield Scott served in the U.S. Army for over fifty years, most of that time as a general. Already a hero after the War of 1812 and the Mexican War in 1847, he rose to command the entire U.S. Army. Although too ill and overweight in the Civil War to command in the field, his mind was still sharp. His "Anaconda" plan, though ridiculed by some, did indeed strangle the Confederacy. This 1861 plan to win the Civil War with minimal loss to the Union consisted of a blockade at sea and control of the Mississippi. This statue by Henry Kirke Brown was dedicated in 1874, only eight years after Scott's death. It stands in Scott Circle, in downtown Washington, D.C.

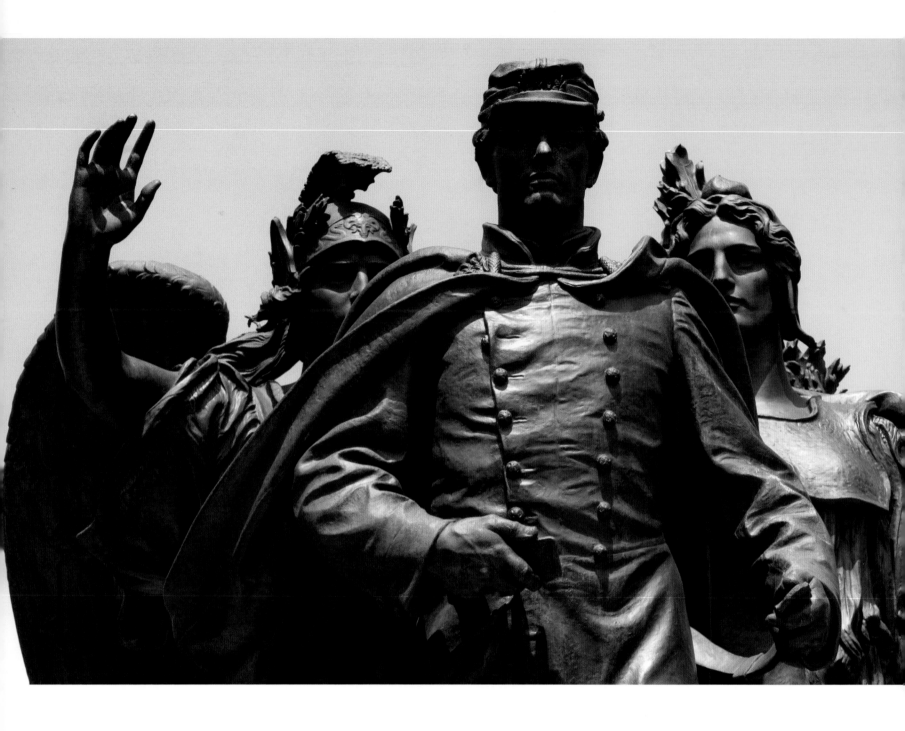

DIVIDED SYMPATHIES

Baltimore's Union Soldiers and Sailors monument by Adolf A. Weiman wasn't erected until 1909. The Confederate Soldiers and Sailors memorial was dedicated first, in 1903, and both are downtown. While the Confederate soldier is wounded and supported by an angel, the Union soldier is shown walking purposefully south.

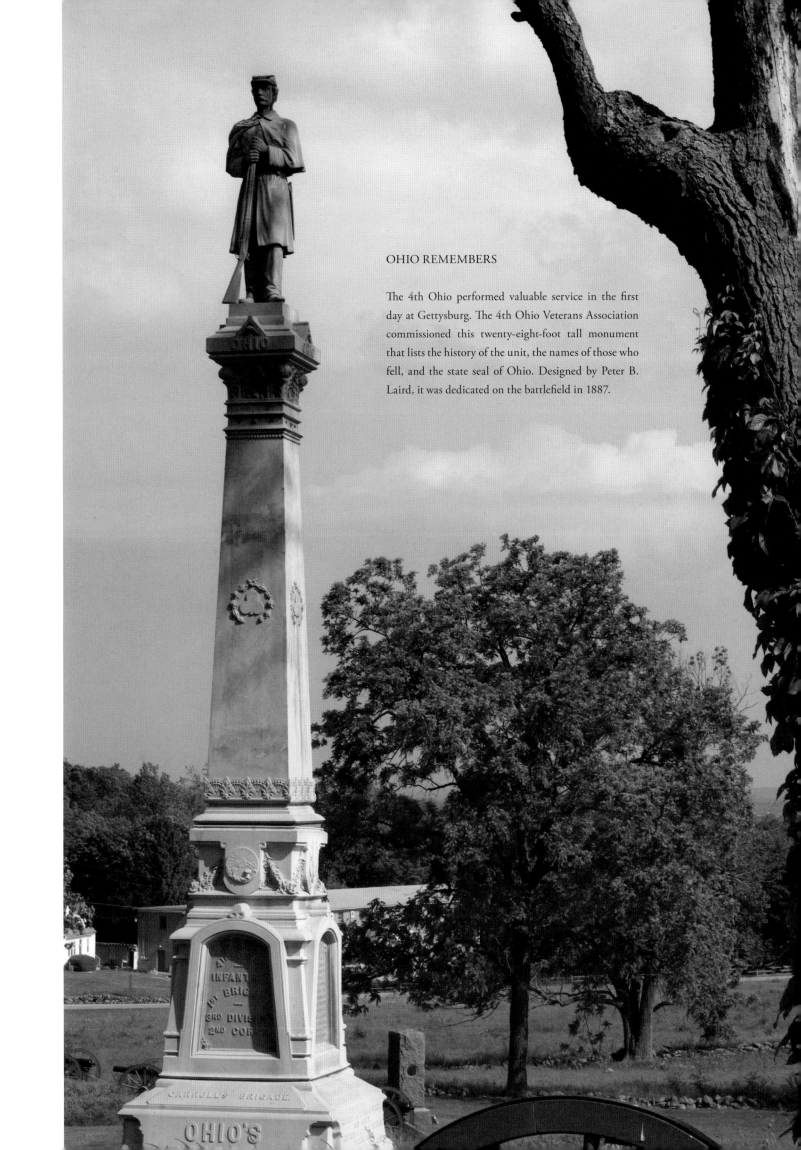

OHIO REMEMBERS

The 4th Ohio performed valuable service in the first day at Gettysburg. The 4th Ohio Veterans Association commissioned this twenty-eight-foot tall monument that lists the history of the unit, the names of those who fell, and the state seal of Ohio. Designed by Peter B. Laird, it was dedicated on the battlefield in 1887.

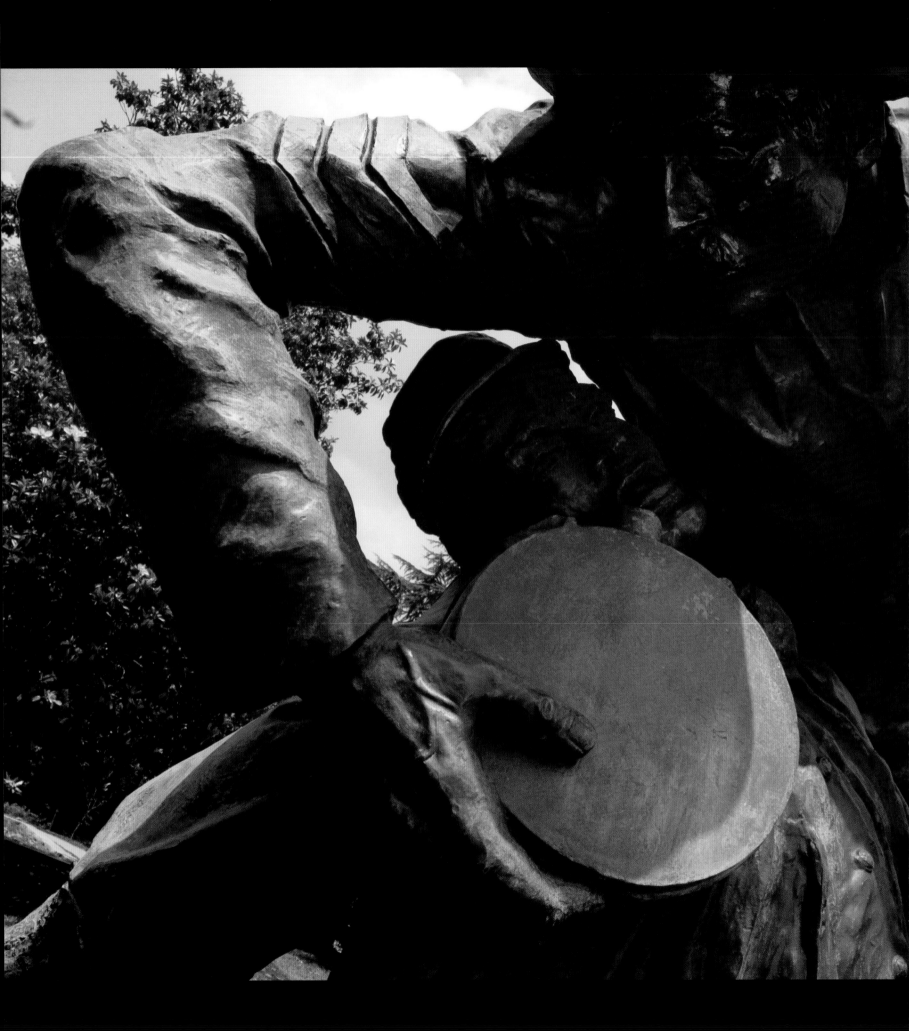

A HERO TO BOTH SIDES

With Confederate defenders at Fredricksburg dug in behind a stone wall, they mowed down the attacking Union troops in frightening numbers. As night fell, the cries of hundreds of wounded could be heard by both sides. One man, a Confederate named Richard Rowland Kirkland, was so moved that he climbed over the wall and gave what aid he could to the wounded, most of them enemy soldiers. After a few shots from the Union side, they held their fire while he continued, and then cheered him as he returned to Confederate lines. This sculpture was designed by Felix de Weldon, who also created the Iwo Jima memorial. It was dedicated in 1965 and rests near the stone wall, on the spot where Kirkland risked his life rendering aid.

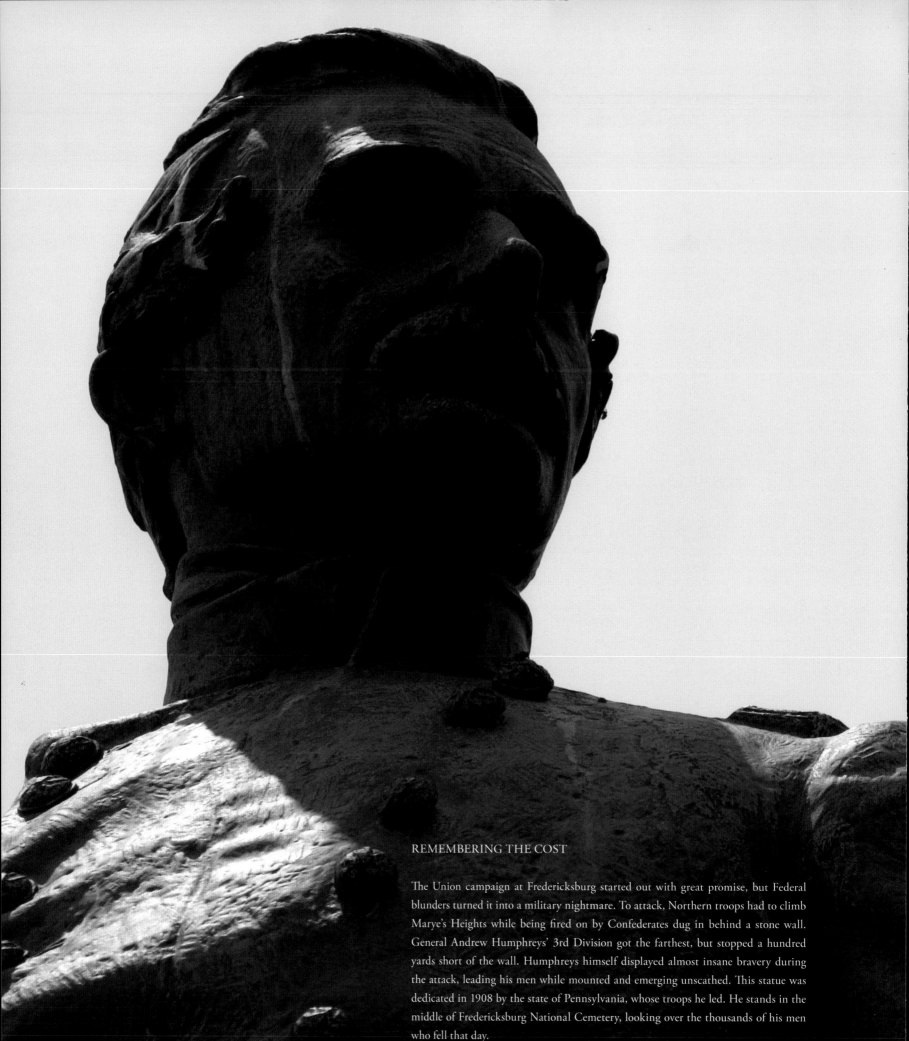

REMEMBERING THE COST

The Union campaign at Fredericksburg started out with great promise, but Federal blunders turned it into a military nightmare. To attack, Northern troops had to climb Marye's Heights while being fired on by Confederates dug in behind a stone wall. General Andrew Humphreys' 3rd Division got the farthest, but stopped a hundred yards short of the wall. Humphreys himself displayed almost insane bravery during the attack, leading his men while mounted and emerging unscathed. This statue was dedicated in 1908 by the state of Pennsylvania, whose troops he led. He stands in the middle of Fredericksburg National Cemetery, looking over the thousands of his men who fell that day.

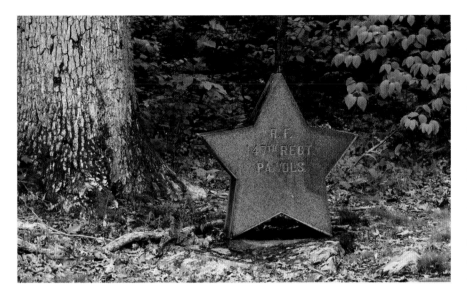

HUMBLE HONOR

The 147th Pennsylvania Infantry was part of I Corps. It was involved in the fighting at Gettysburg from the first day, but it was on the third that it made its name. Late on the second day, the Union had been pushed out of its positions near Culp's Hill, which had been occupied by the Confederates. This included a stone wall. On the morning of the third, the 147th Pennsylvania, led by its commander. Ario Pardee, Jr., charged across an open field and drove the Confederates from the wall. The field is still named "Pardee Field." This simple star marks the southern edge of the field.

NEW HAMPSHIRE'S LOSS

The 5th New Hampshire regiment was one of the units that fought in the Wheatfield on the second day of Gettysburg. It was a firestorm for both sides. Its former colonel, Edward Cross, was now brigade commander. He was a veteran, and had already received twelve wounds. The attack in the Wheatfield was unlucky thirteen. Thirty other New Hampshire men died that day. In 1886, the veterans of the unit came back and identified the spot where Colonel Cross fell. Their simple remembrance consists of boulders collected from around the battlefield and an octagonal block of New Hampshire granite.

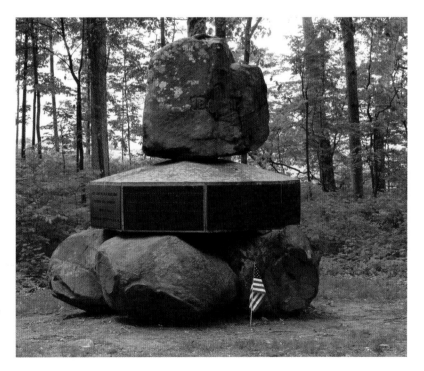

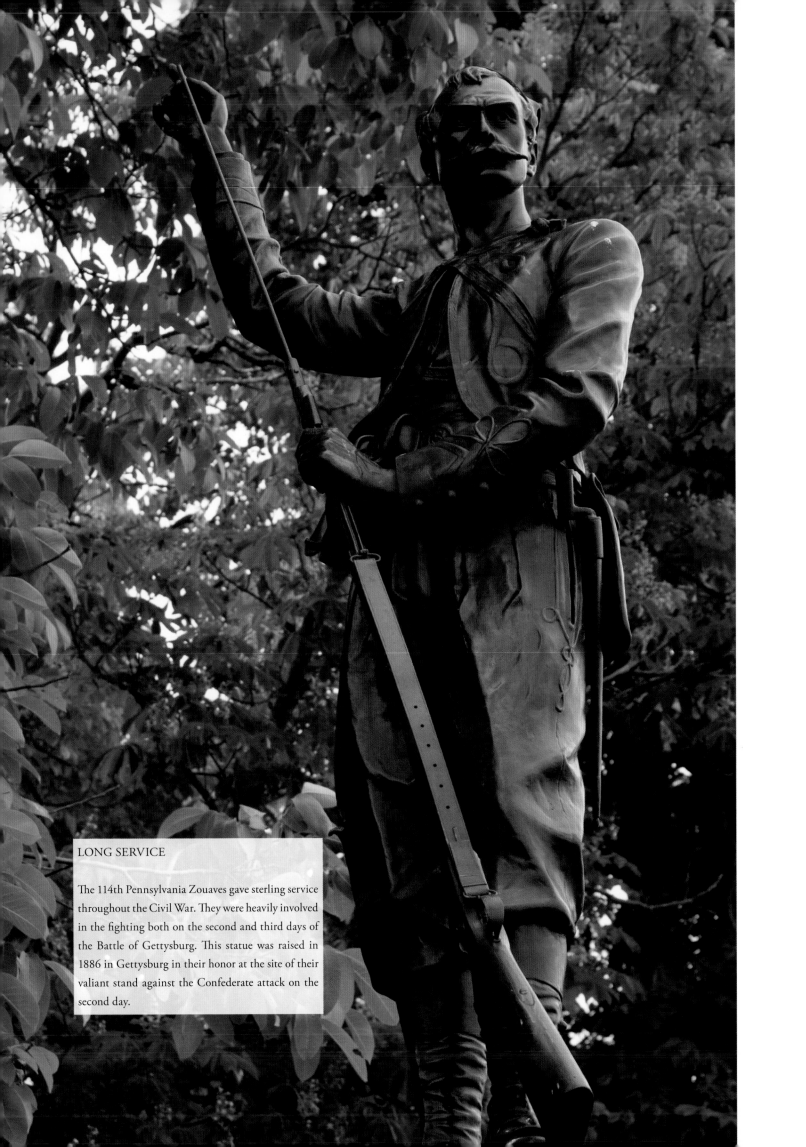

LONG SERVICE

The 114th Pennsylvania Zouaves gave sterling service throughout the Civil War. They were heavily involved in the fighting both on the second and third days of the Battle of Gettysburg. This statue was raised in 1886 in Gettysburg in their honor at the site of their valiant stand against the Confederate attack on the second day.

EARLY HERO

At the beginning of the Civil War, Thomas J. Jackson was a veteran military officer and an instructor at the Virginia Military institute. Appointed a brigadier general, he earned undying fame at the first major battle of the Civil War. General Barnard Bee, rallying his own men, cried, "There stands Jackson like a stone wall!" The quote might have remained only a footnote if Jackson had not proven his worth.

This bronze statue by Joseph Pollia was erected in 1940. It stands on the spot where Jackson earned his nickname and began his career as one of the ablest generals in the Confederacy and American military history. He stands near the Manassas Visitors Center, run by the National Park Service. A visitor could never imagine what was fought over this quiet landscape of the Battle of Manassas.

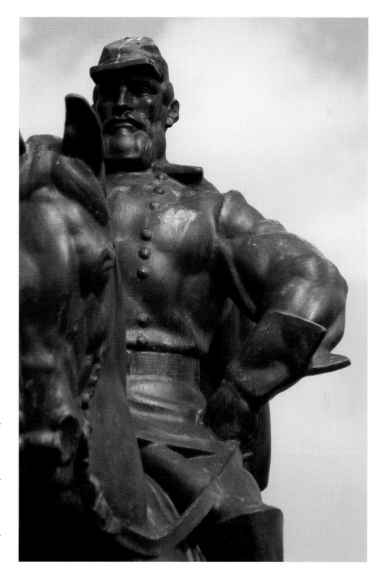

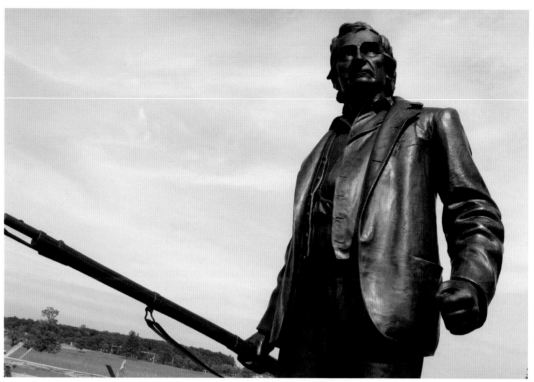

WILLING WARRIOR

John Burns was a civilian, in his seventies, and a veteran of the war of 1812. At the Battle of Gettysburg, instead of sensibly taking shelter with the other citizens, he asked to join a Pennsylvania regiment of Union troops. The troops were moved by his courage. Wounded three times, he survived the fight and lived another eight years. The State of Pennsylvania commissioned Albert G. Bureau to sculpt this bronze statue, dedicated in 1903. It stands near the spot where he was wounded.

HIGH PRICE FOR VICTORY

By July of 1864, General John Fulton Reynolds was one of the most respected officers in the Union Army. Offered command of the Army of the Potomac, he refused it unless he was freed from political constraints. Washington refused, instead appointing General George Meade to command. Thus, as General Fulton Reynolds sole task was command of four Union corps, on the first day of Gettysburg, he was able to rush to General Buford's defense. Reynolds's leadership saved the day, but early in the action, while deploying his men, he was shot and succumbed soon thereafter. This memorial is in Gettysburg National Military Park, Pennsylvania.

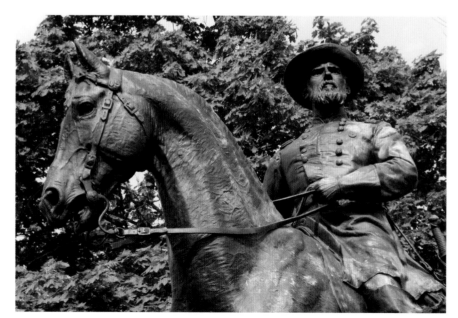

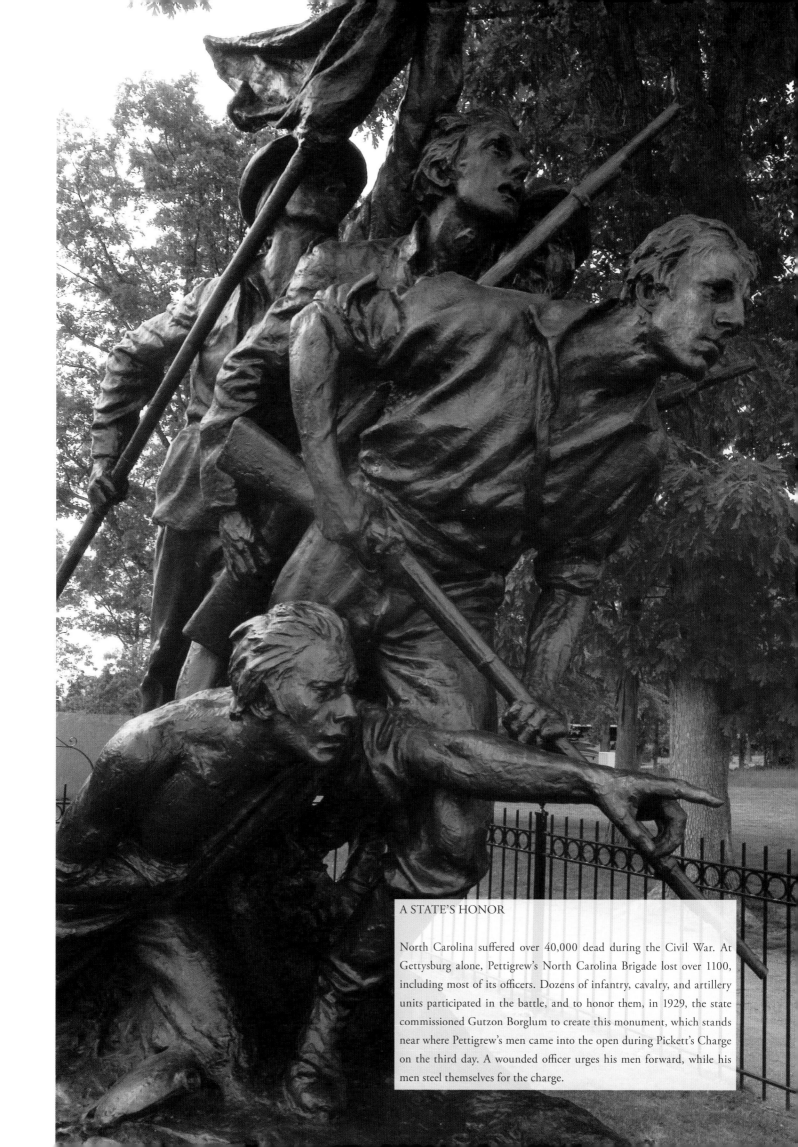

A STATE'S HONOR

North Carolina suffered over 40,000 dead during the Civil War. At Gettysburg alone, Pettigrew's North Carolina Brigade lost over 1100, including most of its officers. Dozens of infantry, cavalry, and artillery units participated in the battle, and to honor them, in 1929, the state commissioned Gutzon Borglum to create this monument, which stands near where Pettigrew's men came into the open during Pickett's Charge on the third day. A wounded officer urges his men forward, while his men steel themselves for the charge.

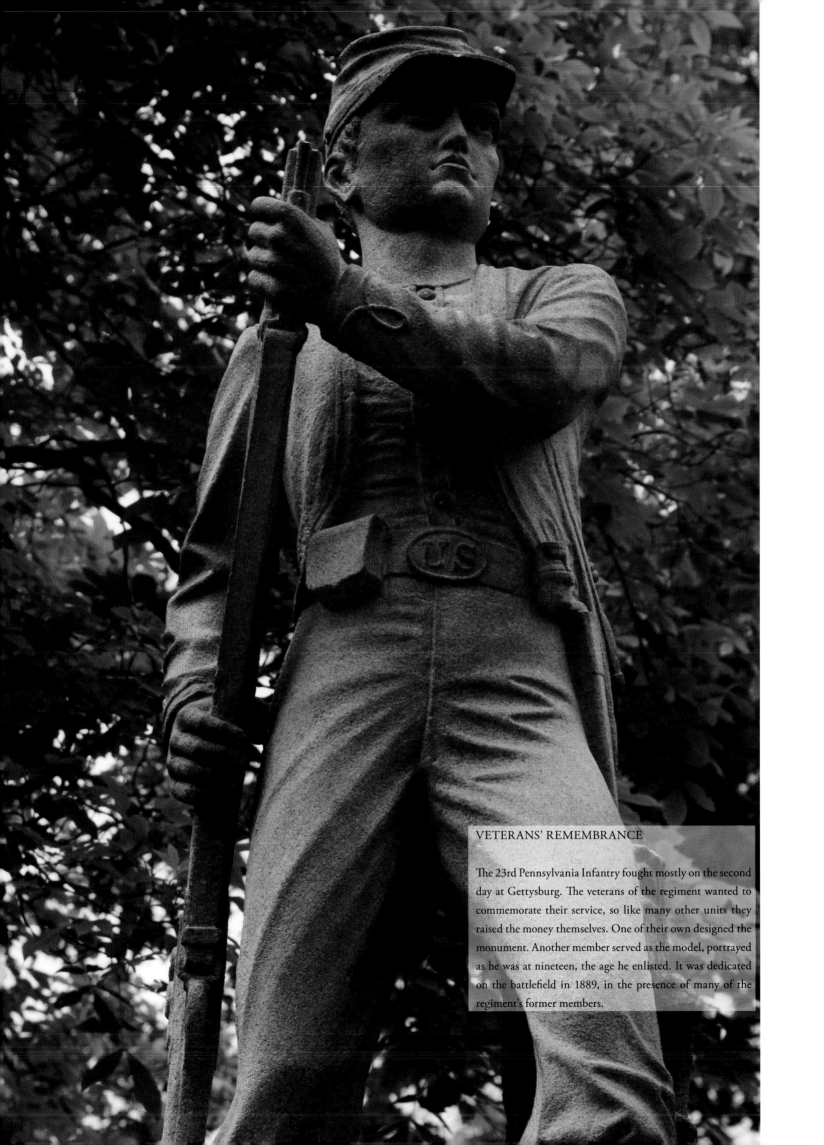

VETERANS' REMEMBRANCE

The 23rd Pennsylvania Infantry fought mostly on the second day at Gettysburg. The veterans of the regiment wanted to commemorate their service, so like many other units they raised the money themselves. One of their own designed the monument. Another member served as the model, portrayed as he was at nineteen, the age he enlisted. It was dedicated on the battlefield in 1889, in the presence of many of the regiment's former members.

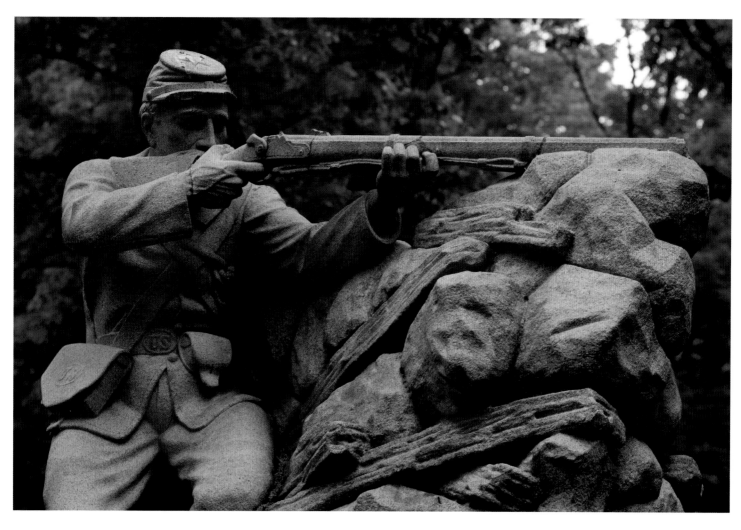

CULP'S HILL

These two monuments are close to each other on Culp's Hill. The right rear of the Union line was anchored there, to the north and east of Gettysburg. It was the site of heavy fighting through the night of July 2nd and most of July 3rd, the first and second days of the battle. Some of the regiments involved were the 78th and 102nd New York Infantry and the 13th New Jersey. The 13th New Jersey veterans designed and dedicated their monument, a stone bas-relief, in 1887. The 78th and 102nd New York fought together and so erected a single monument, sculpted by R. D. Barr and dedicated in 1888. It was also a stone monument with the soldier in a similar pose.

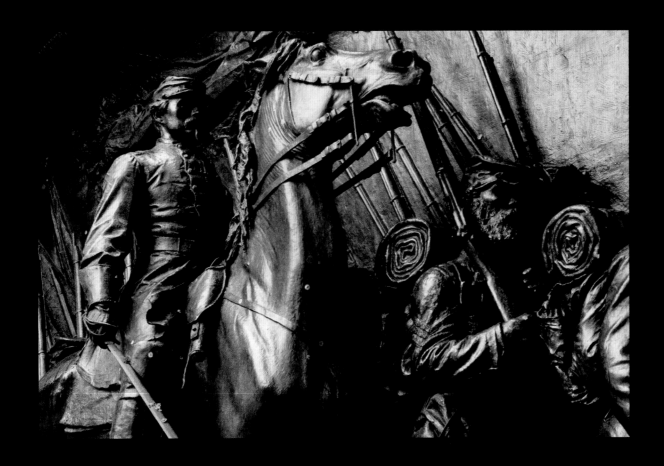

EXCEPTIONAL SERVICE

The 54th Massachusetts Volunteers managed to win two fights, first for the Union cause, and then for the rights of African Americans. After their charge at Fort Wagner, South Carolina, nobody could ever question the bravery or dedication of "colored" troops. This memorial, dedicated in their home city of Boston, was sculpted by Augustus St. Gaudens in 1887.

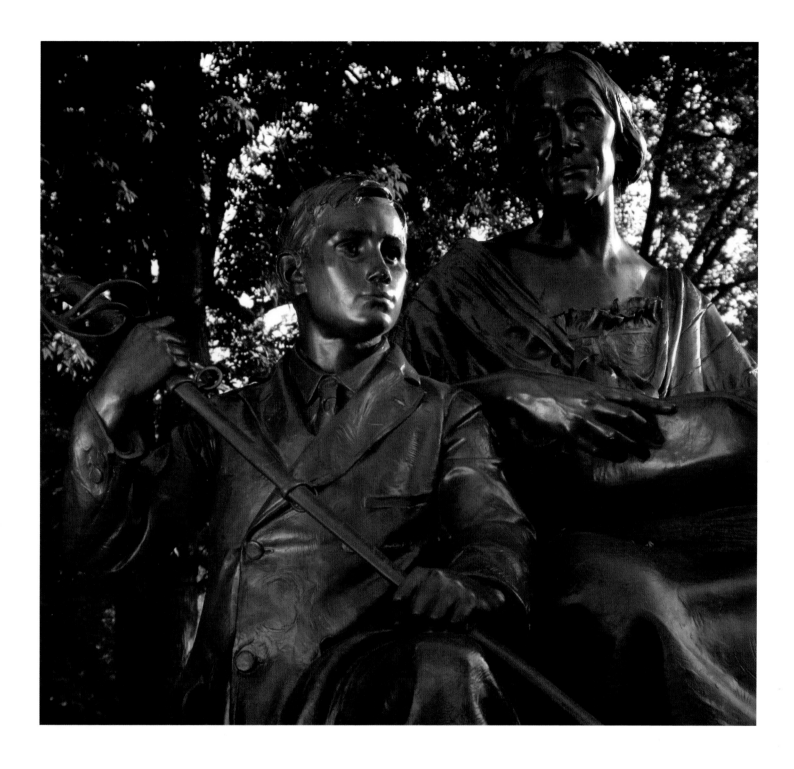

WOMEN IN THE CIVIL WAR

In 1914, sculptor Augusts Lukeman was commissioned to create a monument honoring the sacrifices of the women during the Civil War. His "Women of the Confederacy," in Union Square in Raleigh, North Carolina, shows a woman reading to a small boy, while he holds a sword.

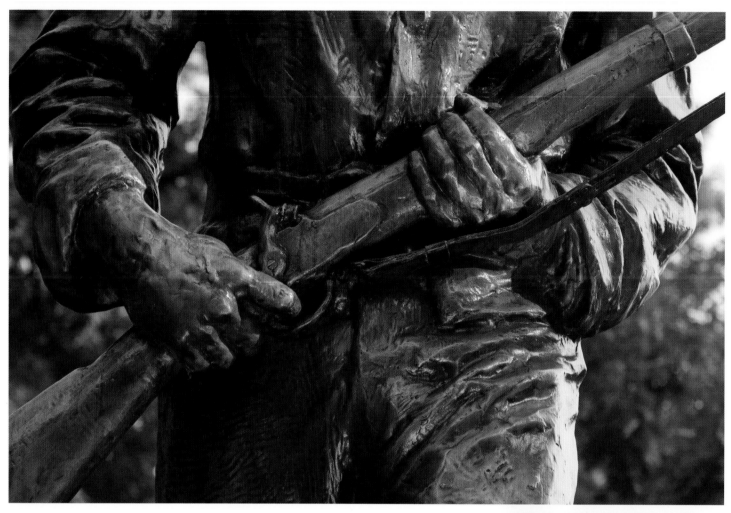

COMMON DUTY

Henry Lawson Wyatt's statue stands on the State House grounds in Raleigh, North Carolina. A member of the First North Carolina Regiment, he fell on June 10, 1861, at the Battle of Big Bethel, Virginia. Sculpted by Gutzon Borglum, the statue was dedicated in 1912, and honors Wyatt as the first Confederate soldier to die during the Civil War. Every soldier risks his life as part of his duty, and so this statue honors not just his death, but the service of all soldiers.

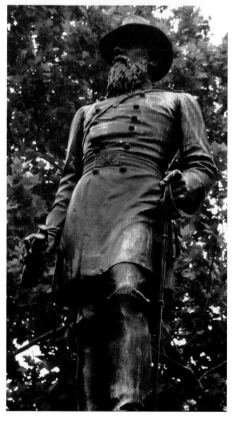

INDISPENSABLE LOYALTY

John A. Rawlins was a lawyer in Illinois when the Civil War started. He knew Ulysses S. Grant, who worked in a shop owned by Rawlins's brother. When Grant rejoined the army, Rawlins became his aide and chief of staff, a teaming that would last eight years. At the end of that time Grant would be president and Rawlins would be his Secretary of War. The partnership that Grant called "indispensable" finally ended when Rawlins died of tuberculosis, refusing to move to drier Arizona so that he could instead stay with Grant. This statue of Rawlins by Joseph A. Bailey was dedicated in 1874 in Washington, D.C.

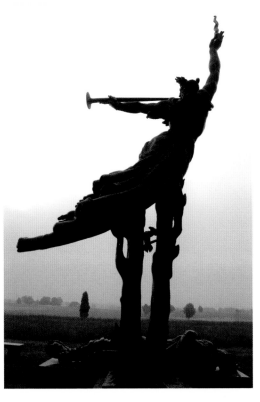

BEAUTY IN HONOR

The Louisiana State Memorial wasn't dedicated until 1971, but its imagery is powerful. It stands on the Gettysburg battlefield. A gravely wounded soldier, an artilleryman, has been draped with a Confederate battle flag. While he clutches it in one hand, a female figure floats above him. In one hand is a trumpet; the other holds a flaming cannonball, the symbol of the artillery. While he sinks, she rises above him.

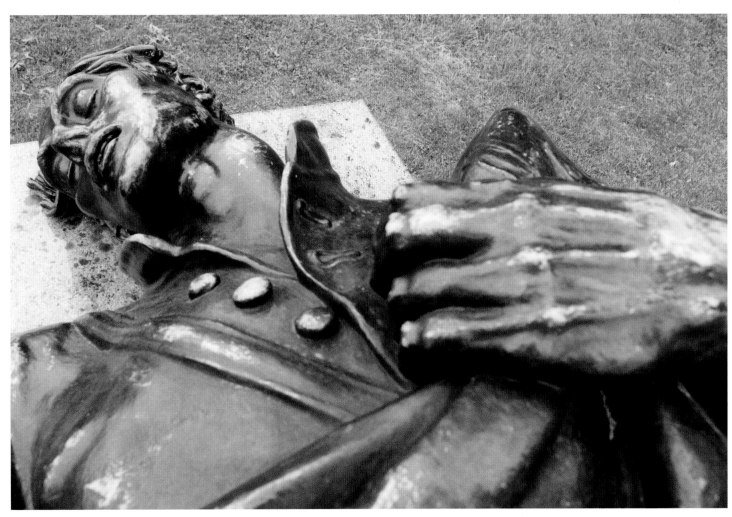

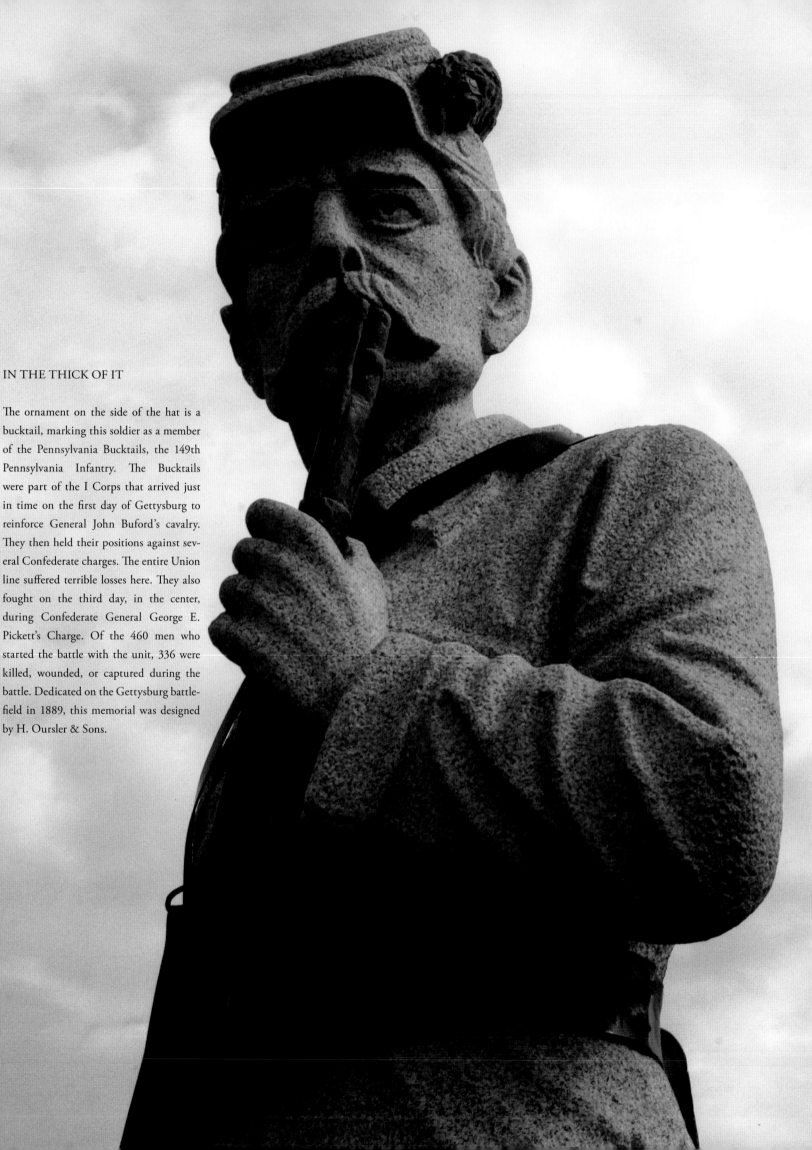

IN THE THICK OF IT

The ornament on the side of the hat is a bucktail, marking this soldier as a member of the Pennsylvania Bucktails, the 149th Pennsylvania Infantry. The Bucktails were part of the I Corps that arrived just in time on the first day of Gettysburg to reinforce General John Buford's cavalry. They then held their positions against several Confederate charges. The entire Union line suffered terrible losses here. They also fought on the third day, in the center, during Confederate General George E. Pickett's Charge. Of the 460 men who started the battle with the unit, 336 were killed, wounded, or captured during the battle. Dedicated on the Gettysburg battlefield in 1889, this memorial was designed by H. Oursler & Sons.

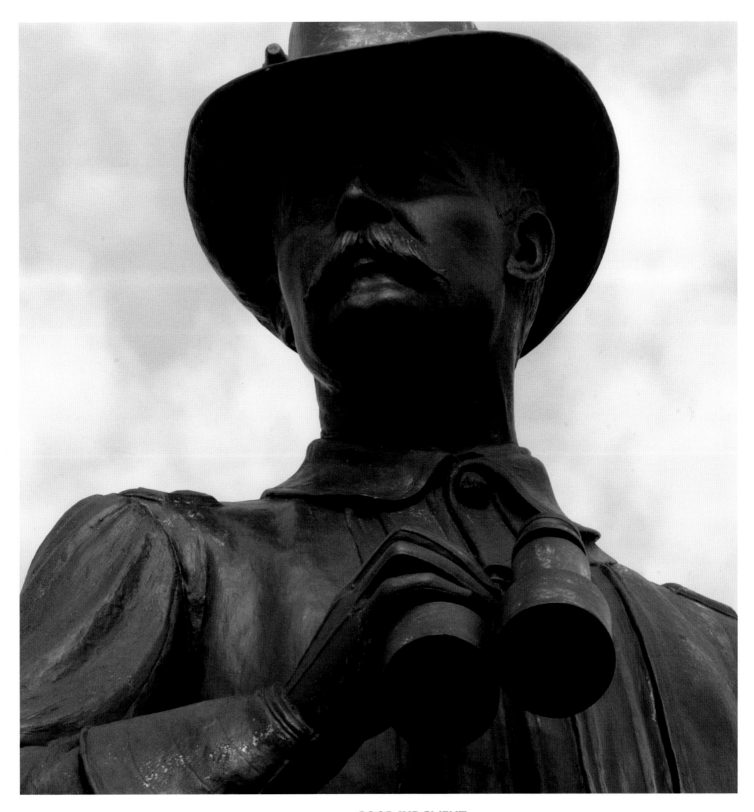

GOOD JUDGMENT

General John Buford provided sterling leadership from the war's start until his death in 1863, but he will always be remembered for his stand on the first day of the Battle of Gettysburg. By dismounting his cavalry to hold vital high ground, he gained precious time for Union reinforcements. James E. Kelly's statue of the general stands on McPherson's Ridge in Gettysburg, dedicated in 1895 by a group of his officers.

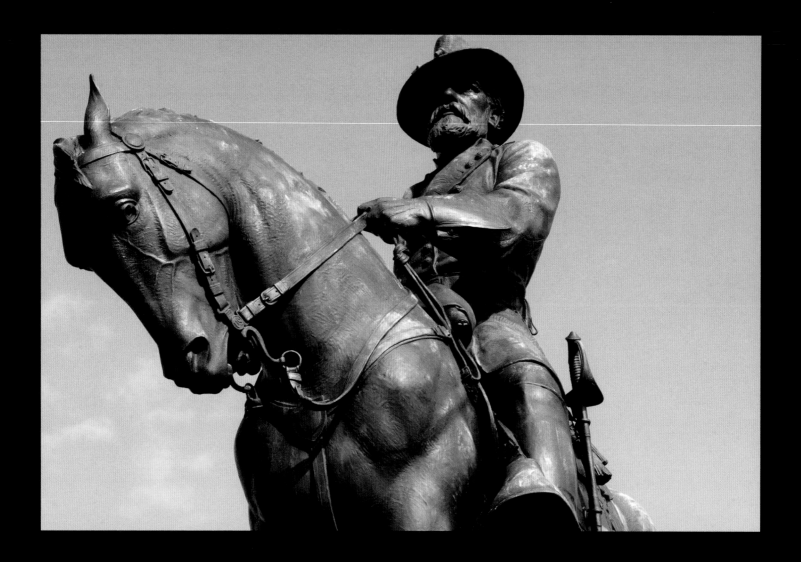

STILL OF VALUE

General Oliver O. Howard's bravery was beyond question. He'd lost an arm at Fair Oaks in 1862, and was awarded the Medal of Honor for his actions in the fight. He returned to service, and fought in several later battles. Unfortunately, his men were routed from the field at Gettysburg, where this statue was erected in 1932. After Gettysburg, he and his men were transferred to the Western theater, where they both gave valuable service at battles like Chattanooga and the Atlanta campaign. This statue is in Gettysburg National Battlefield Park.

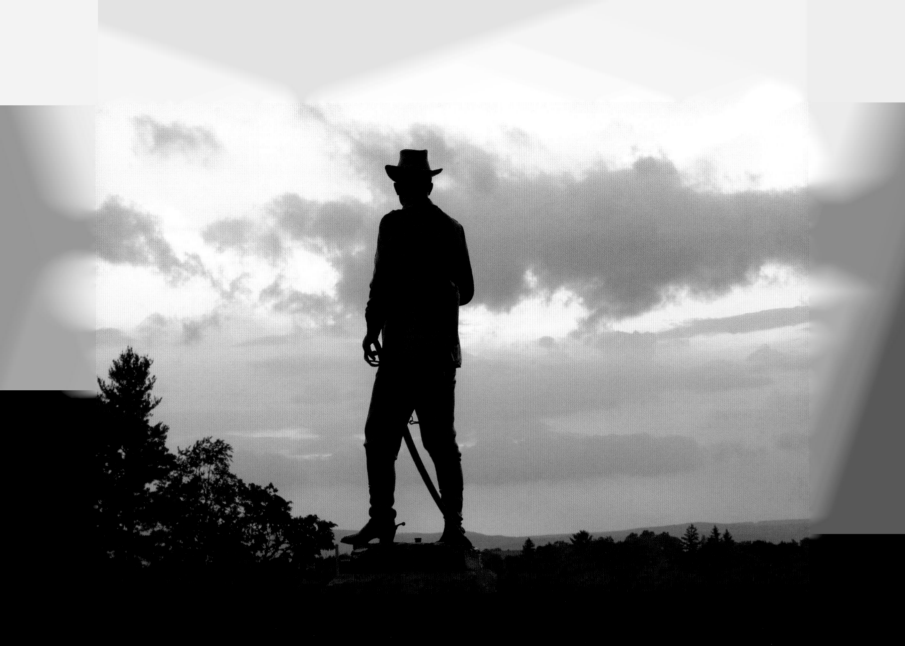

THE SAVIOR OF LITTLE ROUND TOP

Gouverneur K. Warren served throughout the Civil War rising from first lieutenant to major general, a measure of hi ability. His greatest service to the Union cause came on the second day of the battle of Gettysburg, when he spotted Confederate attack and rushed Union troops into position to stop it with only minutes to spare. It is no exaggeration to say that his actions prevented a Confederate victory that day. This statue by Karl Gerhart was erected in 1888 on the place where he spotted the advancing Confederates.

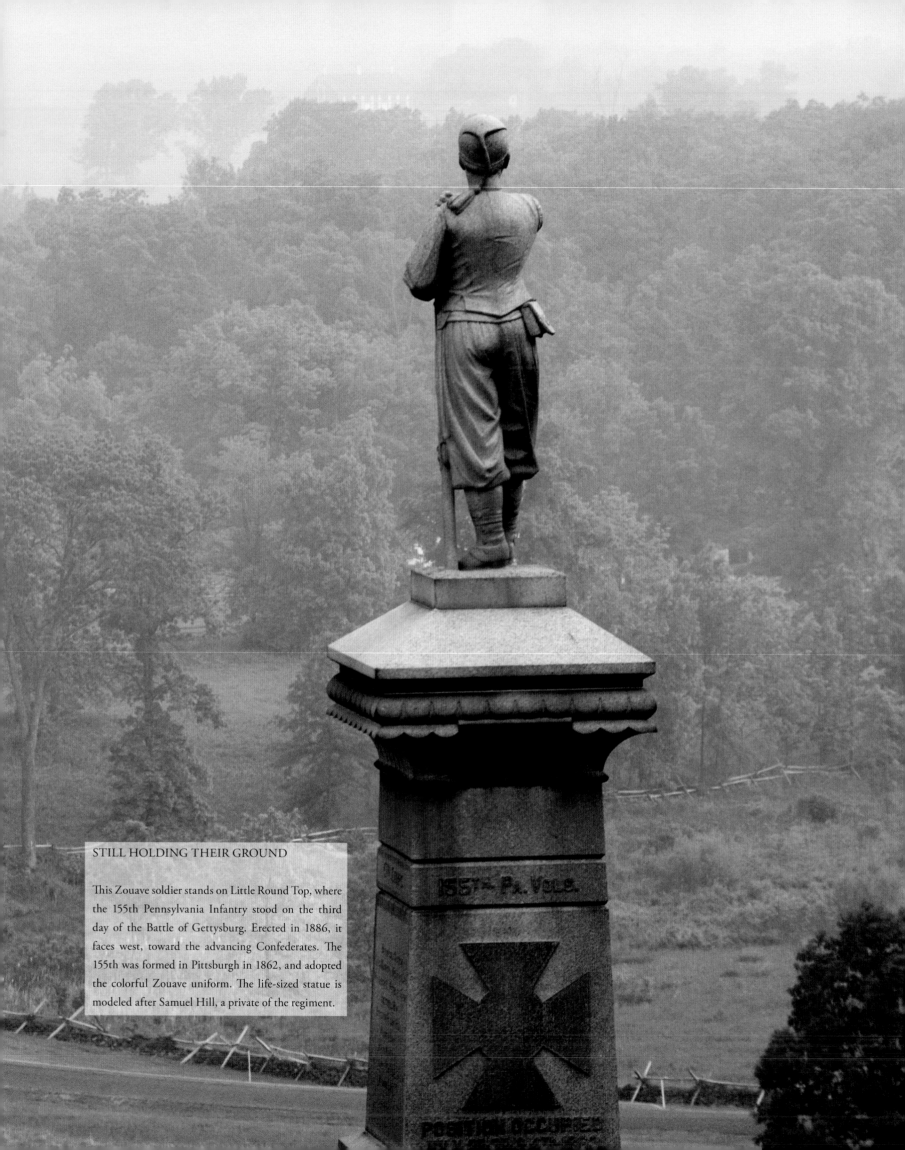

STILL HOLDING THEIR GROUND

This Zouave soldier stands on Little Round Top, where the 155th Pennsylvania Infantry stood on the third day of the Battle of Gettysburg. Erected in 1886, it faces west, toward the advancing Confederates. The 155th was formed in Pittsburgh in 1862, and adopted the colorful Zouave uniform. The life-sized statue is modeled after Samuel Hill, a private of the regiment.

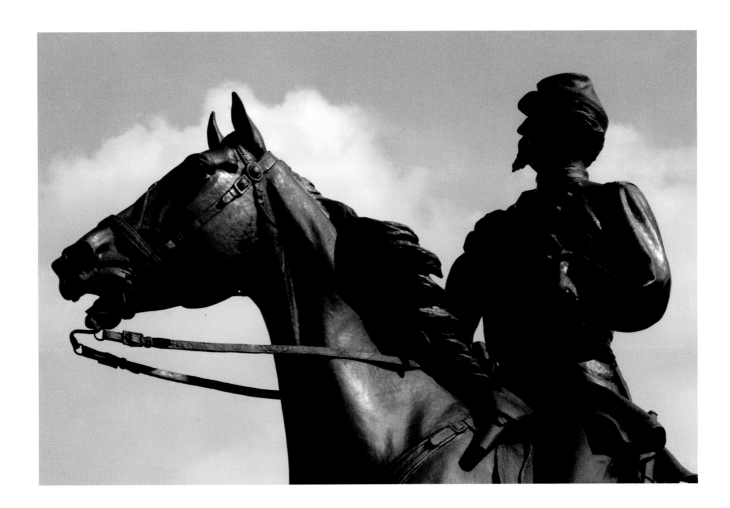

THE REINS IN HIS TEETH

Phllip Kearny lost an arm while leading a cavalry charge at the Battles of Churubusco in Mexico, during the 1847 war with Mexico. Most men would have retired from the military, but the aggressive Kearny was not satisfied with peacetime pursuits. When the South seceded, he argued his way back into the army. Initially relegated to drilling recruits, the army soon recognized his value and he took command again, always leading from the front. He would be seen on his horse, waving a sword in one hand while he held the reins in his teeth. Kearny's aggressiveness was matched by his care of the men he led. Killed at the Battle of Chantilly in Fairfax County, Virginia, in 1862, he was first interred in Trinity Churchyard in New York, but in 1912 his remains were moved to Arlington National Cemetery in Virginia, where his grave was marked in 1914 with this statue by Edward Clark Potter.

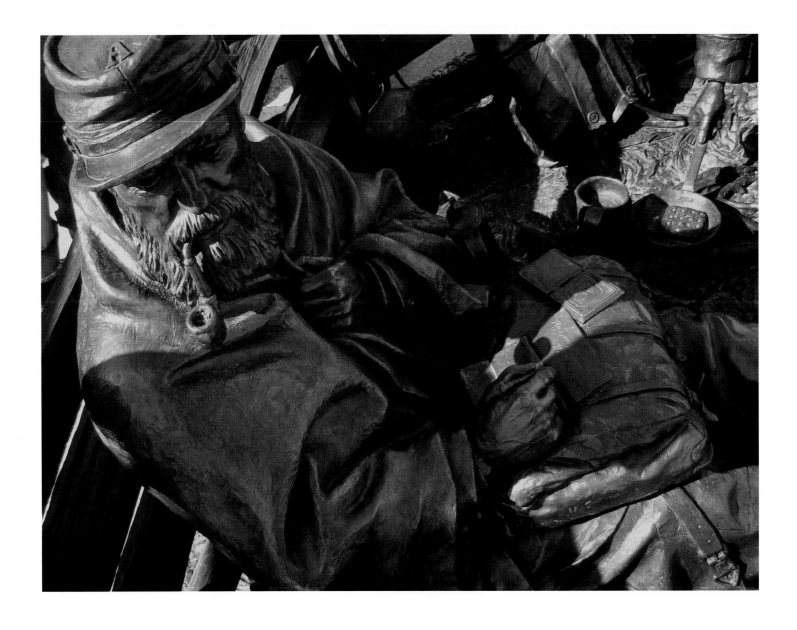

THE BIVOUAC

Dedicated in 1999, this scene marks the entrance to the National Museum of the Civil War Soldier in Petersburg, Virginia. The soldiers are shown preparing a small roadside meal. One is writing a letter. Artist Ron Tunison deliberately sculpted the figures so that they could be either Union or Confederate. The entire museum focuses on the experiences and sacrifices of the common soldier during the Civil War.

SOLDIERS AND SAILORS

Philadelphia honored the soldiers, sailors, and marines of the Civil War in 1927 with two 40-foot marble pillars designed by artist Hermon Atkins MacNeil. One honors the soldiers, the other the sailors and marines. This detail from the soldier's pillar shows not only the detail that MacNeil included, but a reminder of the price they paid for our freedoms.

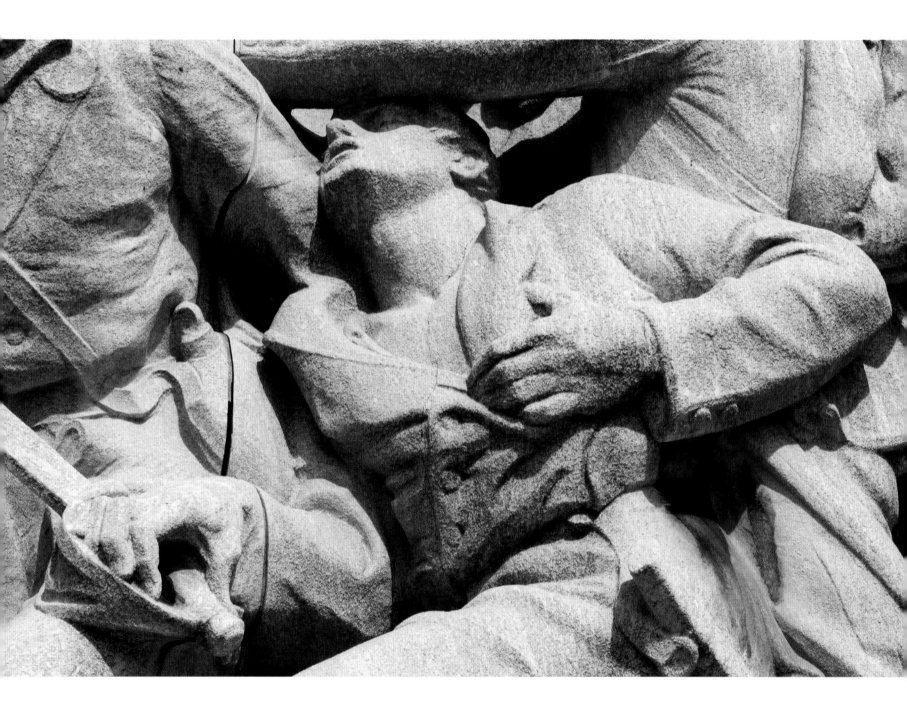

CLUBBED MUSKET

This statue in Gettysburg honoring the 72nd Pennsylvania Infantry was dedicated in 1891. Veterans of the unit erected the statue at the place where they rushed to reinforce the Union line during Pickett's charge. At its high-water mark, even after suffering horrendous losses, the Confederates nearly managed to break though the Union's defenses. The soldier's clubbed musket testifies to the ferocity of the hand-to-hand combat.

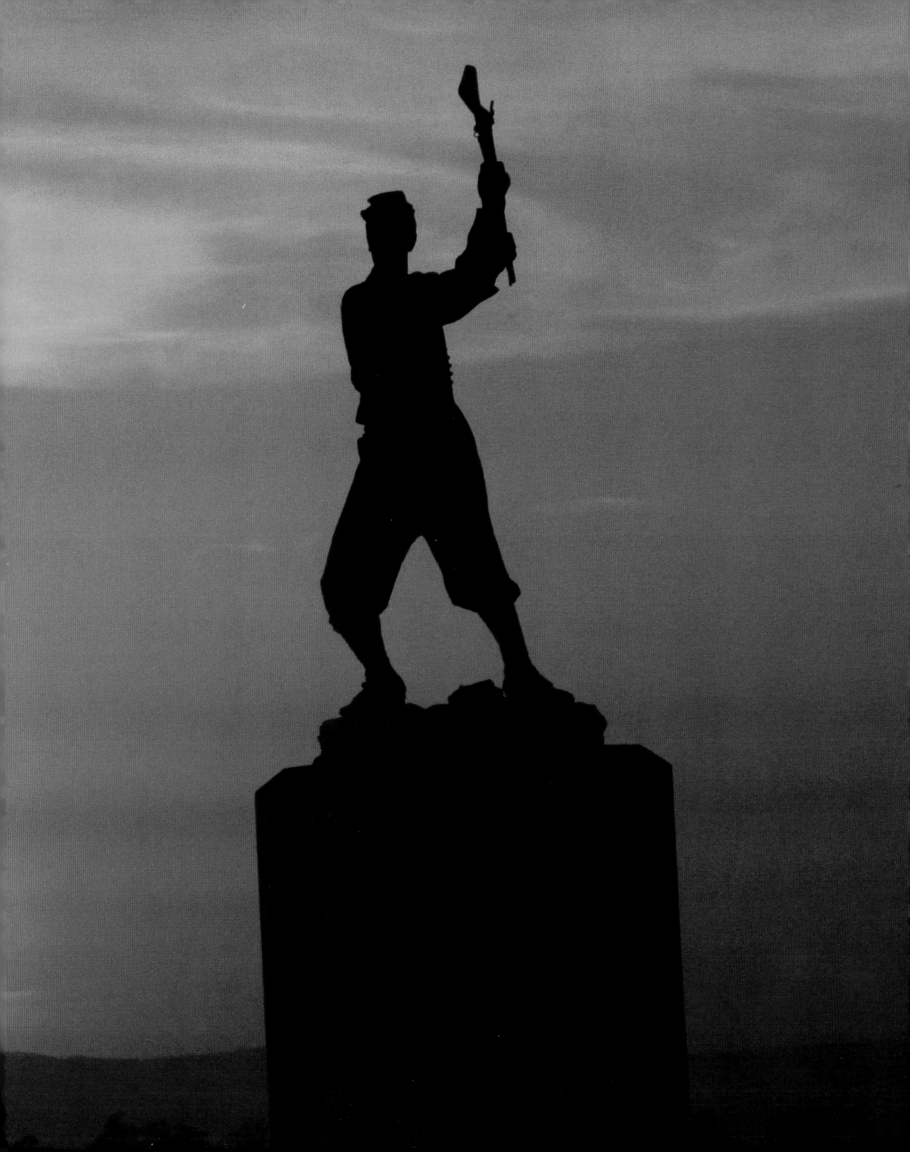

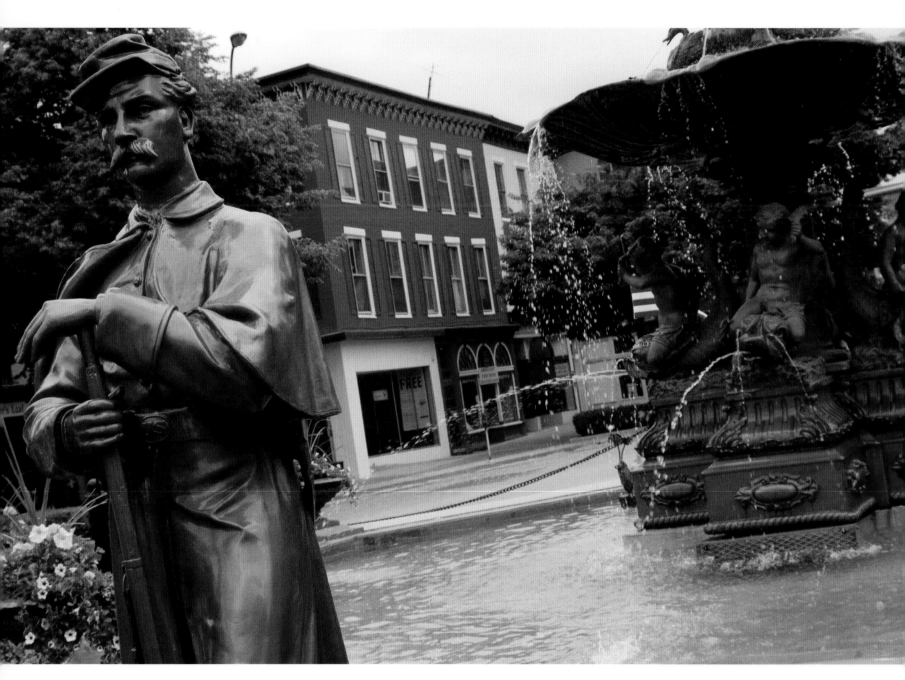

MEMORIAL FOR A TOWN

Chambersburg, Pennsylvania felt the Civil War's passage harder than any other Northern town. Raided by Jeb Stuart, and site of a famous meeting, it was finally burned to the ground in 1864 by a vengeful Confederate general. As soon as it was rebuilt, the citizens began to discuss memorializing the town and the soldiers from the area who had fought in the war. Memorial Square, dedicated in 1878, includes a fountain and statue of a Union soldier. He faces south, guarding against the return of Confederate raiders. Other markers commemorate the burning of the town and a famous meeting between Generals Lee and A.P. Hill before Gettysburg.

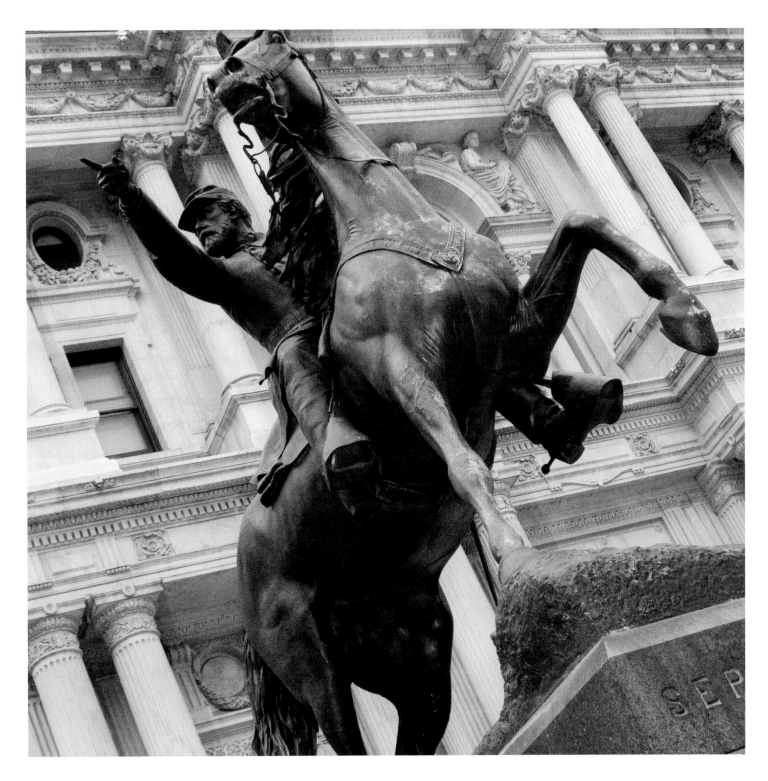

PENNSYLVANIA HERO

General John Fulton Reynolds was an able and inspiring general. His loss at Gettysburg was a tragedy for the Union, but he'd already saved the battle that day and earned immortality. He was also a Pennsylvanian, born in Lancaster, and he was buried there after he fell. Philadelphia's first equestrian statue was to General Reynolds, sculpted by popular artist John Rodgers and dedicated in 1884. It stands in front of City Hall.

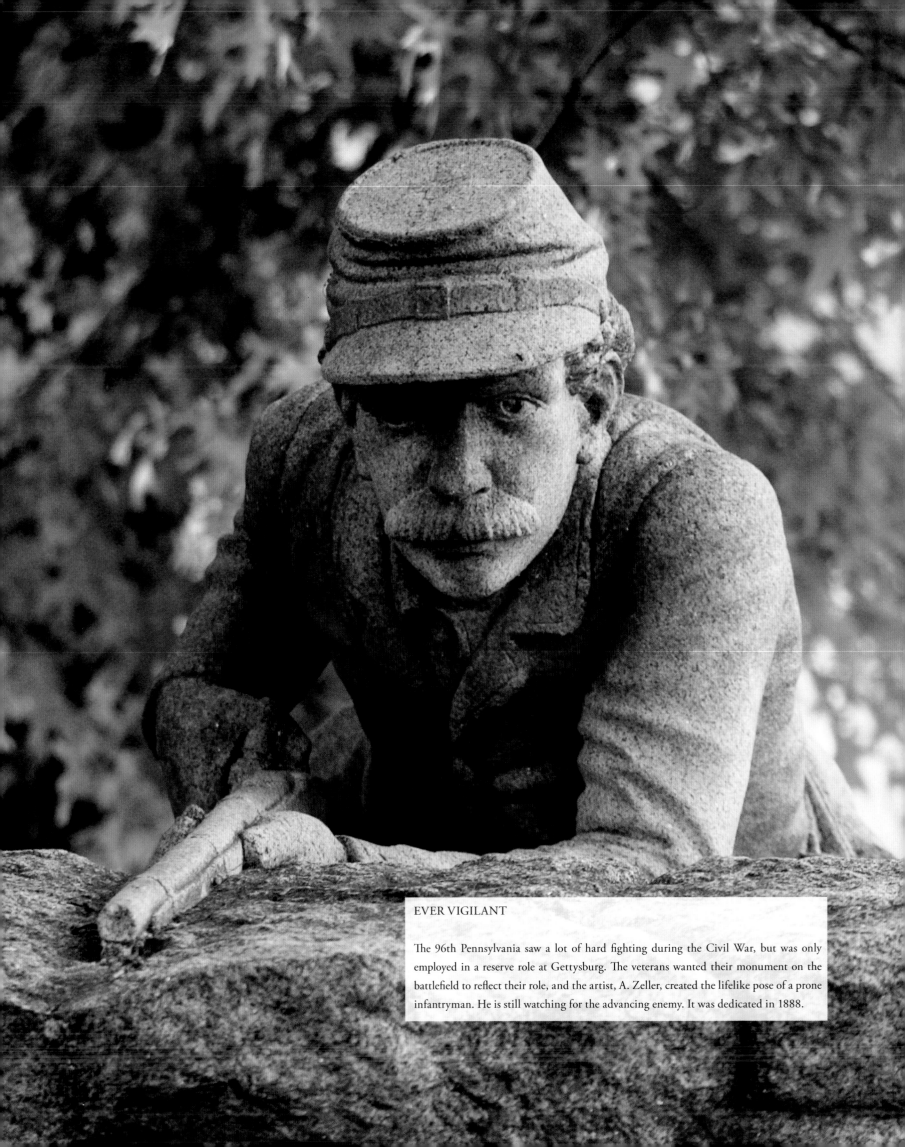

EVER VIGILANT

The 96th Pennsylvania saw a lot of hard fighting during the Civil War, but was only employed in a reserve role at Gettysburg. The veterans wanted their monument on the battlefield to reflect their role, and the artist, A. Zeller, created the lifelike pose of a prone infantryman. He is still watching for the advancing enemy. It was dedicated in 1888.

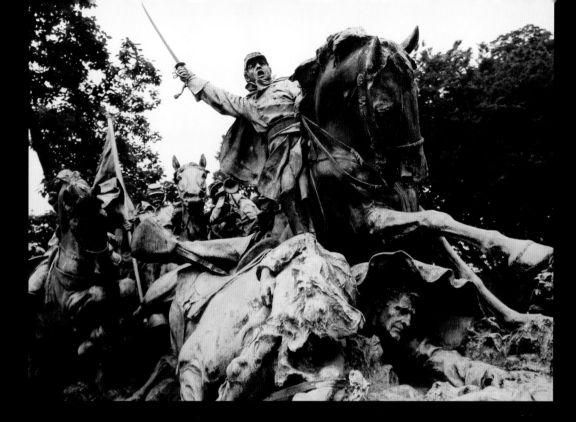

CALM WARRIOR

When the U.S. Government decided to honor Ulysses S. Grant, they planned his memorial to anchor one end of the new National Mall in Washington, D.C. Artist Henry Merwin Shrady, commissioned to do the work in 1901, thought in grand terms. A massive equestrian statue of Grant sits on a huge marble plaza while he watches cavalry and artillery charge into battle. The animation and life of the soldiers contrasts with Grant's legendary calm demeanor in battle, reinforced by four lions in repose that surround him. It was dedicated in 1922.

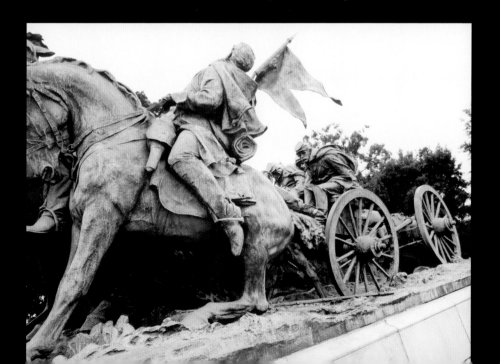

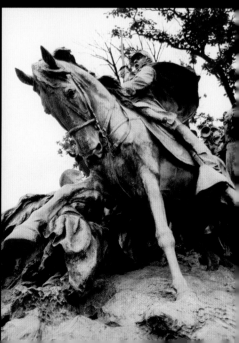

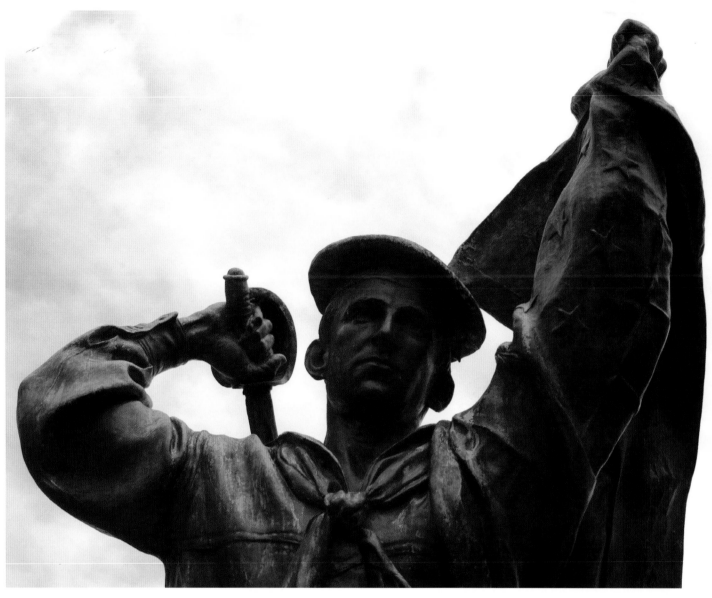

BRISTOL'S HONOR

Commissioned by the Grand Army of the Republic fifty years after the Civil War, Bristol, Rhode Island's memorial follows the pattern of many in that era. A "Soldiers and Sailors" memorial was created by Henri Schonhardt, a Rhode Islander who designed several other Civil War monuments. The 1914 sculpture simply shows an armed soldier and sailor advancing. The sailor carries a flag, and the memorial is dedicated "...to the brave men who have fought for this flag."

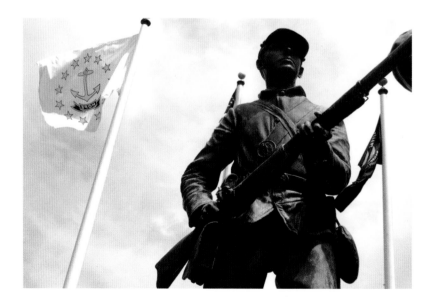

EARLY LOSS

Colonel John Slocum commanded the 2nd Rhode Island Infantry. On June 7, 1861, the regiment was paraded throughout its hometown for the first time before it embarked for Washington. Six weeks later, the 2nd marched to battle near the Bull Run River. As they moved toward the enemy position, Colonel Slocum was in front of the regiment, scouting the enemy's position. He was struck in the head and later died. His tomb and memorial can be found in the Swan Point Cemetery in Providence.

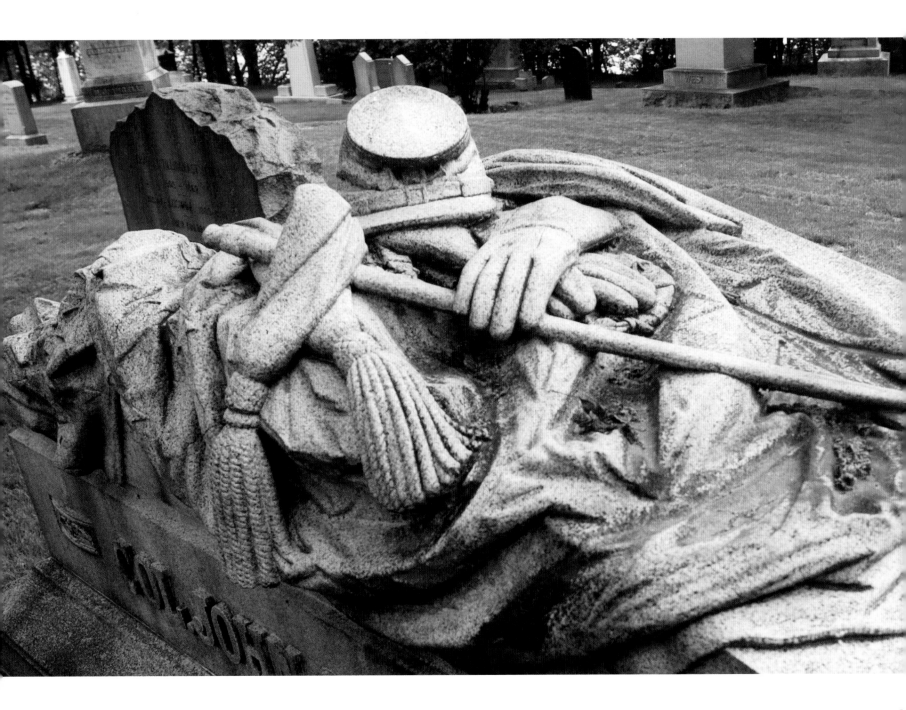

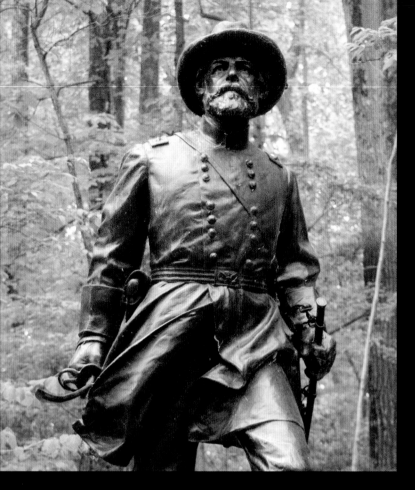

THE IDEAL CAVALRY OFFICER

William Wells enlisted in the Union Army as a private in 1861. He finished the war as a major general. A cavalryman, he fought in over seventy engagements, and was praised by cavalry Generals Sheridan and Custer for his ability. While he did not turn the tide of battle at Gettysburg, he fought its last engagement, a charge at Big Round Top into General Law's Alabama regiments. Wells received the Medal of Honor for his actions that day. The statue by J. Otto Schweizer was dedicated in 1913 where the Union cavalry began their charge.

SAINTS OF THE CONFEDERACY

The grandeur and artistry of the bas-relief at Stone Mountain belies its troubled past and purpose. The portraits of Jefferson Davis and Generals Lee and Jackson stride across the face of the mountain in lifelike grandeur. Originally, the memorial was funded by the Ku Klux Klan and the state of Georgia. Noted monument artists Gutzon Borglum and Augustus Lukeman were both involved in the work, but these attempts failed, and work stopped in the early 1930s with very little done.

When the work was restarted again in the 1950s using new technology, it still was not completed until 1970. Along the way, the state of Georgia went to great lengths to break any ties between the mountain and the Klan. Today the memorial is an historical site and museum, emphasizing the history of Georgia in the Civil War.

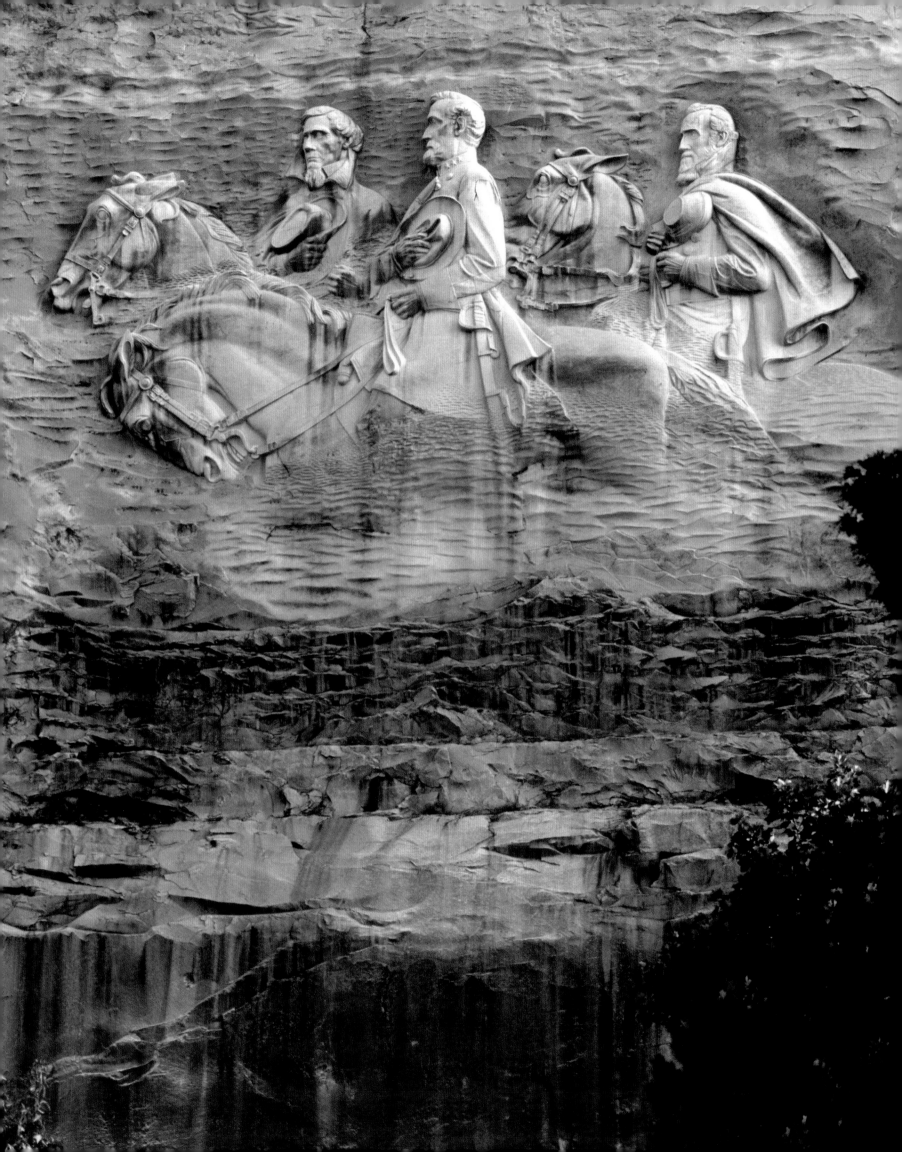

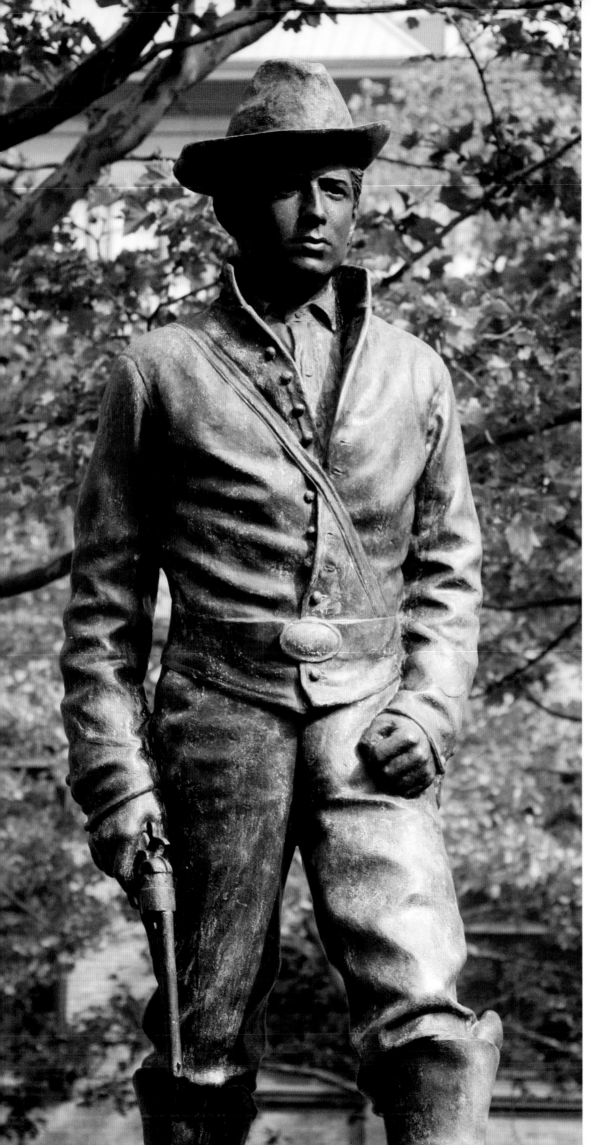

YOUNG HERO

Titled "The Scout," this statue is a portrait of Lieutenant Colonel Henry Harrison Young. A Rhode Islander, Young gathered intelligence for General Phillip Sheridan. In those days, the terms "scout" and "spy" were interchangeable, and this statue could have depicted him in civilian dress or even a Confederate uniform. His daring and success certainly merit a statue, which was sculpted by Henri Schonhardt. It was dedicated in 1911 and stands in front of Providence City Hall, Rhode Island.

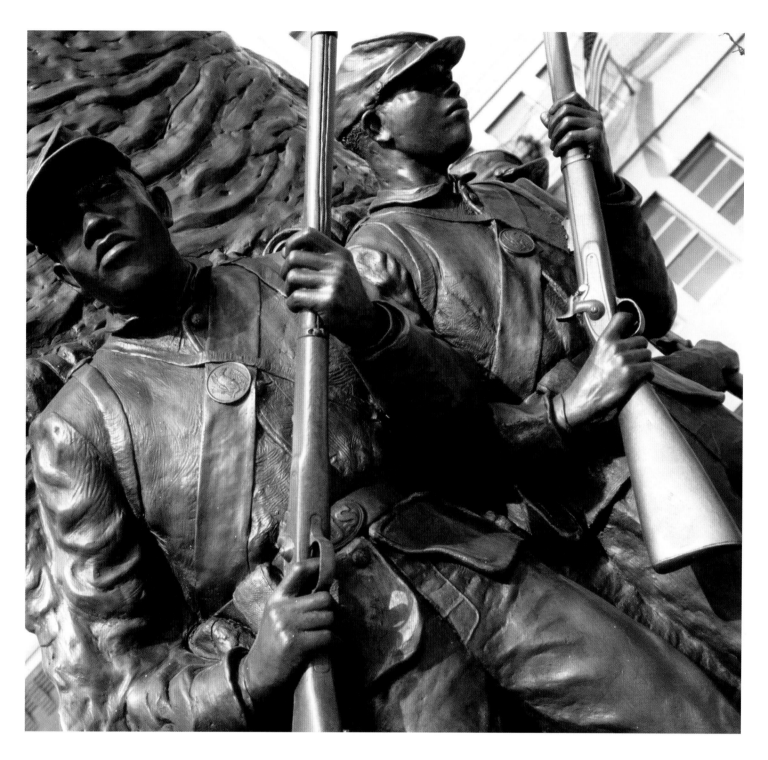

AFRICAN AMERICAN SOLDIERS

Sometimes education has to come before remembrance. The Spirit of Freedom sculpture is the centerpiece of a display honoring the contribution and sacrifice of hundreds of thousands of African Americans to the Civil War. Although at the center of the storm that became a national struggle, postwar history painted African Americans as pawns, passively freed by the North. The African American Civil War Memorial & Museum, Wall of Honor, and this central sculpture in Washington, D.C., were dedicated in 1998, to help correct a long-running historical bias, over one hundred and thirty years after the actual event.

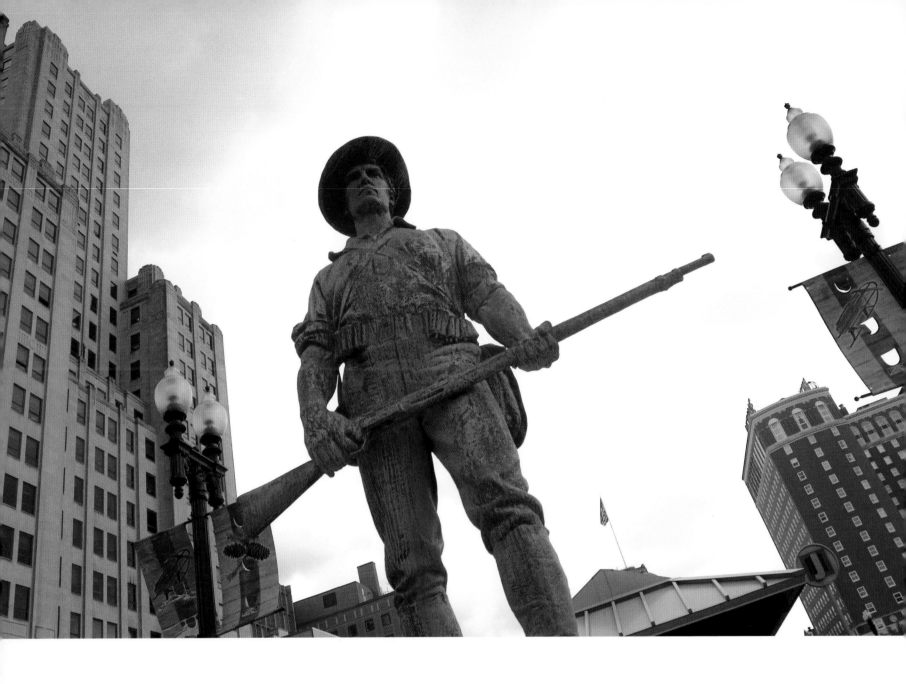

THE HIKER

Soldiers in the Spanish-American War called themselves "Hikers," no doubt because of their love of fresh air and exercise. Sculptor Theodora Alice Ruggles Kitson created her sculpture "The Hiker" in 1902, almost immediately after the end of the Spanish-American War in 1899. The sculpture was erected in Providence, Rhode Island, but proved so popular that over fifty copies of the work were cast between 1906 and 1965, and erected in towns all over the United States.

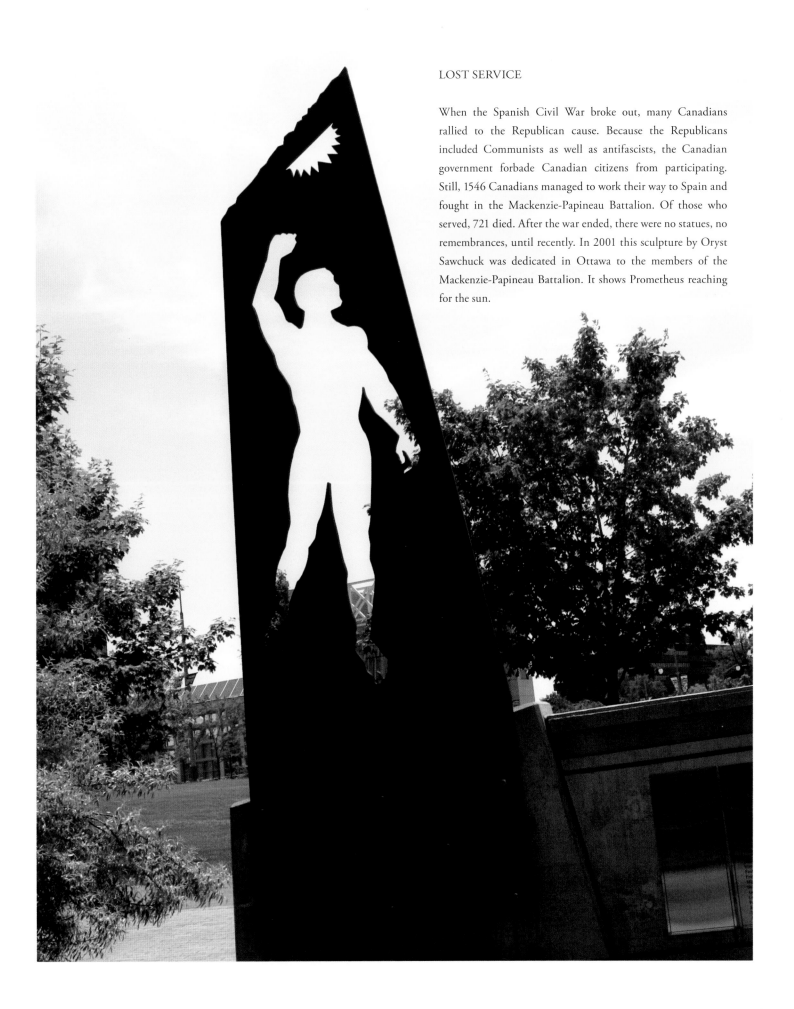

LOST SERVICE

When the Spanish Civil War broke out, many Canadians rallied to the Republican cause. Because the Republicans included Communists as well as antifascists, the Canadian government forbade Canadian citizens from participating. Still, 1546 Canadians managed to work their way to Spain and fought in the Mackenzie-Papineau Battalion. Of those who served, 721 died. After the war ended, there were no statues, no remembrances, until recently. In 2001 this sculpture by Oryst Sawchuck was dedicated in Ottawa to the members of the Mackenzie-Papineau Battalion. It shows Prometheus reaching for the sun.

20TH CENTURY
CONFLICTS

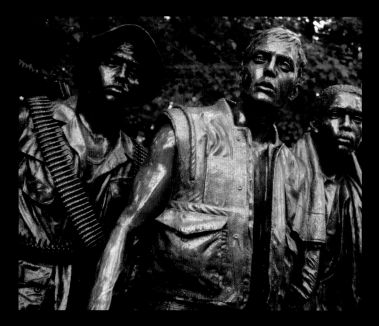

A CENTURY OF WARFARE

The twentieth century has seen more and larger wars than any other part of human history. Memorials in this section honor the First and Second World Wars, the Korean War, and the Vietnam War. These are "major" wars that America participated in, but there have been many more.

This century saw the industrial revolution expand out of the textile mills into all parts of society. Machines replaced manual labor, and mass-produced goods replaced handicrafts. Warfare could be considered an industry, and its product went through the same revolution. Huge armies were armed with mass-produced weapons of new efficiency. They were moved by steamship, locomotives, or automobiles, and supplied the same way.

To someone raised in the last half of the nineteenth century, the world-wide conflict in the second decade of the twentieth must have seemed apocalyptic. Industrialized, the horror of war engulfed entire populations. For the first time, civilian casualties were as great as the military's. To countries suffering from aerial bombing, poison gas, and trench warfare, "The Great War" must have indeed seemed like "The War to End All Wars." Improved communications, including audio recordings and movies, let ordinary citizens experience what the fighting men at the front really faced. What could possibly be worse?

The hope that "The World War" would be the last, endured for two decades. The League of Nations and the Kellogg-Briand Pact were established to make sure of it. There were smaller wars in the twenties and thirties, but the man in the street could still think of "The Great War" as an aberration. That is, until 1939.

The Second World War added death camps and nuclear weapons to a list of horrors that caused fifty-two million deaths, instead of World War One's mere fifteen million. Civilian fatalities exceeded deaths in battle.

But the end of the Second World War didn't bring peace.

A new "Cold War" took its place. Nuclear weapons changed the timeline of war. There would not be time to mobilize, so nations maintained large standing armies, along with massive nuclear arsenals on hair-trigger alert. This was their only deterrent to a nuclear Pearl Harbor.

Preventing nuclear war didn't guarantee peace, though. Below the nuclear threshold, brushfire wars waged across Asia and Africa, and only the threat of nuclear oblivion kept them small. Civilians struggled and suffered along with soldiers through these "wars of liberation."

Then television broadcasting arrived, bringing war straight into our homes. Instead of carefully edited and narrated newsreels, the images were raw, often violent. We shared the soldier's experiences in a new, intimate way. It brought us closer to "our boys," but also let us feel their pain. Starting in the 1950s and growing, by the 1990s and the Persian Gulf War, news coverage brought every conflict—any conflict—into our homes any time we wanted.

Some us of did want to see it. Interest in national affairs, simple curiosity, or wanting to be "in the know" were the obvious motivations to watch, but for many it helped them feel connected with their sons and daughters overseas. Relatives might not see their loved ones, but seeing their friends and comrades and what they were going though was some compensation.

Our improved communications have brought us closer and closer to our fighting men and women. In the beginning of the twenty-first century, satellite phones, cell phones, and email have made them as easy to reach as the next-door neighbor—when they're not in combat. They can draw on some of our strength, but we also feel some of their burden: stress, fear, pain, or even grief.

We still build monuments and memorials to those who fell—and we will continue to build them. We use them to express our admiration for what they have sacrificed. But now we understand a little better what they went through.

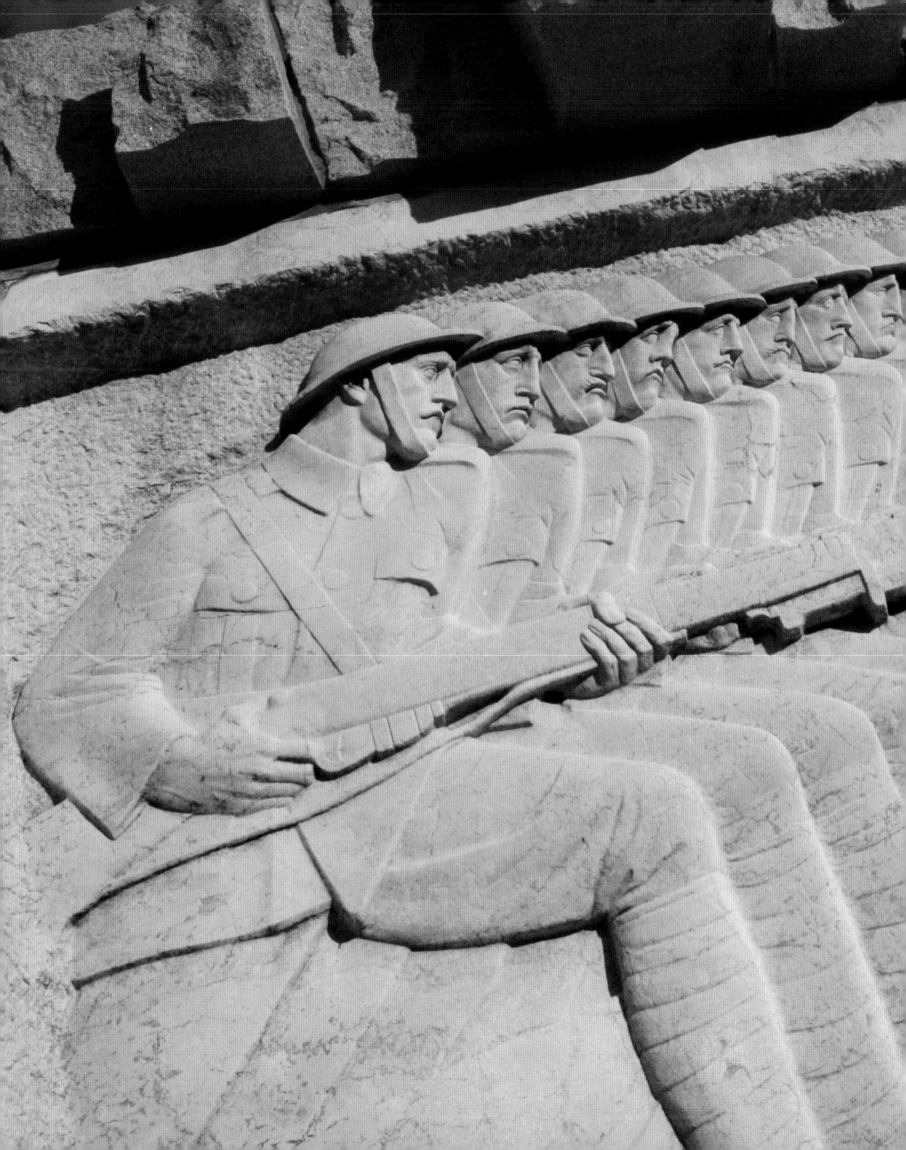

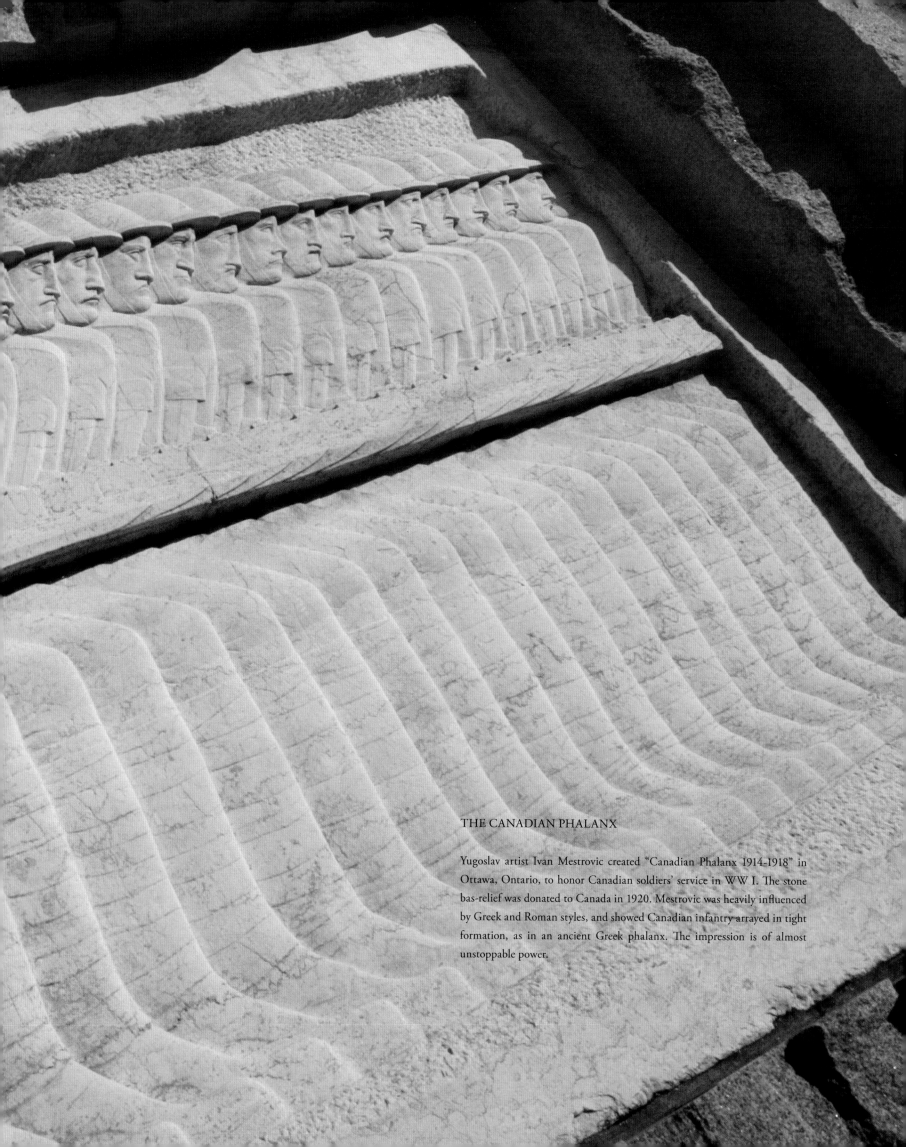

THE CANADIAN PHALANX

Yugoslav artist Ivan Mestrovic created "Canadian Phalanx 1914-1918" in Ottawa, Ontario, to honor Canadian soldiers' service in WW I. The stone bas-relief was donated to Canada in 1920. Mestrovic was heavily influenced by Greek and Roman styles, and showed Canadian infantry arrayed in tight formation, as in an ancient Greek phalanx. The impression is of almost unstoppable power.

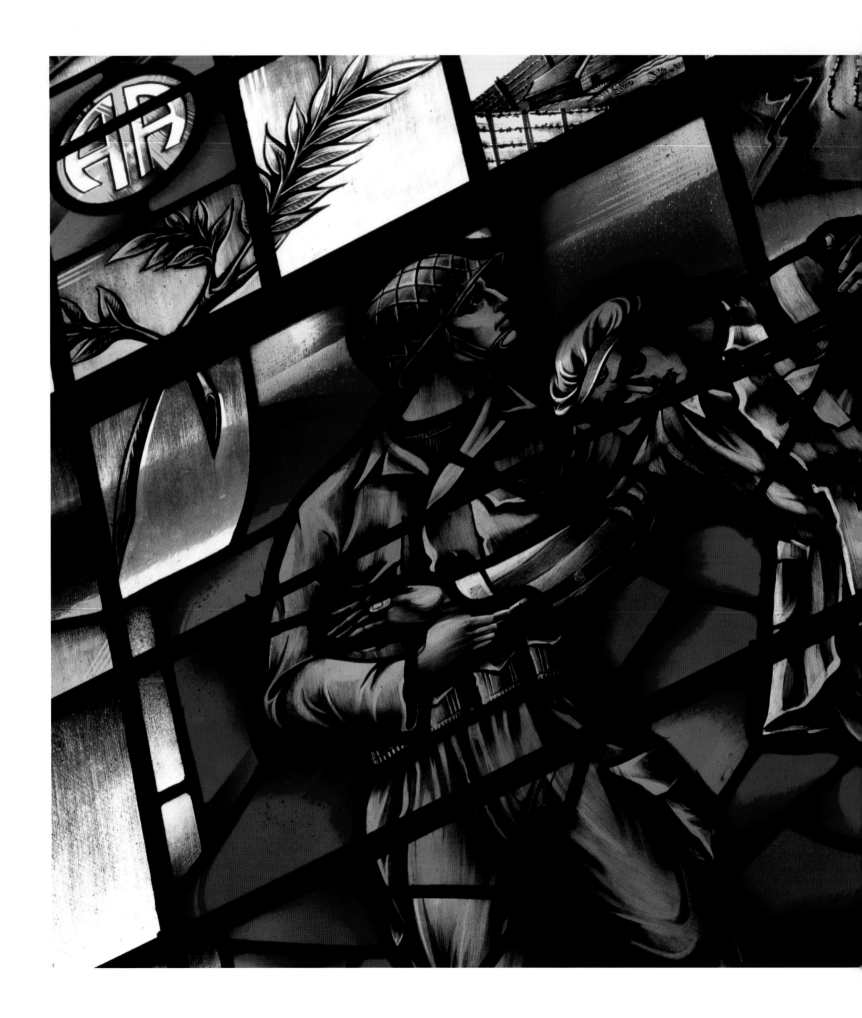

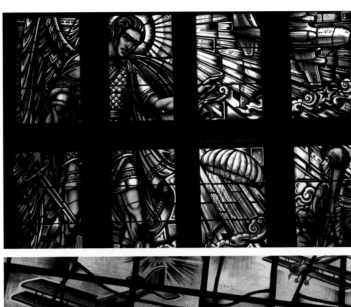

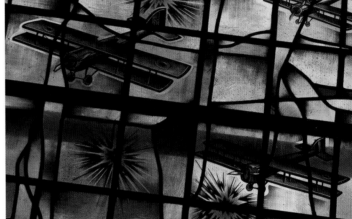

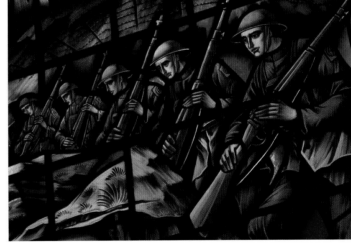

HONORED WITH LIGHT

Stained glass windows usually have religious themes, but at two of the chapels at Fort Bragg, North Carolina, they have special purposes. At the John F. Kennedy Memorial Chapel, the windows depict the history of the Green Berets. The artist, Milcho Silianoff, created seven scenes honoring the special warfare community and its goals, such as democratic freedom.

The windows in the 82nd Airborne Division Memorial Chapel honor the divison's history. These images show the "All American" division in its WW I service, as well as Archangel Michael, the patron saint of Airborne soldiers.

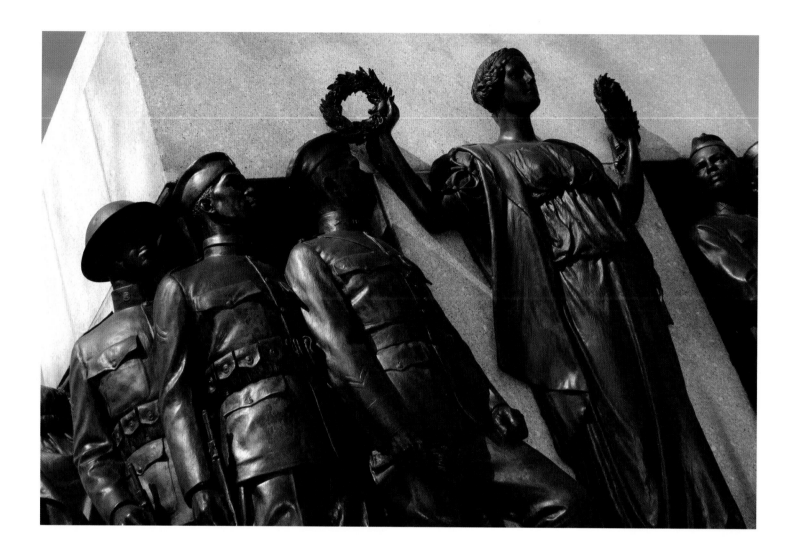

ALL WARS MEMORIAL

"…That a lasting record shall be made of their unselfish devotion to duty as an inspiration to future generations…" That message is inscribed on the All Wars Memorial to Colored Soldiers and Sailors in Philadelphia. Erected in 1934, the central figure symbolizes justice, holding wreaths of honor and reward. It honors African American service from the Revolution through WW I, the last conflict before the memorial was dedicated. Originally located in out-of-the way Franklin Park, J. Otto Schweizen's monumental work was moved with great ceremony to the center of the city in 1994.

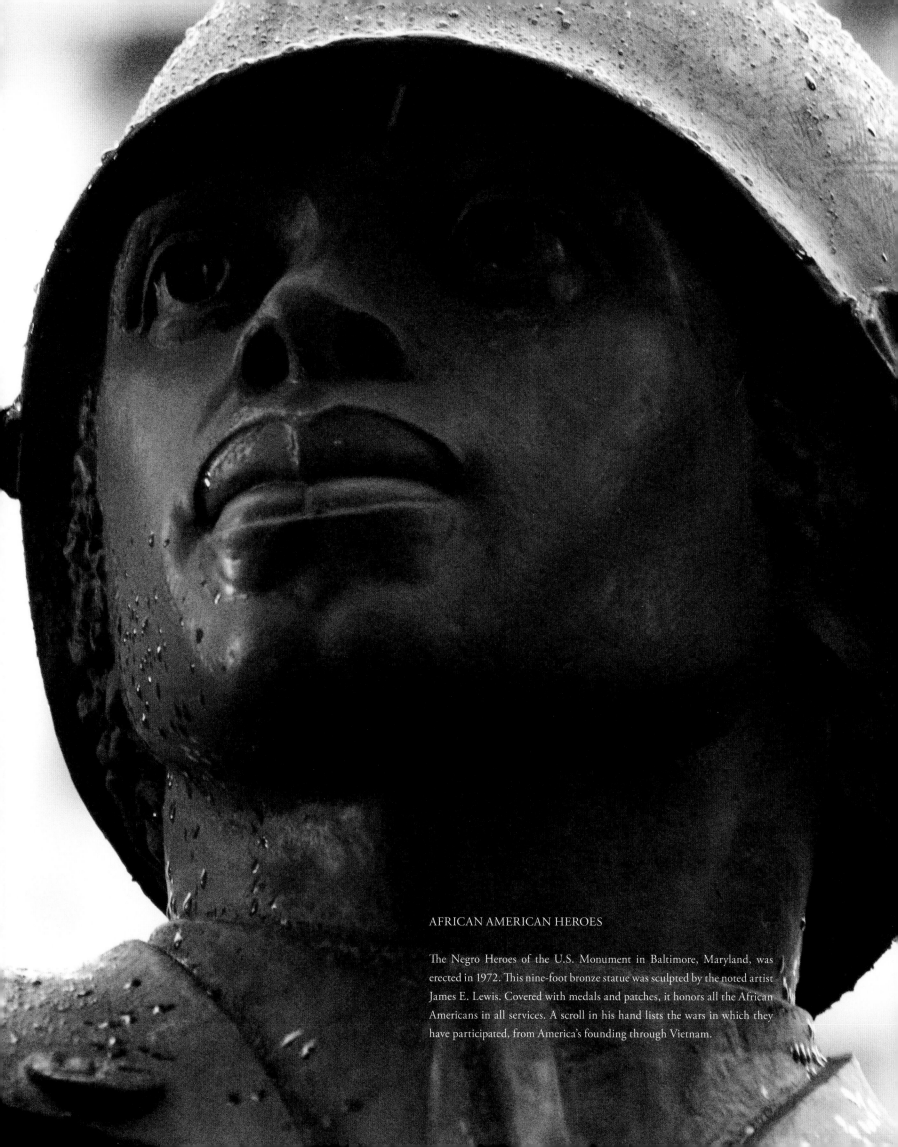

AFRICAN AMERICAN HEROES

The Negro Heroes of the U.S. Monument in Baltimore, Maryland, was erected in 1972. This nine-foot bronze statue was sculpted by the noted artist James E. Lewis. Covered with medals and patches, it honors all the African Americans in all services. A scroll in his hand lists the wars in which they have participated, from America's founding through Vietnam.

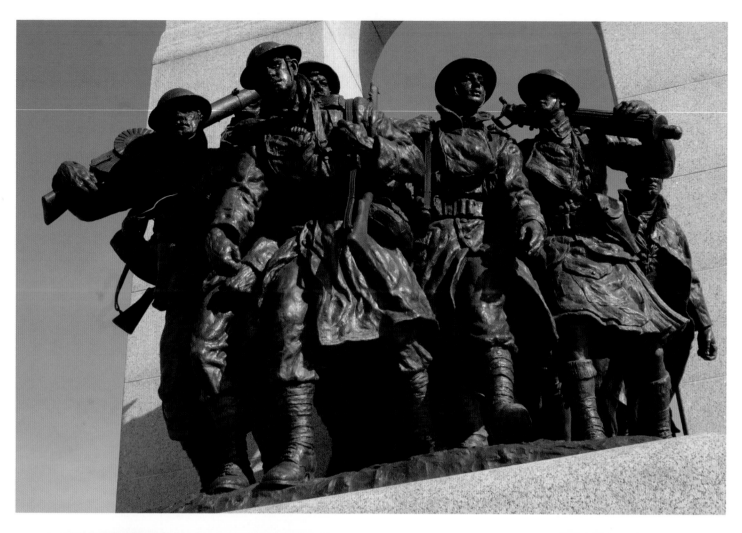

CANADA'S REMEMBRANCE

Canada's National War Memorial in Ottawa honors her WW I dead. Built from 1925 to 1939, it shows twenty-two larger-than-life bronze figures passing through an arch. The figures represent all of Canada's services and the 60,000 who died in "The Great War." The arch symbolizes the journey to service. The figures' efforts show it wasn't an easy trip.

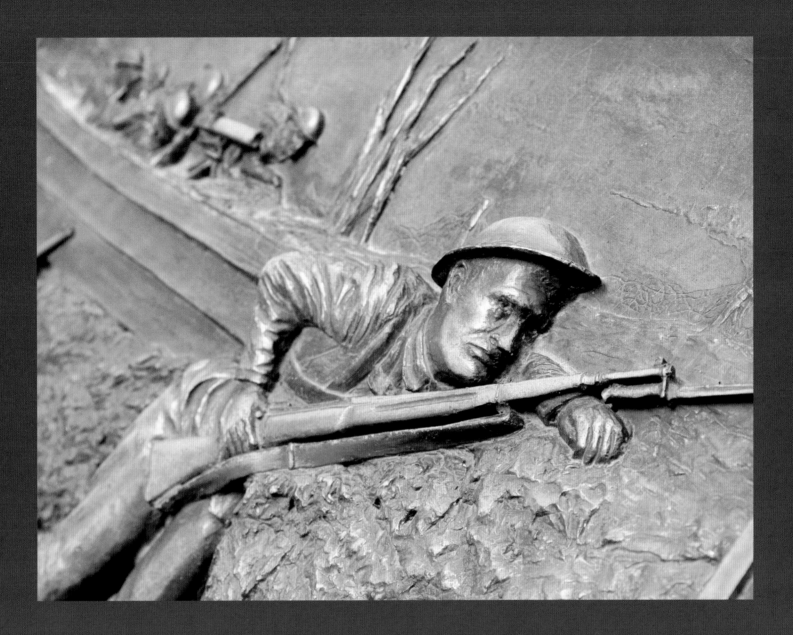

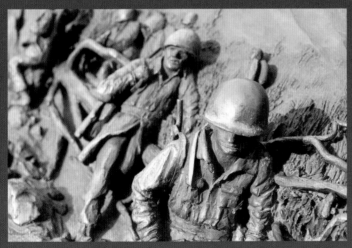

HONORING MANY

The North Carolina Veterans Monument sits in Union Square, right next to the State Capitol Building in Raleigh, North Carolina. It honors all veterans from WW I, WW II, and Korea. Bronze bas-reliefs surround the base, illustrating scenes and battles from all three conflicts. Lady Liberty, symbolizing peace and victory, stands over all.

PERSONAL SERVICE

What are the boundaries of a man's duty? Andrew Hamilton Gault, a Canadian, served in the Boer War and then returned to Canada to become a successful businessman. In 1914, as war clouds gathered in Europe, he offered to raise a regiment of Canadians. Contributing $100,000 of his own funds to the effort, he organized the Princess Patricia's Canadian Light Infantry, and served as its second-in-command during WW I. He lost his left leg in that war, but still served in WW II as a staff officer. This statue honoring him is in Ottawa. There are larger statues for men who did much less.

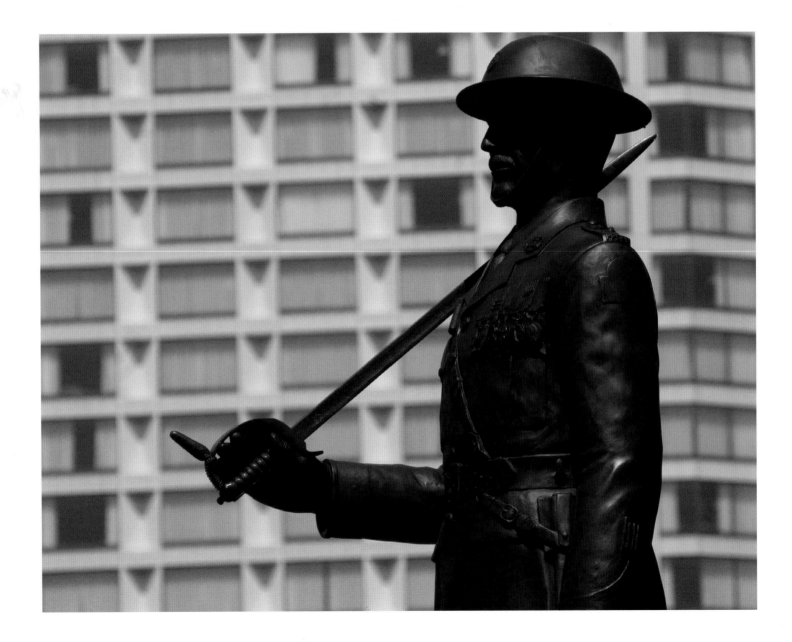

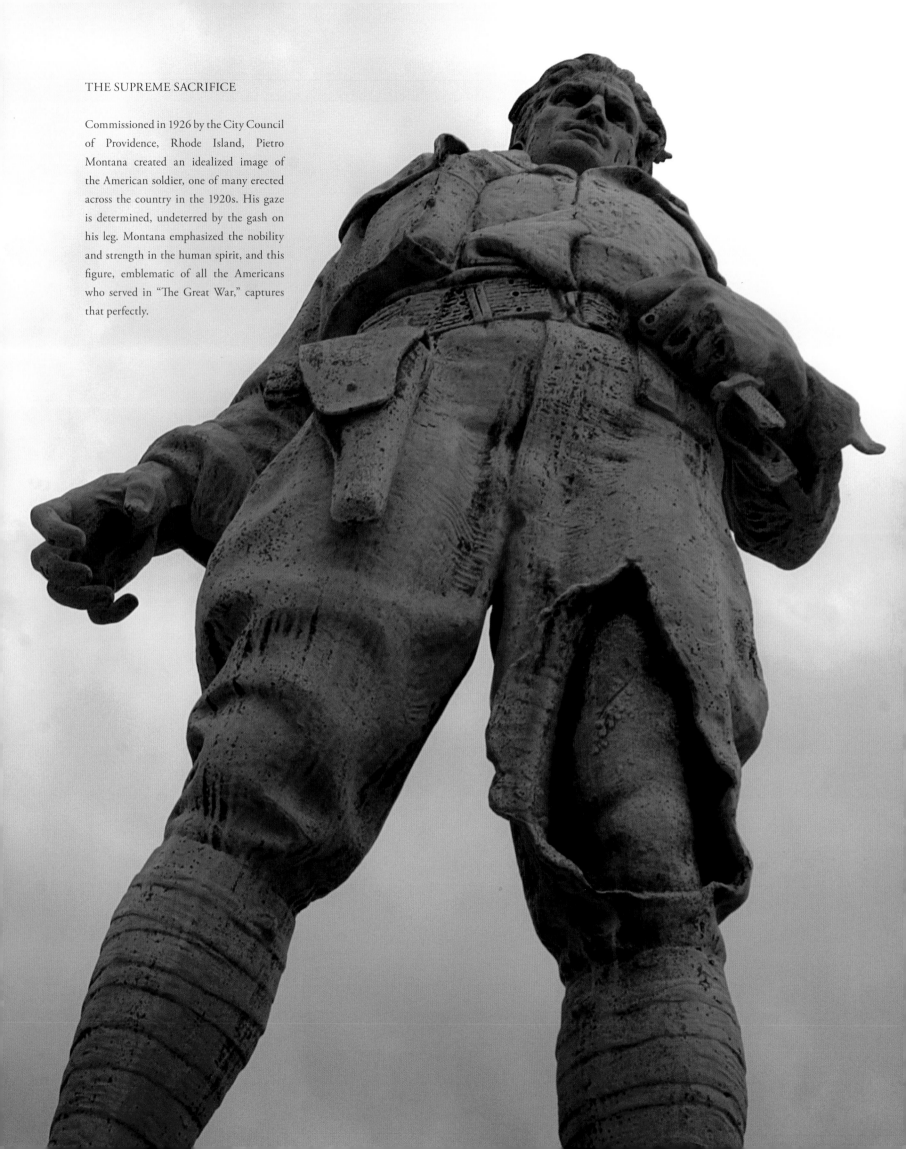

THE SUPREME SACRIFICE

Commissioned in 1926 by the City Council of Providence, Rhode Island, Pietro Montana created an idealized image of the American soldier, one of many erected across the country in the 1920s. His gaze is determined, undeterred by the gash on his leg. Montana emphasized the nobility and strength in the human spirit, and this figure, emblematic of all the Americans who served in "The Great War," captures that perfectly.

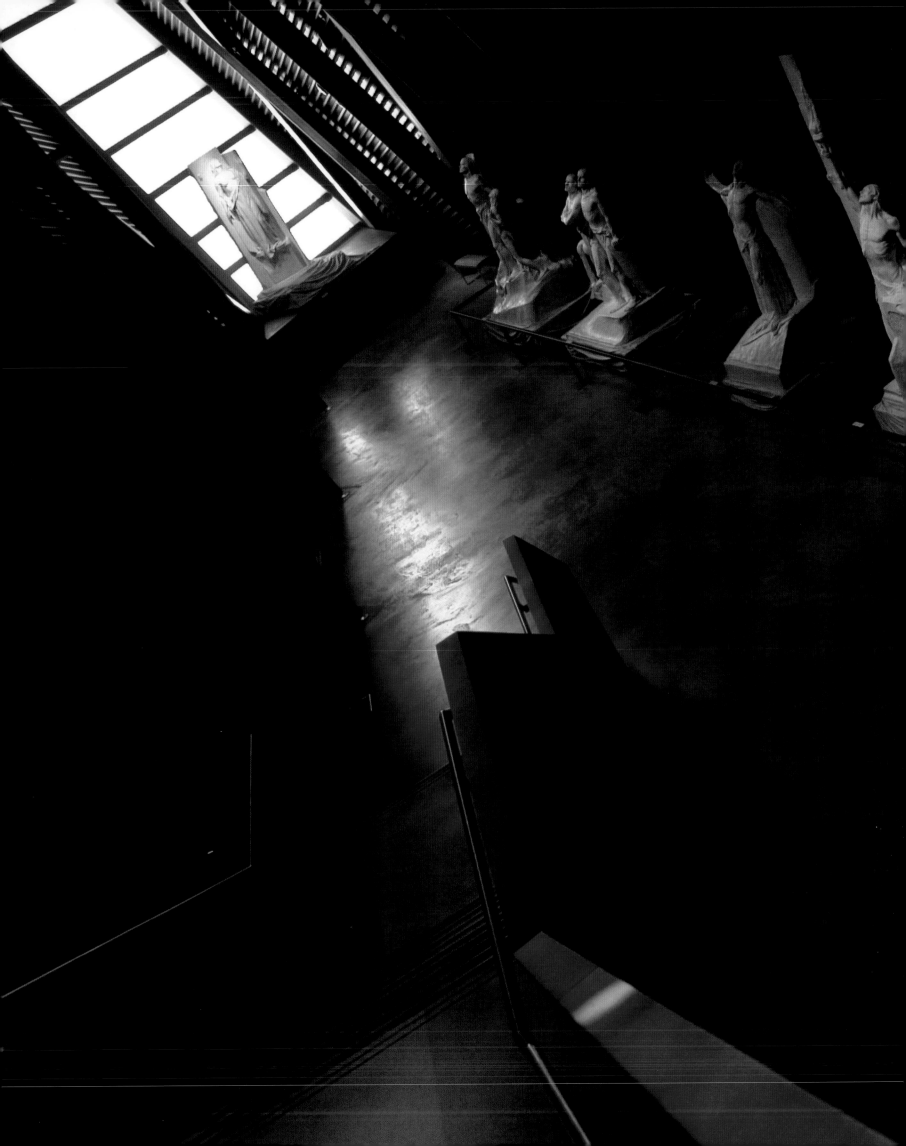

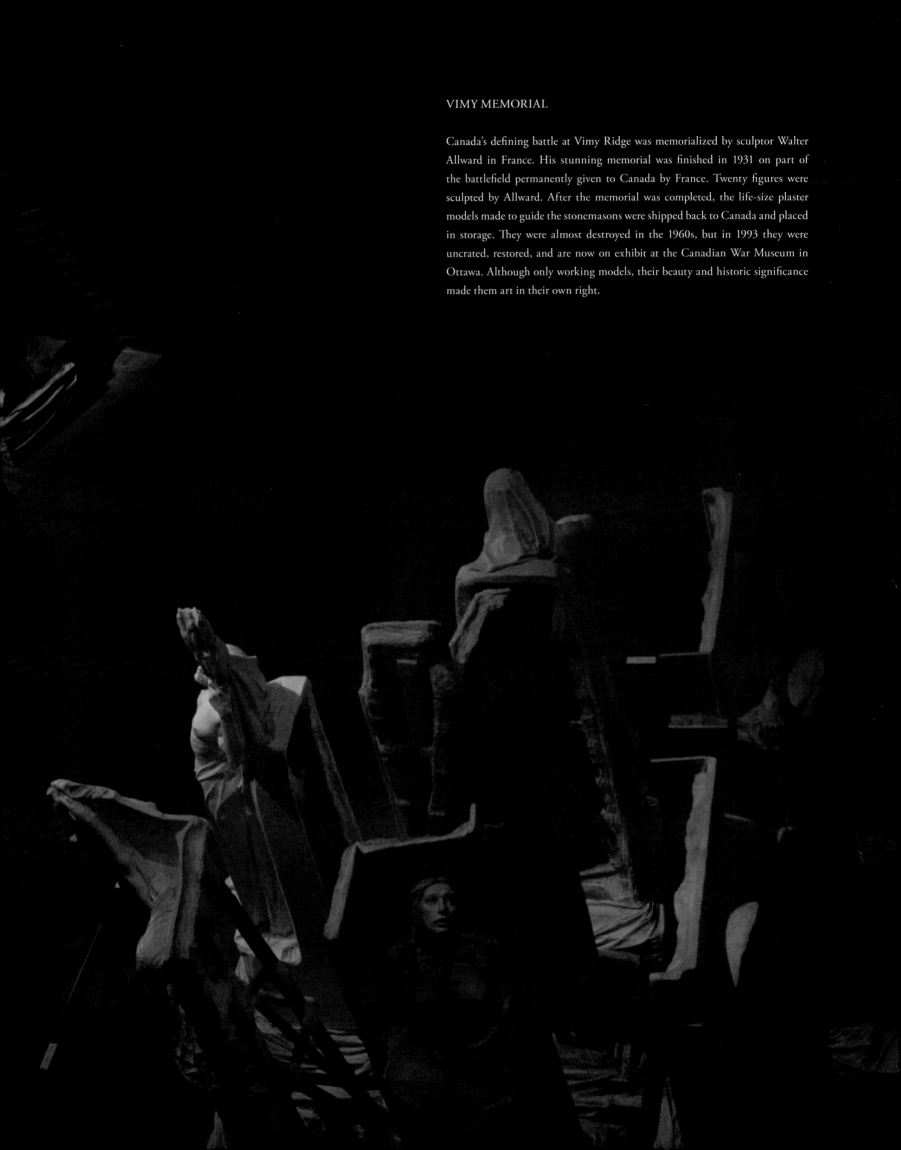

VIMY MEMORIAL

Canada's defining battle at Vimy Ridge was memorialized by sculptor Walter Allward in France. His stunning memorial was finished in 1931 on part of the battlefield permanently given to Canada by France. Twenty figures were sculpted by Allward. After the memorial was completed, the life-size plaster models made to guide the stonemasons were shipped back to Canada and placed in storage. They were almost destroyed in the 1960s, but in 1993 they were uncrated, restored, and are now on exhibit at the Canadian War Museum in Ottawa. Although only working models, their beauty and historic significance made them art in their own right.

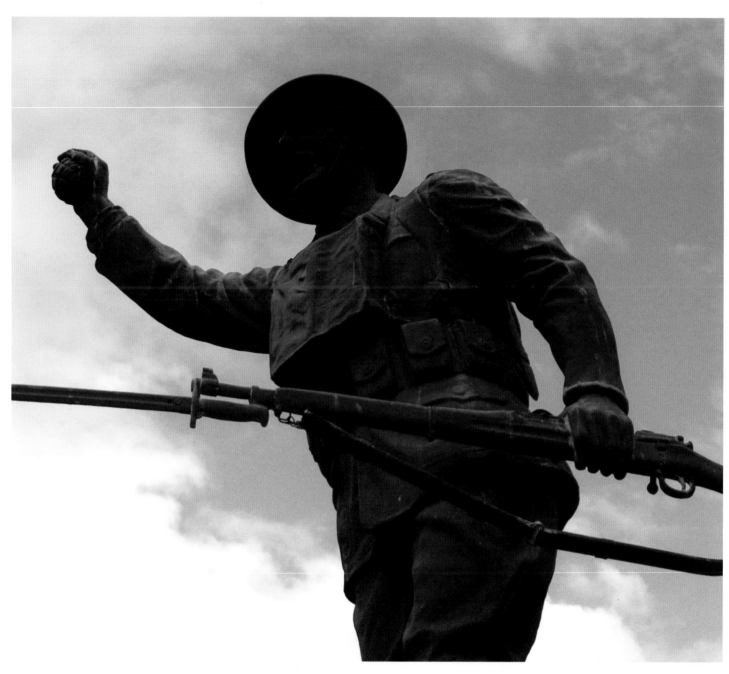

AMERICA'S DOUGHBOY

In the 1920s and 1930s there was a nationwide sentiment to honor the men who had served in the then-recent "Great War." While most monuments are one-of-a-kind creations, sculptor Ernest Moore Viquesney created "The Spirit of the American Doughboy" statues, the nickname for WW I soldiers. Faithfully accurate in details of uniform and equipment, the soldier is depicted striding forward through no-man's land. It was a commercial as well as an artistic success. Because they were mass-produced, they cost a fraction of what a conventional monument would. About one hundred and forty were made at Viquesney's foundry in Spencer, Pennsylvania and erected in small towns throughout the 1920s and 1930s. This example is in Chambersburg, Pennsylvania.

THE MAN AND HIS ARMY

General John Pershing's career spanned fights with Apache and Sioux and mechanized warfare with tanks and airplanes. Throughout his career he served with distinction, but his greatest accomplishment was his leadership of the American Expeditionary Force in WW I. He oversaw the rapid expansion of the U.S. troops to over two million men. Robert White's 1983 statue in Washington, D.C. brings the general to life. Equally important are the walls that surround the statue, telling the story of the Allied Expeditionary Force. A quote on the wall behind the general does not praise him, rather, it is his praise of the men he commanded.

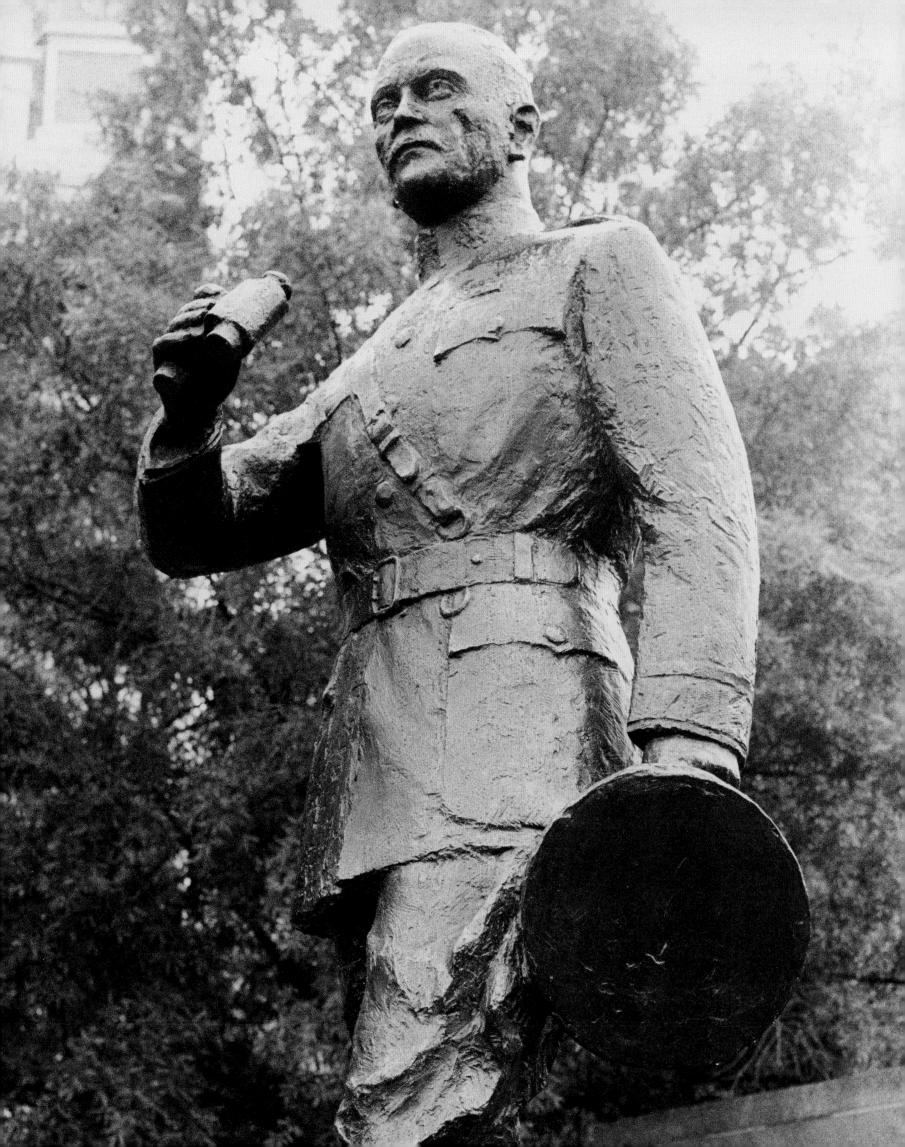

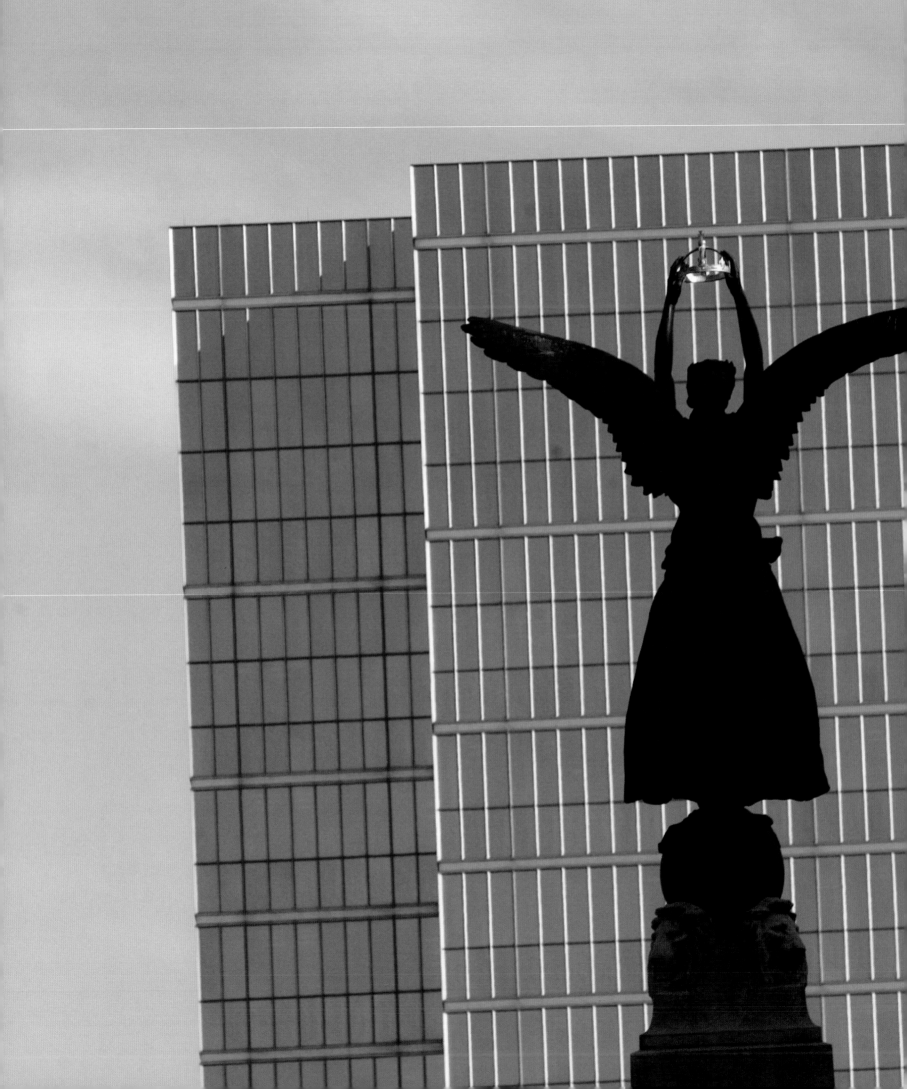

NIKE'S GIFT

Walter S. Allward's 1910 monument in Toronto, Ontario, to the South African War put three figures at the base of a 90-foot granite column. At the top of the column, the angel Nike, symbolizing the victory, holds a golden crown. Allward's angel doesn't look like she needs a stone column to stay in the air.

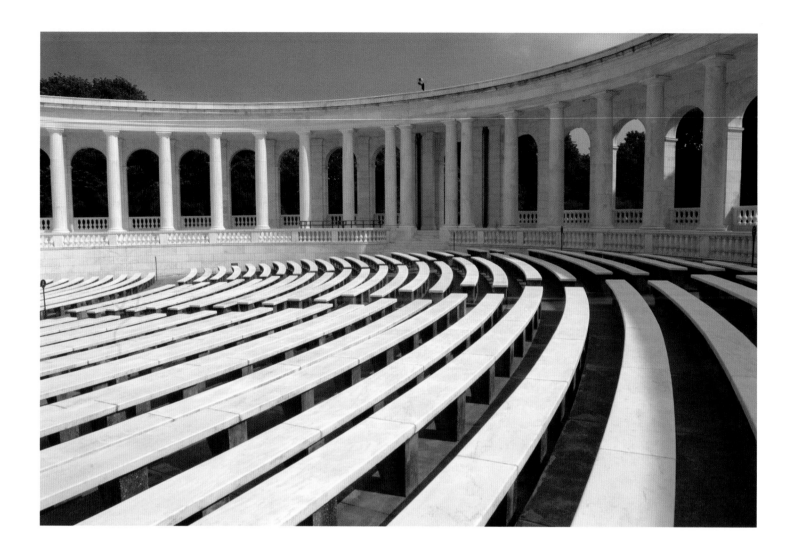

THE TOMB OF THE UNKNOWN

If there is an American shrine to those who have fallen in war, it is the Tomb of the Unknown Soldier. Located in the already-hallowed Arlington Cemetery, it was created in 1921 to honor those truly lost in "The Great War"—those who never came back, even in death. After careful selection and with greatest honor, an unidentified American was interred so that a grieving family could stand before the grave and say, "This could be mine."

More unknowns were added after WW II, Korea, and Vietnam, but advancing technology let them exhume the last addition in 1994 and identify him. His remains were returned to his family and that vault has been left empty. The beauty and solemnity of the simple vault and amphitheater have drawn many who have not suffered loss, but who still wish to pay their respects.

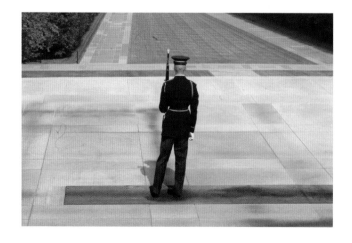

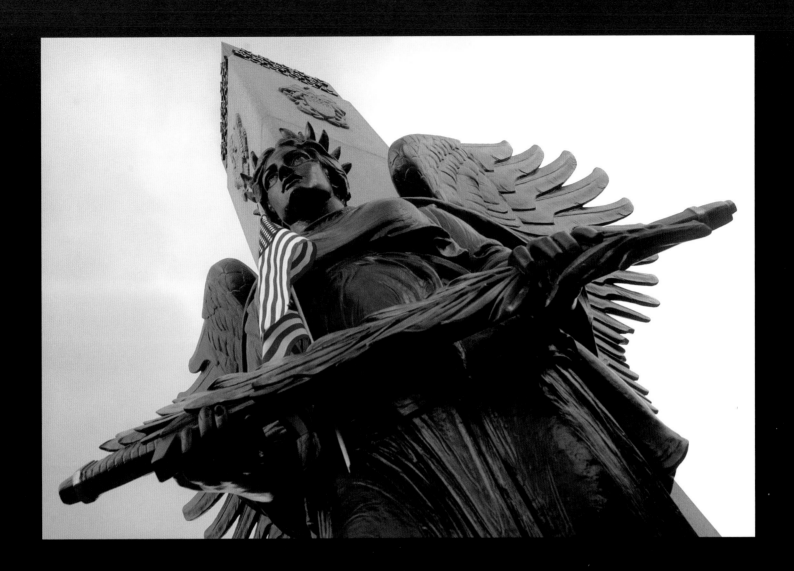

SOLDIERS REMEMBERED

Boston lost no time in honoring her WW II dead. By 1949, a sculpture designed by renowned artist John Paramino graced Boston's Back Bay Fens Park. An angel guards a wall listing the names of Boston's veterans who were lost in WW II. Additions later included Boston's Korean and Vietnam losses. Paramino's design, set in an oasis of green trees and water, encourages quiet reflection on service and sacrifice. The angel holds a sword, but it is not drawn. Her stern expression is meant only for those who would violate the peace of the memorial.

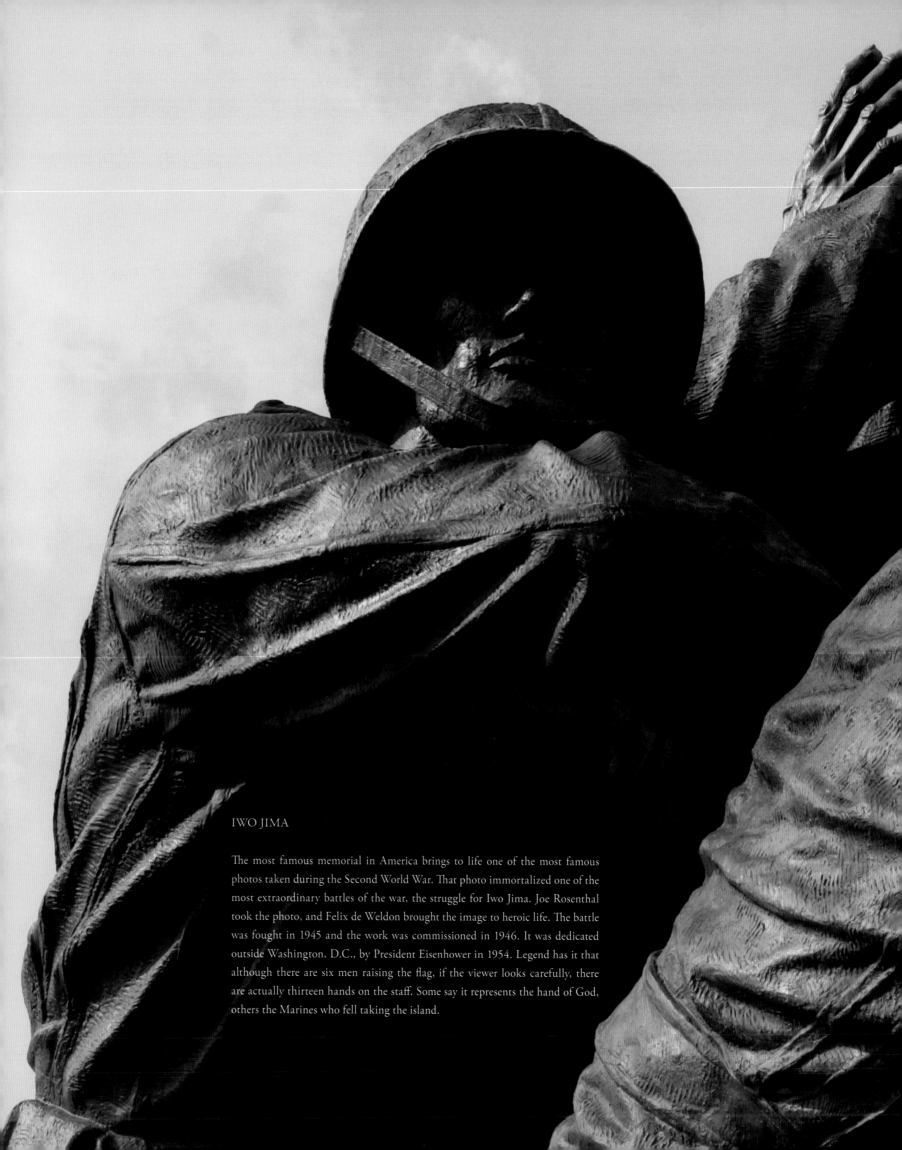

IWO JIMA

The most famous memorial in America brings to life one of the most famous photos taken during the Second World War. That photo immortalized one of the most extraordinary battles of the war, the struggle for Iwo Jima. Joe Rosenthal took the photo, and Felix de Weldon brought the image to heroic life. The battle was fought in 1945 and the work was commissioned in 1946. It was dedicated outside Washington, D.C., by President Eisenhower in 1954. Legend has it that although there are six men raising the flag, if the viewer looks carefully, there are actually thirteen hands on the staff. Some say it represents the hand of God, others the Marines who fell taking the island.

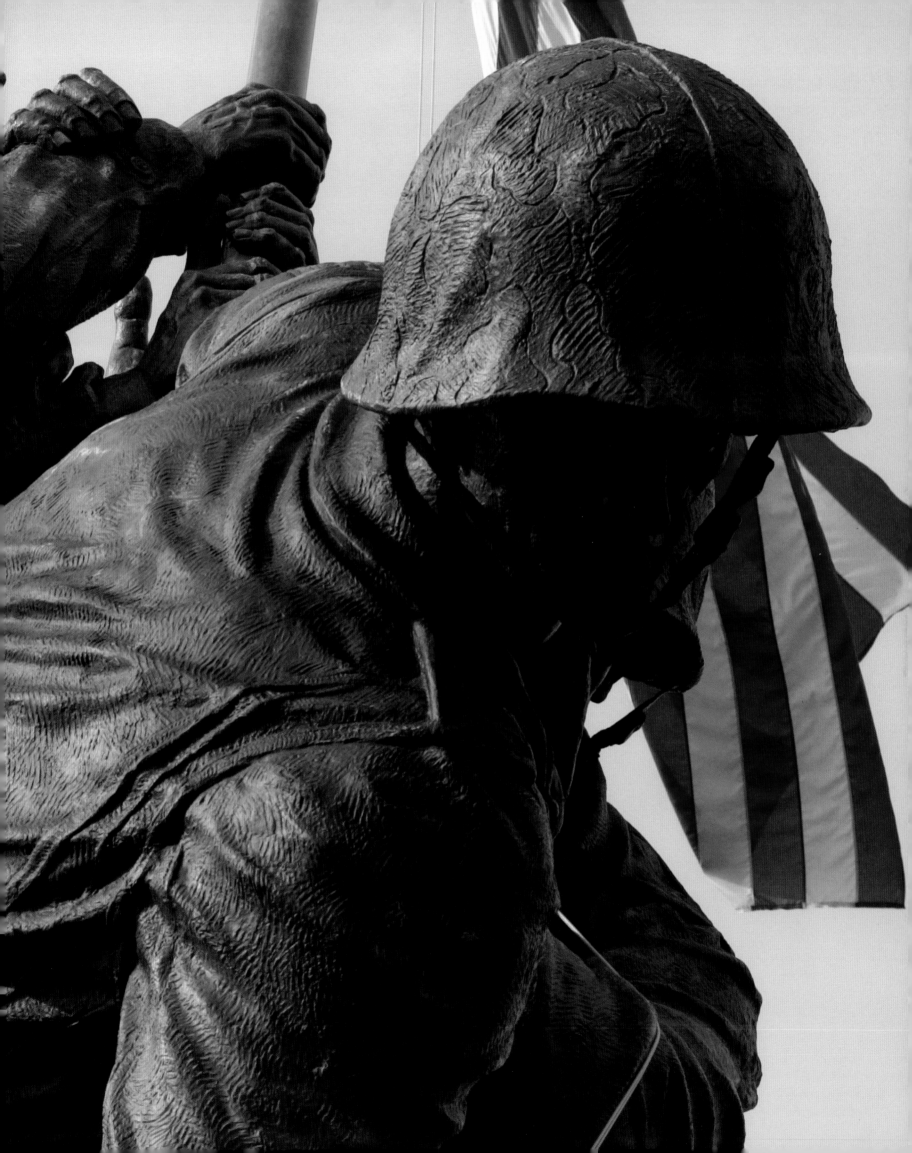

SERVING HIS COUNTRY

In 1942, Terry Sanford was working as a special agent when he left the FBI and joined the army. He became an airborne trooper and fought in five major campaigns. He rose from private to lieutenant, was wounded, and decorated for bravery. After the war, he served as a North Carolina state senator, governor, president of Duke University, and finally a U.S. Senator, always with distinction. This plaque honoring him was dedicated on August 16, 2003 in the Airborne and Special Operations Museum at Fort Bragg, North Carolina. They wanted to honor a favorite son who'd done more than his share, and always done it well.

A GRATEFUL COMMUNITY

Fayetteville, North Carolina's Freedom Memorial Park is an island of green and water in a downtown landscape. Built with private funds from 2002 to 2004, the park's builders wanted to make sure that they honored everyone—those who came back, as well as those who were lost. Obelisks and standing monuments commemorate those from each war: WW I, WW II, Korea, and Vietnam. MIAs are also remembered. A central plaque reads in part, "A grateful community remembers those who served."

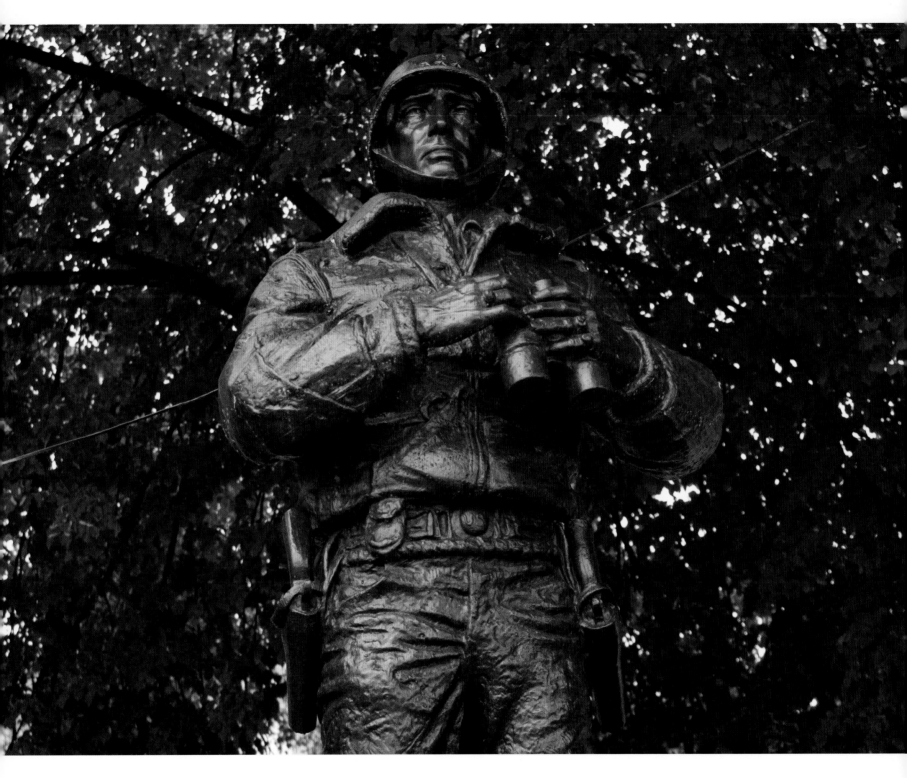

GENERAL GEORGE PATTON

Almost immediately after General George Patton's death in 1945, noted sculptor James Earl Fraser was commissioned to create a statue for the United States Military Academy at West Point. It was erected in 1951. Patton's links to West Point are obvious, but he is also a favorite son in Boston. He purchased Green Meadows Farm nearby in 1928, which is still owned by his family today. The city of Boston erected a duplicate of the Fraser work on the Esplanade, near the Charles River. His name has become an icon for aggressiveness, but Patton's drive came from his devotion to the men he led. Moving fast not only won battles, it kept casualties down.

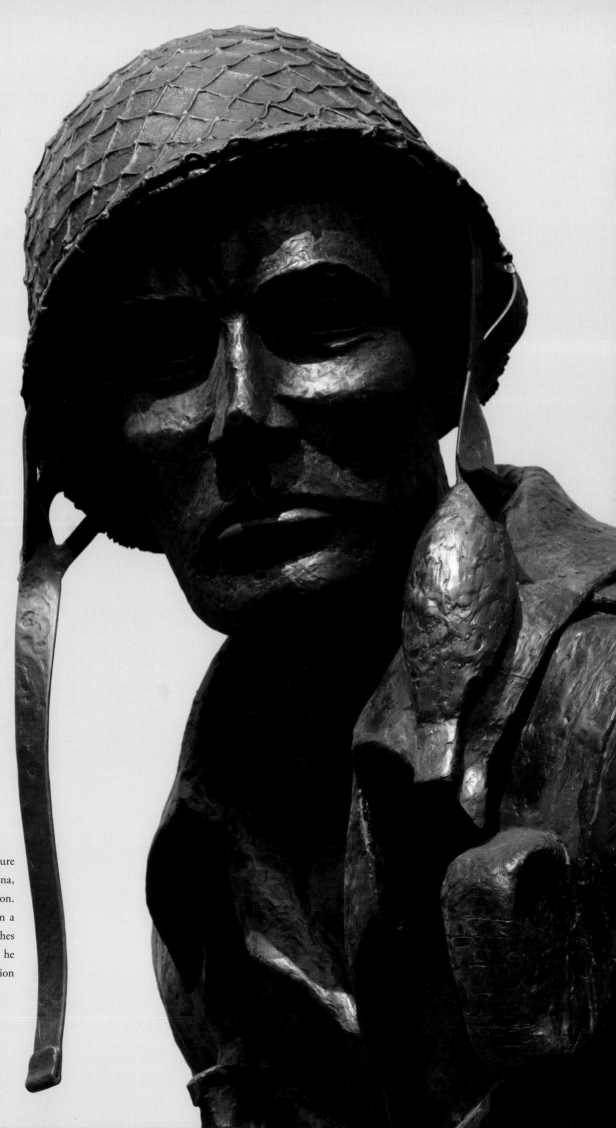

IRON MIKE

Titled "The Airborne Trooper," this figure stands guard at Fort Bragg, North Carolina, home to the 82nd Airborne Division. Sculpted in 1961 by Leah Heibert from a live model, it stands sixteen feet, four inches tall. Immediately dubbed "Iron Mike," he radiates the strength and determination demanded of the airborne soldier.

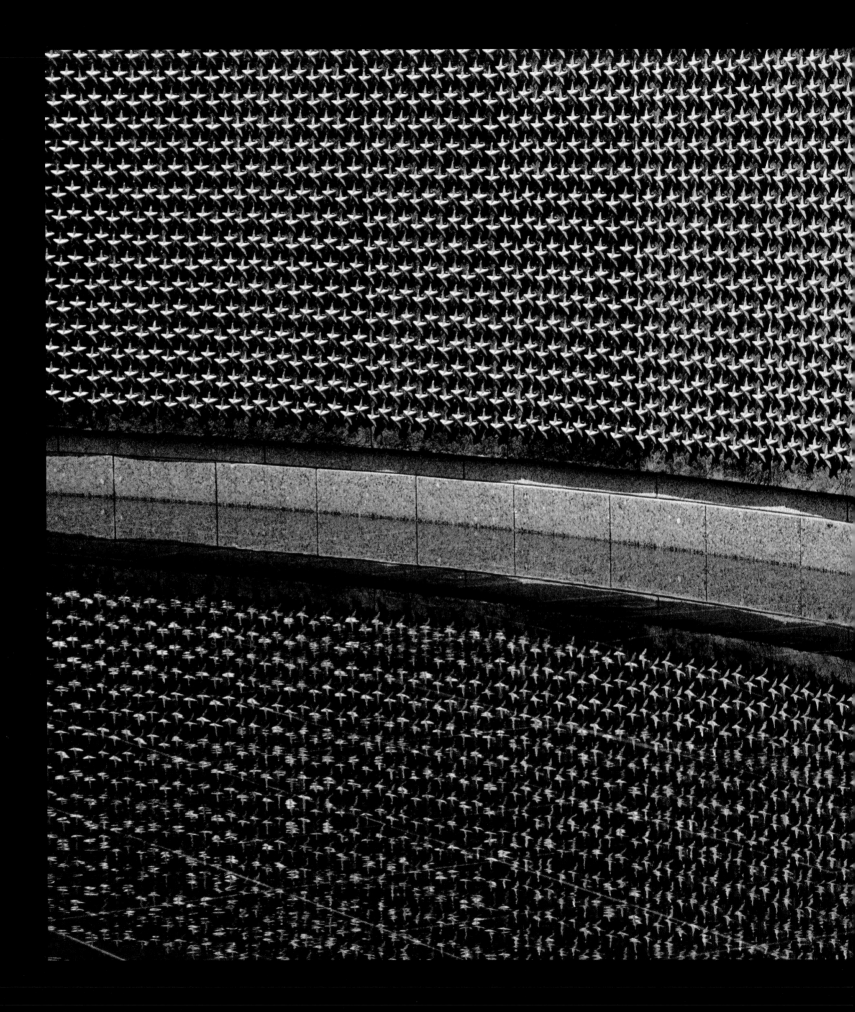

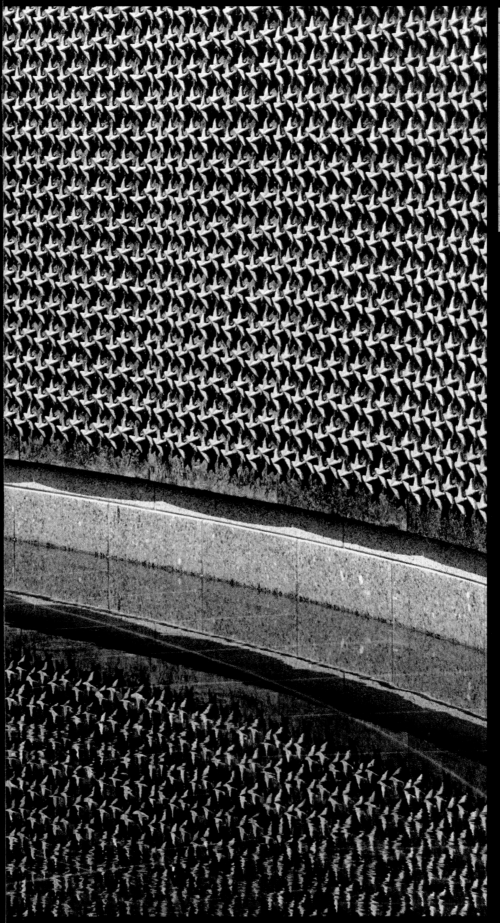

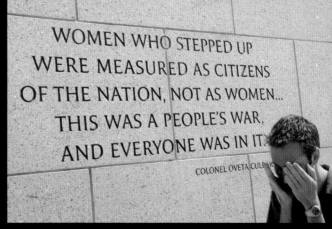

A PEOPLE'S WAR

The National WW II Memorial in Washington, D.C. covers more than seven acres, with fifty-six pillars circling a central plaza and reflecting pool. It also includes two memorial arches, dedication stones to each theater of the war, and a wall honoring those who died. The wall circling the plaza is lined with bas-reliefs, and there is even an engraved "Kilroy was here." The memorial does its best to describe and commemorate a war that encompassed a nation and all its people. Its effects will be felt for and by generations to come.

THE PRICE OF FREEDOM

This portion of the WW II Memorial in Washington, D.C. is the Freedom Wall. It contains twenty-three panels, each with eleven columns and sixteen rows of stars—a total of 4048 gold stars, approximately one for each 100 American deaths during the war. Gold stars were a symbol of sacrifice during WW II. Families who had lost a member would hang a gold star in their window. A plaque on front of the wall declares, "Here we mark the price of freedom."

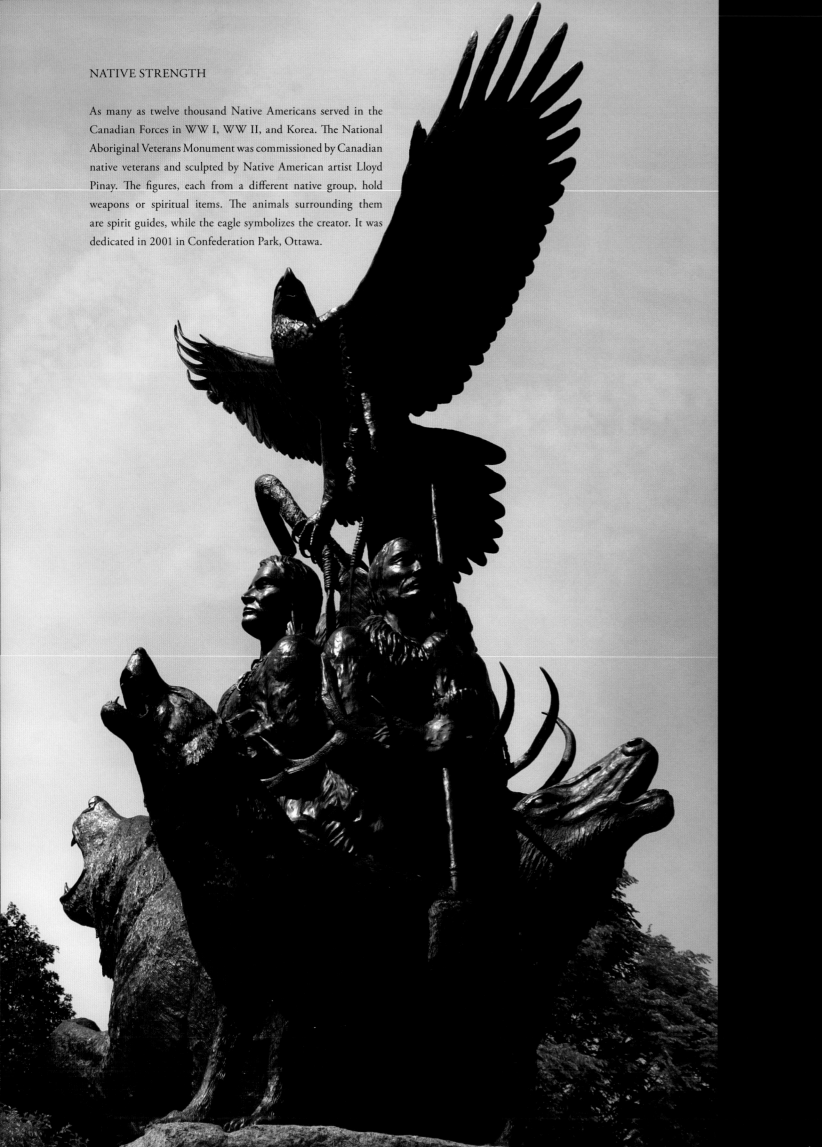

NATIVE STRENGTH

As many as twelve thousand Native Americans served in the Canadian Forces in WW I, WW II, and Korea. The National Aboriginal Veterans Monument was commissioned by Canadian native veterans and sculpted by Native American artist Lloyd Pinay. The figures, each from a different native group, hold weapons or spiritual items. The animals surrounding them are spirit guides, while the eagle symbolizes the creator. It was dedicated in 2001 in Confederation Park, Ottawa.

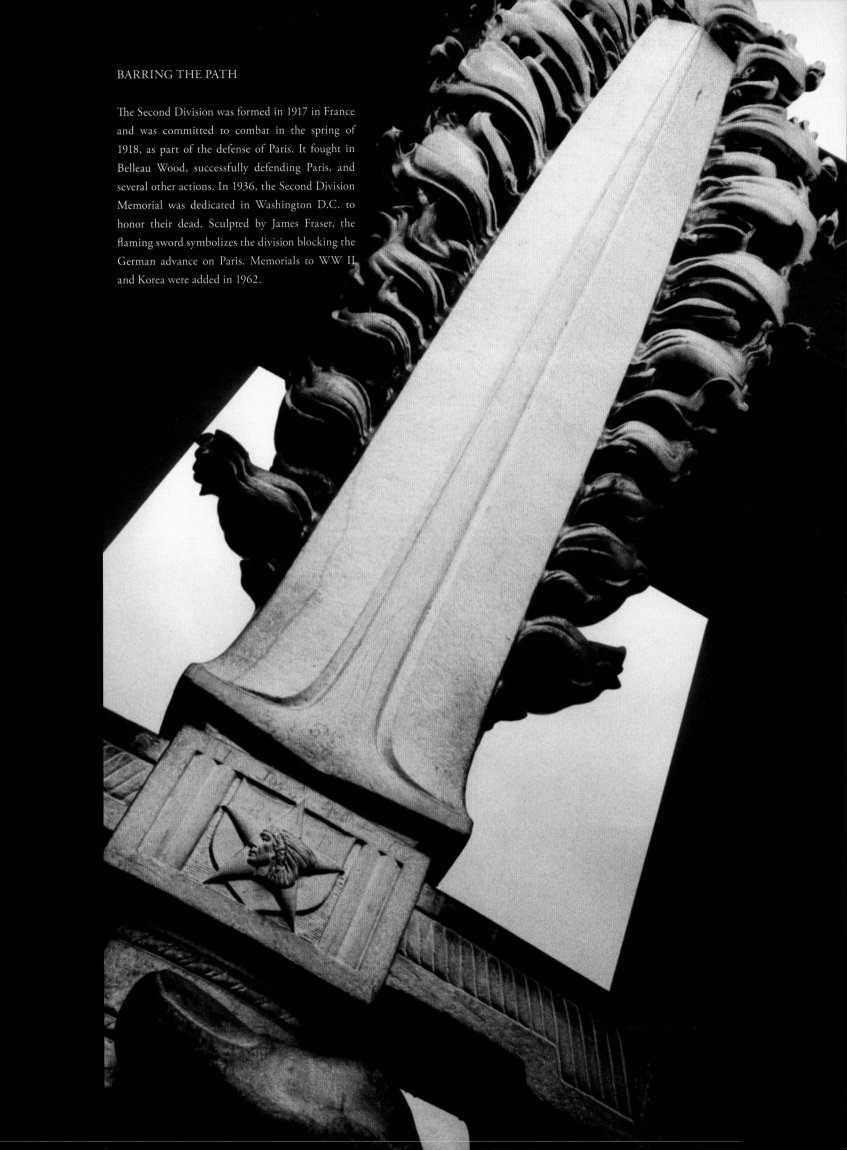

BARRING THE PATH

The Second Division was formed in 1917 in France and was committed to combat in the spring of 1918, as part of the defense of Paris. It fought in Belleau Wood, successfully defending Paris, and several other actions. In 1936, the Second Division Memorial was dedicated in Washington D.C. to honor their dead. Sculpted by James Fraser, the flaming sword symbolizes the division blocking the German advance on Paris. Memorials to WW II and Korea were added in 1962.

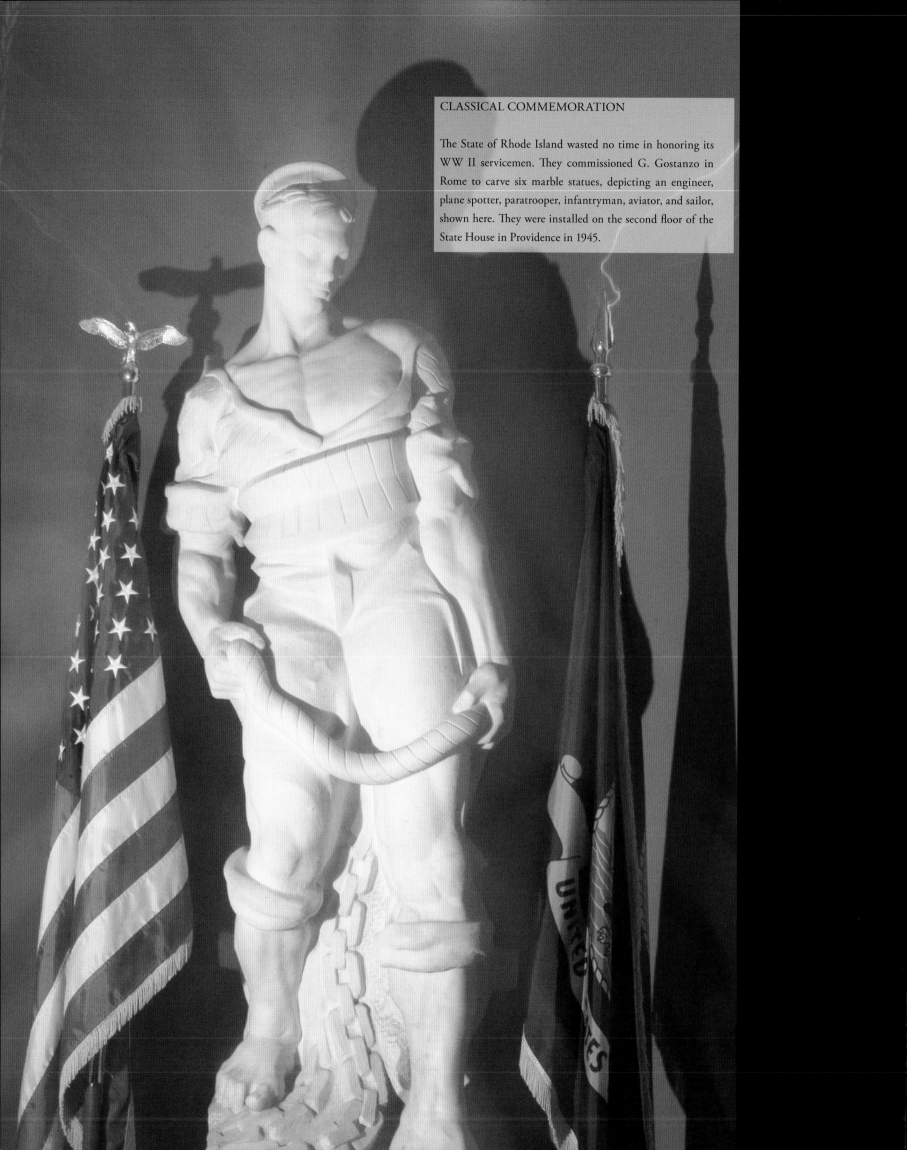

CLASSICAL COMMEMORATION

The State of Rhode Island wasted no time in honoring its WW II servicemen. They commissioned G. Gostanzo in Rome to carve six marble statues, depicting an engineer, plane spotter, paratrooper, infantryman, aviator, and sailor, shown here. They were installed on the second floor of the State House in Providence in 1945.

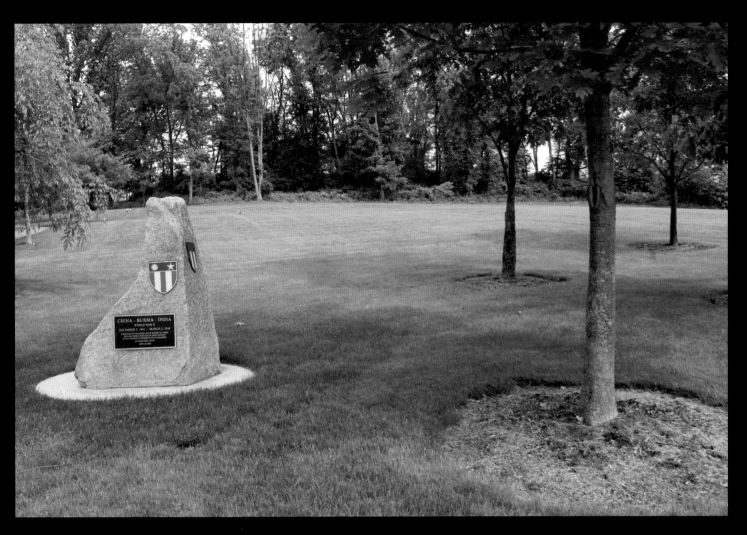

PERSONAL REMEMBRANCE

This six-foot granite marker was not erected by a veterans group or city fathers, but by one man, Wendall A. Phillips. A veteran of the China-Burma-India theatre, he has spent most of his life honoring his comrades—"the guys that didn't come back." Located in the Indiantown Gap National Cemetery in Pennsylvania, it remembers the troops who fought in that theater. In addition to the plaque and shoulder insignia visible in the image, another plaque on the back bears the quote, "When you go home, tell them of us and say, 'For your tomorrow, we gave our today.'" This is the third memorial Mr. Phillips has erected, all at his own expense. There are similar ones in Carlisle and Allentown, Pennsylvania.

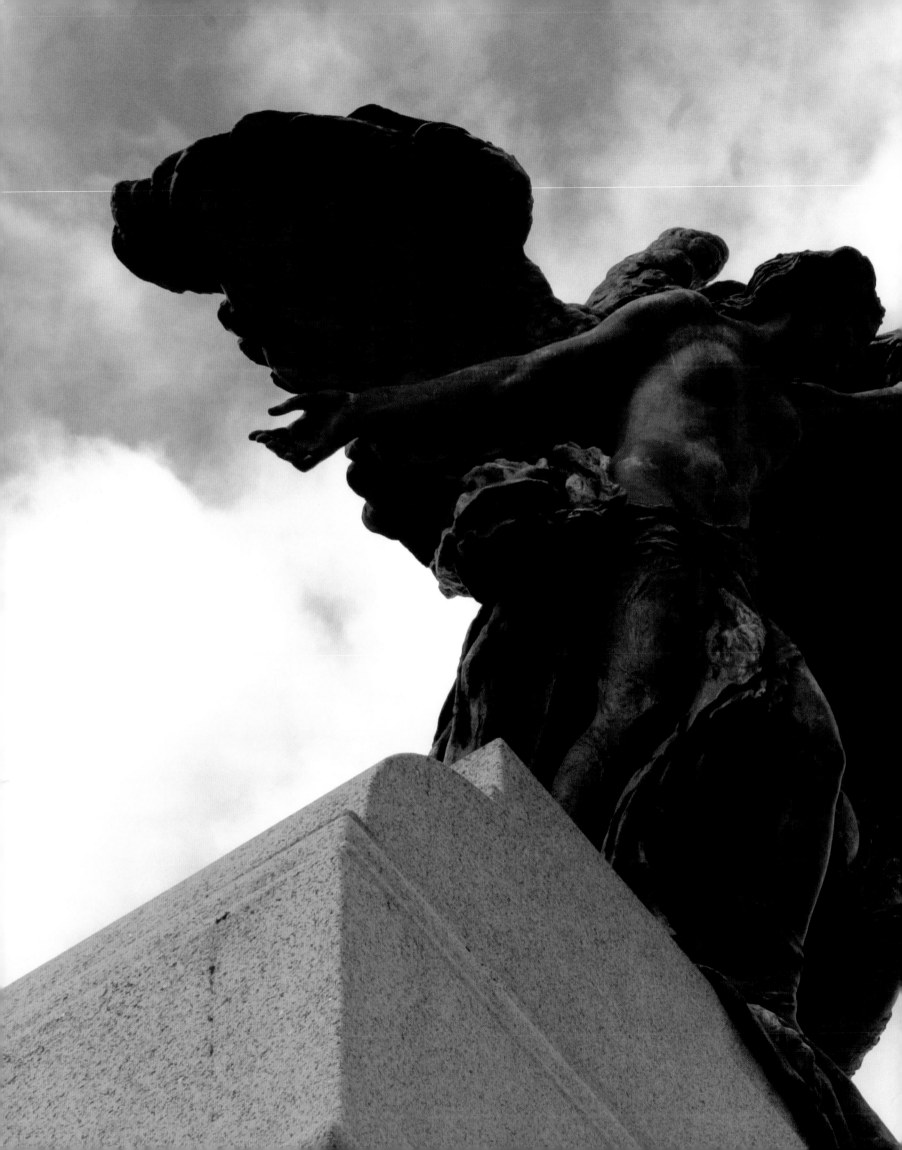

DUTY'S REWARD

In Vernon March's towering 1938 memorial to Canada's servicemen in WW I, twenty-two larger-than-life bronze figures march through an arch, symbolizing their response to the call to duty. Members from all branches of the service are represented. Atop the arch, two angels, symbolizing peace and freedom, are alighting. The massive statues seem almost featherweight as they bring their gifts. The Ottawa sculpture now honors all of Canada's service members.

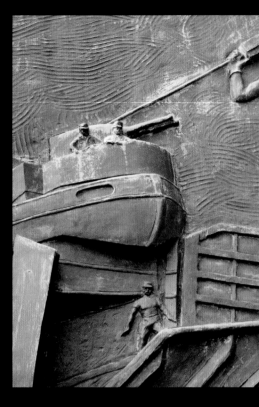
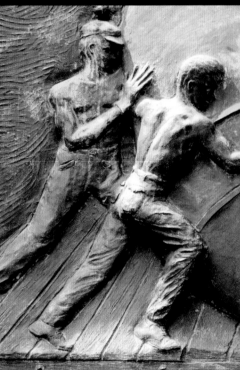

SEA BEE MONUMENT

The pugnacious "Sea Bee" is the emblem of the U.S. Navy's Construction Battalions, first created during WW II. Its six arms hold tools as well as a tommy gun, reflecting their motto: "We build, we fight." The pop-art-style sculpture was erected in Davisville, Rhode Island, in 1969. This was an important training and staging point for the Seabee units as they prepared to go overseas. Appropriately enough, it was built by Seabee veterans, and it reflects not only their fighting spirit but their good humor and "Can Do" attitude.

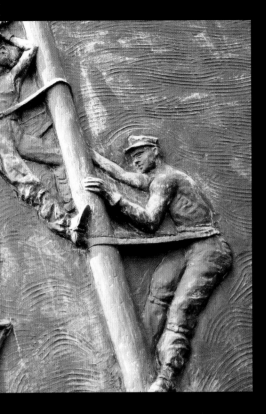

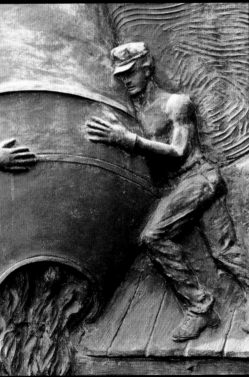

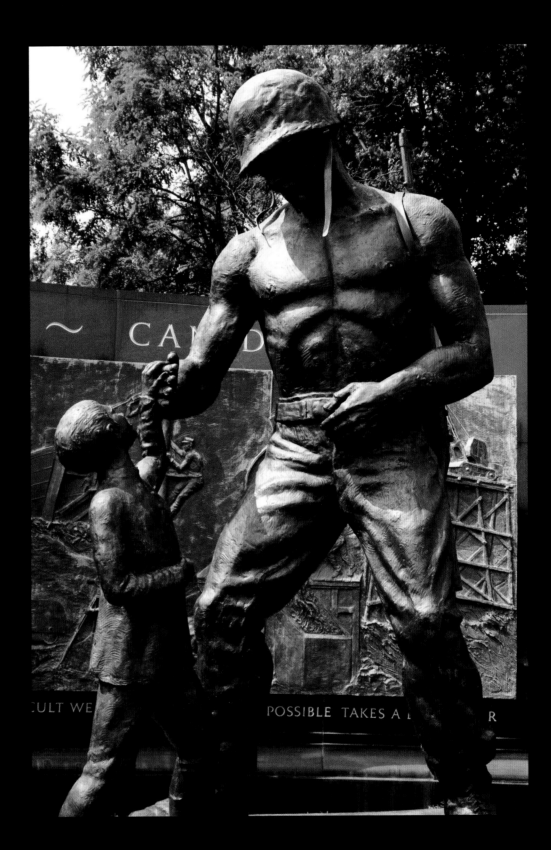

CONSTRUCTION BATTALIONS

Some memorials take longer to build than others. The Seabees were a vital part of the U.S. victory in the Pacific, but they were not as glamorous as other branches of the service. This Washington, D.C. memorial was dedicated in 1974, not only by Seabee veterans but by their now-grown children. Their purpose was remembrance, symbolized by the small child and the panels showing the many tasks performed by the Construction Battalions during the war. The builders made sure that the Seabees' role would be known by future generations. The memorial association that financed the monument also keeps the Seabees' memory alive with a scholarship fund.

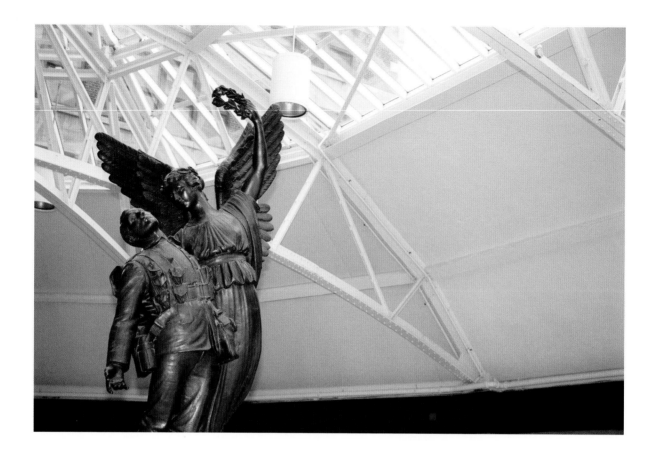

WINGED VICTORY

Sculptor Coeur de Lion MacCarthy was commissioned by the Canadian Pacific Railroad to design a memorial to employees who had died in "The Great War." What MacCarthy created went far beyond corporate art. Dedicated in 1923, it was installed in the Windsor train station. "Winged Victory" carries a fallen soldier heavenwards, and has become a Montréal landmark. It was later rededicated to include those lost in WW II.

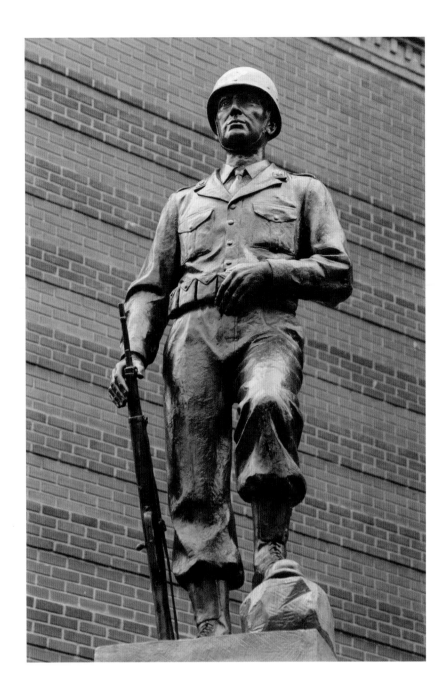

A NEW HOME

The Church of Notre-Dame-de-la-Defense is the centerpiece of Montréal's Little Italy, a thriving community that began in the late nineteenth century when over a hundred thousand Italians emigrated to Canada, looking for a better life. Their numbers were increased further by immigration after WW II. This statue, in front of the church, is also from Italy, commissioned in honor of the thousands of Italian-Canadians who served and died fighting fascism in the Second World War.

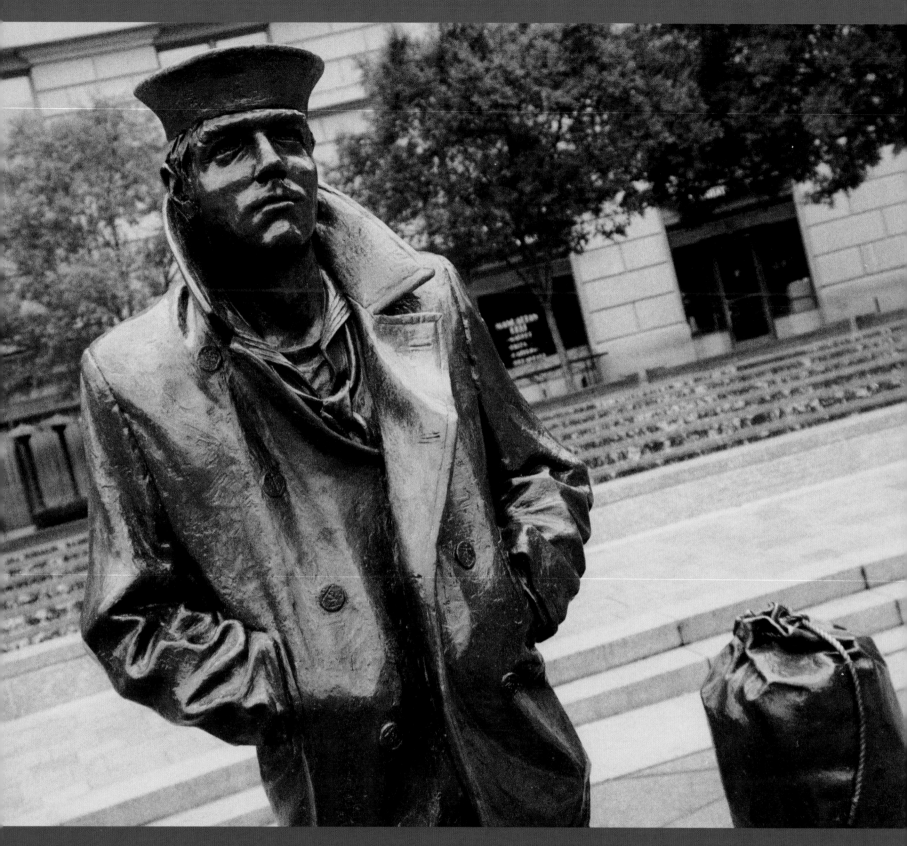

THE LONE SAILOR

The U.S. Navy Memorial in downtown Washington, D.C. was dedicated in 1987. A 100-foot-diameter map of the world forms a central plaza known as the "Granite Sea." Standing over the world's seas is the figure of a young petty officer. Sculptor Stanley Bleifeld created a composite of all Navy sailors, from 1775 to the present day. The bronze material of the statue includes artifacts from eight Navy ships, ranging from the USS *Constitution* to the nuclear sub USS *Seawolf*.

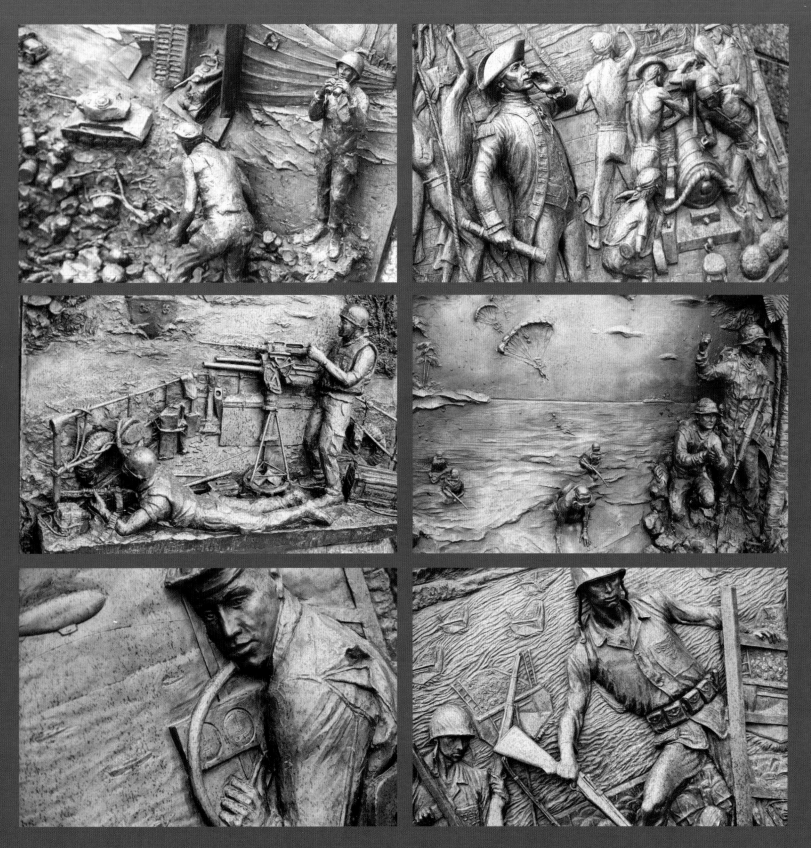

BRONZE RELIEFS

Surrounding the Granite Sea at the Navy Memorial are 26 bronze bas-relief sculptures. They honor different parts of the Navy, important people, or events in the past. Many different sculptors contributed designs covering subjects from John Paul Jones to special warfare operations to airships.

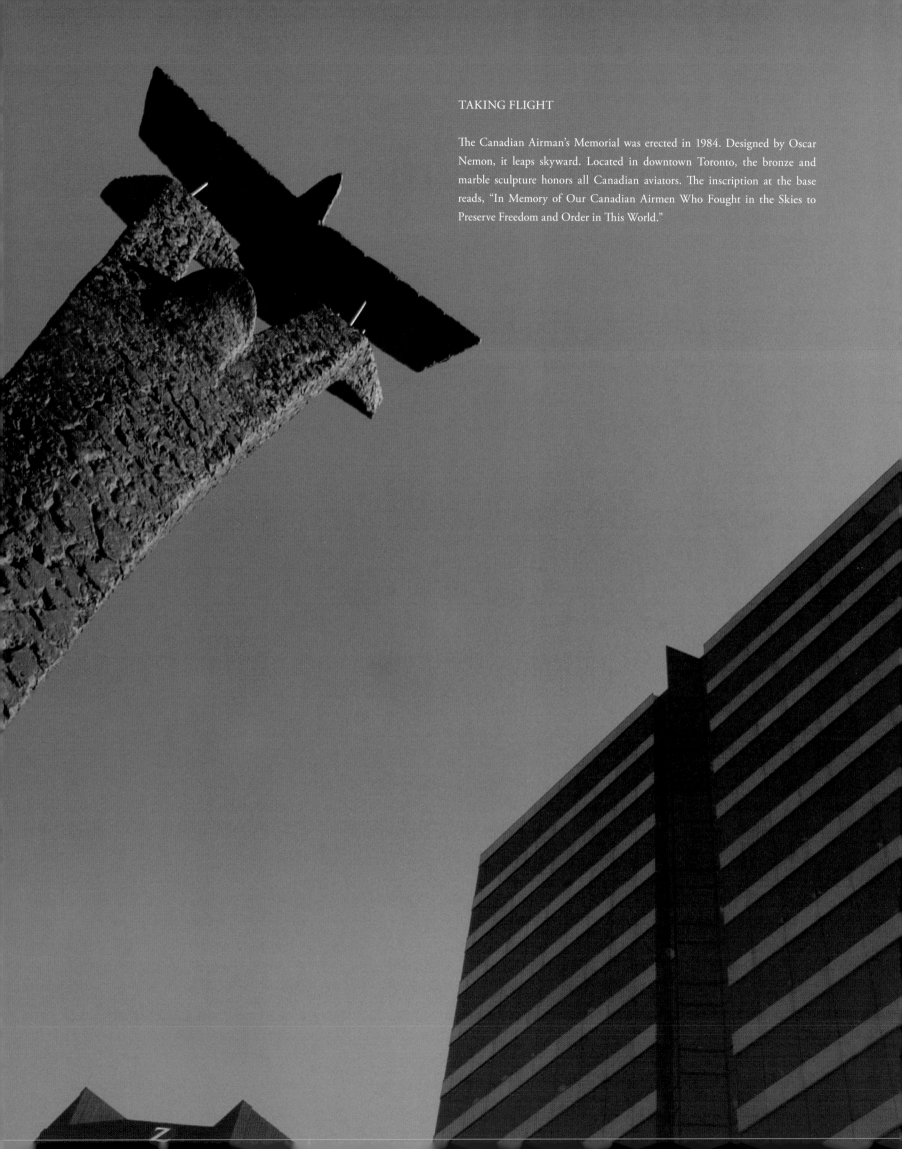

TAKING FLIGHT

The Canadian Airman's Memorial was erected in 1984. Designed by Oscar Nemon, it leaps skyward. Located in downtown Toronto, the bronze and marble sculpture honors all Canadian aviators. The inscription at the base reads, "In Memory of Our Canadian Airmen Who Fought in the Skies to Preserve Freedom and Order in This World."

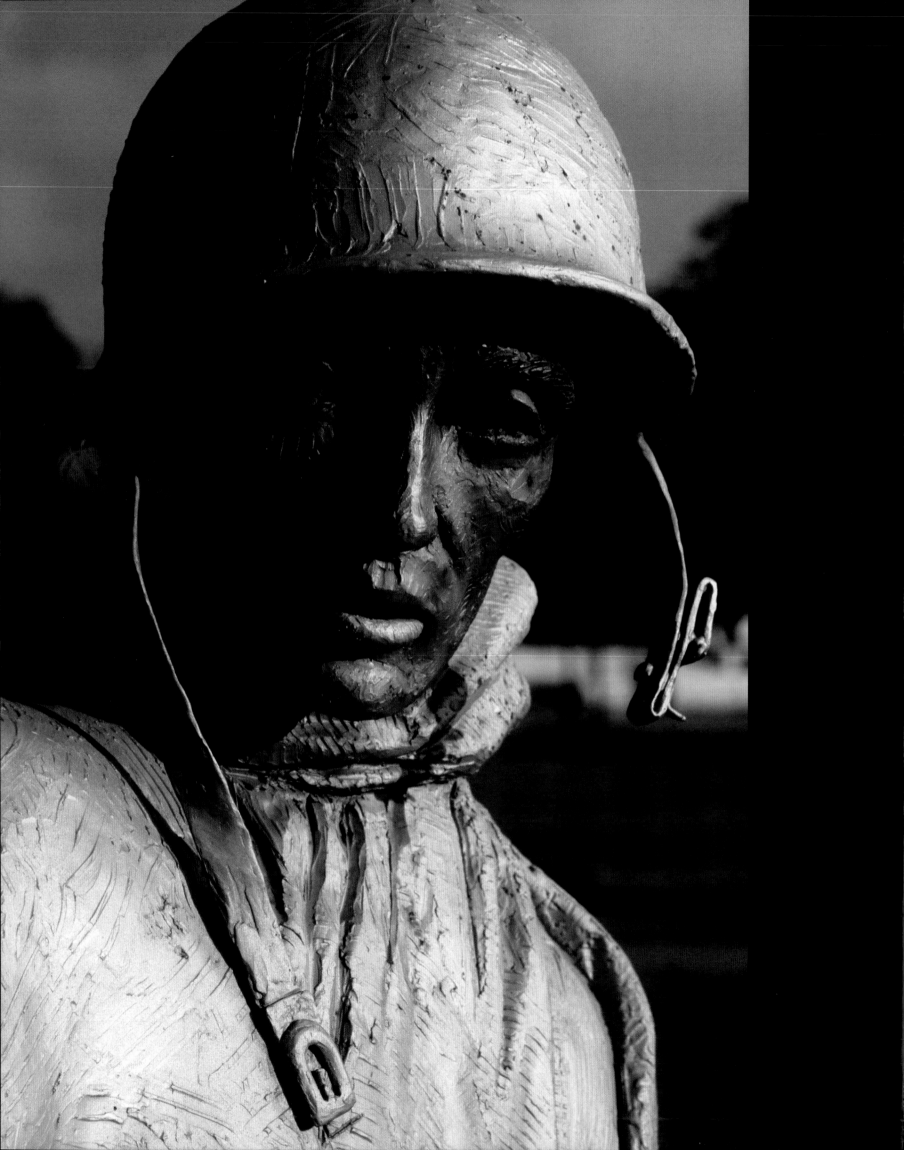

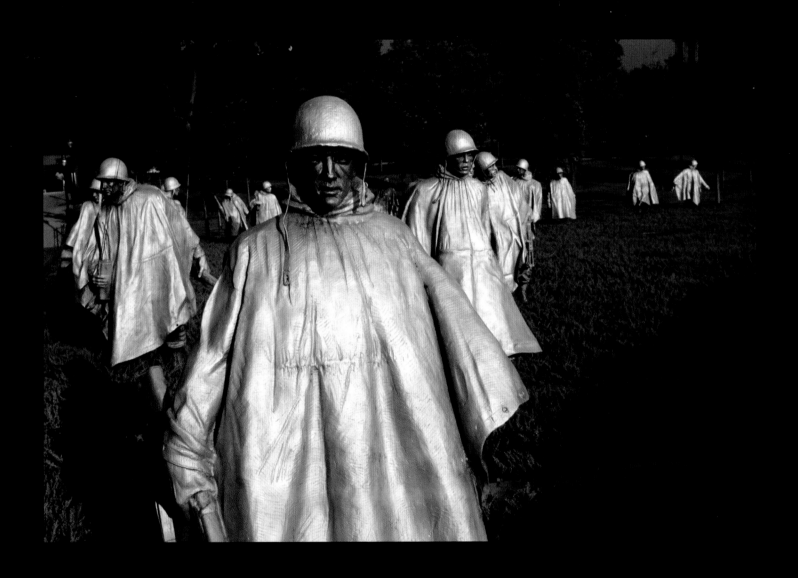

ON PATROL

The Korean War Veterans Memorial in Washington, D.C. has many elements: a reflecting pool, a granite mural wall with thousands of etched images, the UN Curb listing the countries that took part, and an honor roll that lists those lost in the conflict. But these are peripheral. A visitor's eyes are always drawn to the center of the memorial, the triangular Field of Service. Sculptor Frank Gaylord created a patrol of nineteen figures emerging from the woods. Authentically uniformed and equipped, they stride through simulated Korean terrain, harsh wind billowing their ponchos. It's a symbolic patrol, because the figures are a mixture of Army, Marines, Navy, and Air Force. Stand in that place and you are there with them. The memorial was dedicated in 1995.

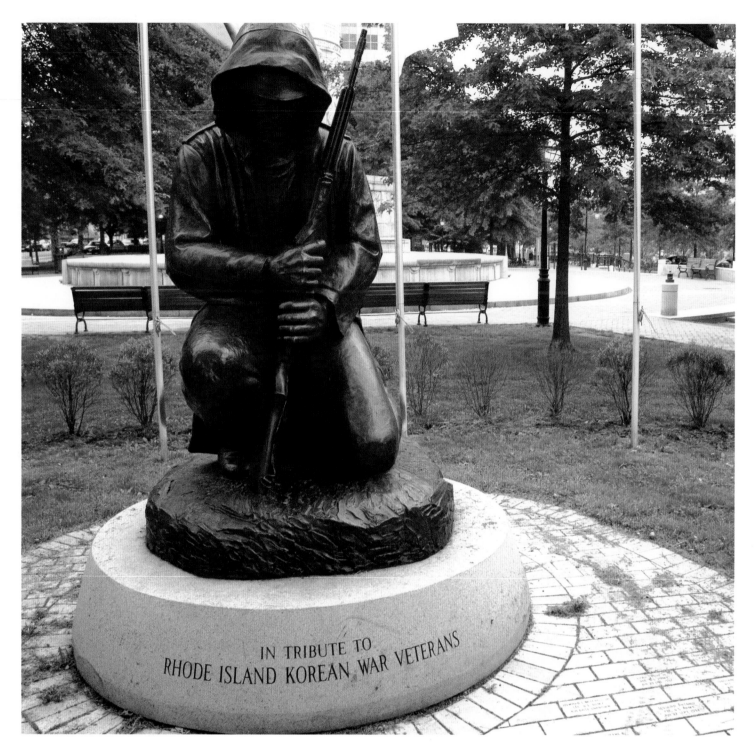

FACING THE ENEMY

Rhode Island's memorial to the Korean War lies at the end of a red brick pathway in
Veterans Memorial Park in Providence. Along the path, 145 white bricks stand for
Rhode Islanders who died, and 55 stand for those who are MIA. Finished in 1998,
Robert Shure's statue of an American soldier is hooded, kneeling, as if on sentry.
The bronze statue faces north, toward the enemy.

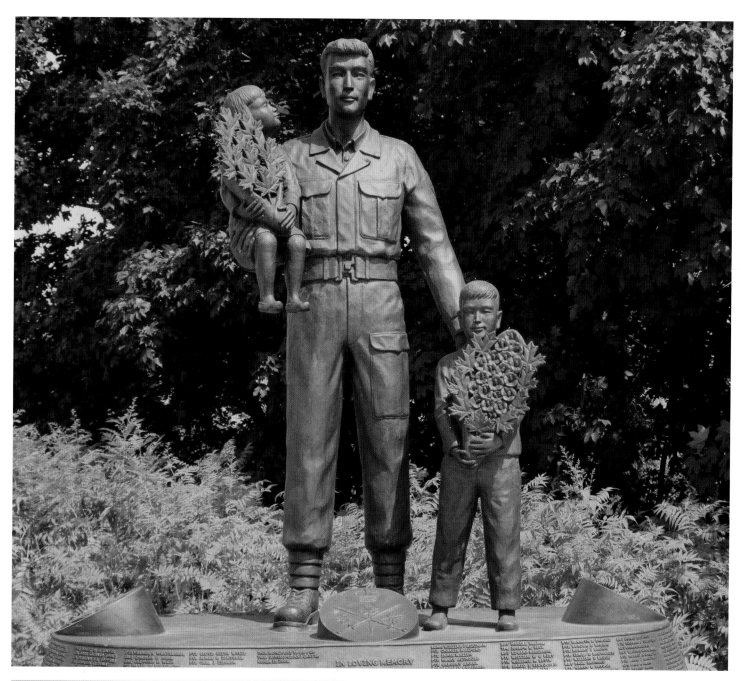

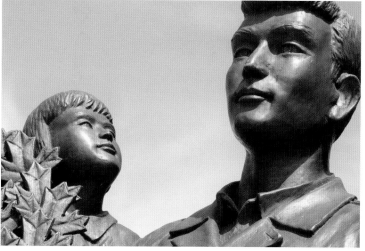

WE SHALL NOT FORGET

In 2003, Canada remembered their 516 soldiers who died in Korea, with "The Forgotten War." Identical monuments in Pusan and Ottawa show a soldier and two small children. The soldier is unarmed, symbolizing that the fighting has stopped, and the children symbolize the future of Korea. The memorial was designed by Korea veteran Vince Courtenay, and sculpted by Korean artist Yoo Young-Mun. The names of those lost are listed on the base. The emphasis is on their sacrifice, not for victory, but the peace they helped create.

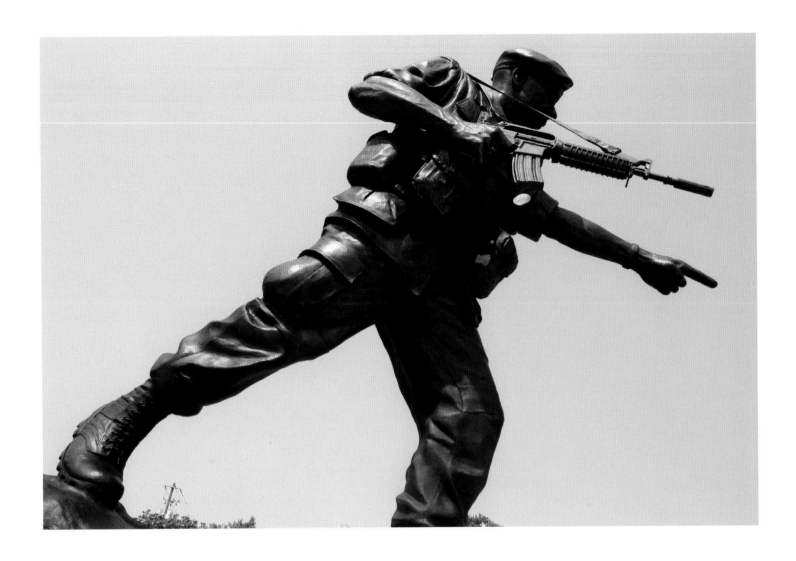

SPECIAL WARRIOR

Every group needs an exemplar, an individual who embodies what it believes in and strives for. Serving in WW II, Korea, and Vietnam during his 32 years in uniform, Colonel Arthur "Bull" Simons commanded both Ranger and Special Forces units, helping create these organizations. This statue outside the Special Warfare Museum at Fort Bragg, North Carolina, is an honor, but Colonel Simons should be emulated, not just remembered. Every year the Special Operations community awards one individual the Bull Simons Award, for displaying the spirit and values that he demonstrated.

It can also be an expression of gratitude. Sculpted by Lawrence Ludtke, the statue is eight feet tall and rests on a granite pedestal. It was donated by H. Ross Perot, who approached Colonel Simons to help rescue two of Perot's employees captured during the 1979 Iranian revolution. Only someone like Colonel Simons could have successfully brought them home. It was erected in 1999.

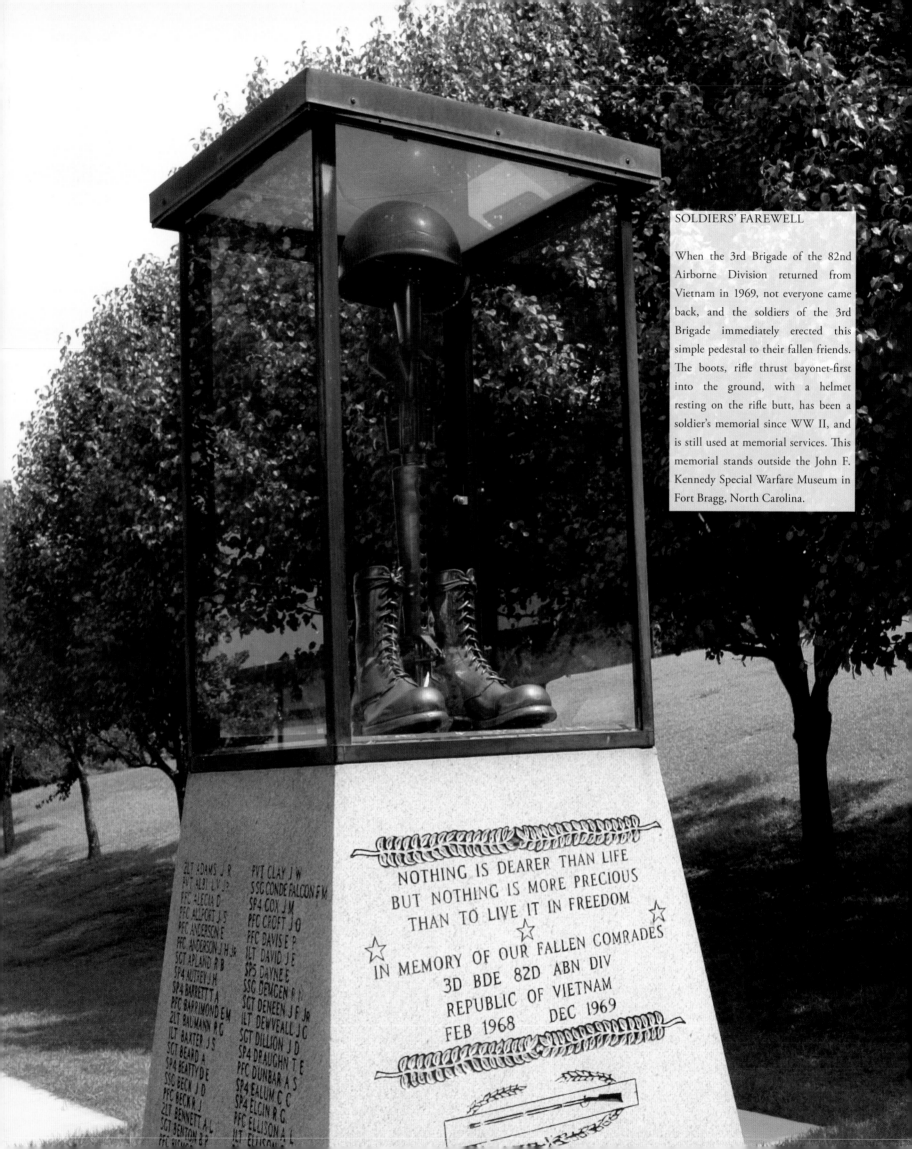

SOLDIERS' FAREWELL

When the 3rd Brigade of the 82nd Airborne Division returned from Vietnam in 1969, not everyone came back, and the soldiers of the 3rd Brigade immediately erected this simple pedestal to their fallen friends. The boots, rifle thrust bayonet-first into the ground, with a helmet resting on the rifle butt, has been a soldier's memorial since WW II, and is still used at memorial services. This memorial stands outside the John F. Kennedy Special Warfare Museum in Fort Bragg, North Carolina.

NOTHING IS DEARER THAN LIFE
BUT NOTHING IS MORE PRECIOUS
THAN TO LIVE IT IN FREEDOM

IN MEMORY OF OUR FALLEN COMRADES
3D BDE 82D ABN DIV
REPUBLIC OF VIETNAM
FEB 1968 DEC 1969

2LT ADAMS J R
PVT ALBY L V Jr
PFC ALECIA D
PFC ALLPORT J S
PFC ANDERSON E
PFC ANDERSON J H Jr
SGT APLAND R B
SP4 AUTREY J M
SP4 BARRETT T A
PFC BARRIMOND E M
2LT BAUMANN R G
1LT BAXTER J S
SGT BEARD A
SP4 BEATTY D E
SSG BECK J D
PFC BECK R J
2LT BENNETT A L
SGT BENTON B P
PFC RICH

PVT CLAY J W
SSG CONDE FALCON F M
SP4 COX J M
PFC CROFT J O
PFC DAVIS E P
1LT DAVID J E
SP5 DAYNE E
SSG DEMCEN R N
SGT DENEEN J F Jr
1LT DEWVEALL J C
SGT DILLION J D
SP4 DRAUGHN T E
PFC DUNBAR A S
SP4 EALUM C C
SP4 ELGIN R G
PFC ELLISON A L
1LT ELLISON

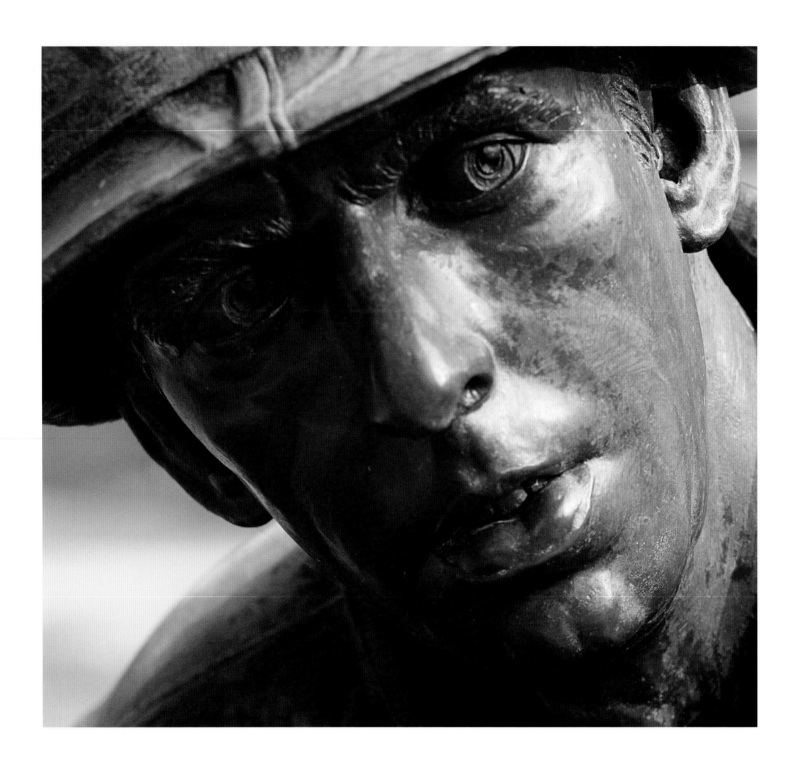

FIGHTING TO SAVE A FRIEND

The memorial to North Carolina's Vietnam veterans was designed by Abbe Godwin, a North Carolina artist who sculpted three amazingly detailed infantrymen. It was dedicated in Raleigh, North Carolina in a homecoming ceremony on May 23, 1987. Titled "After the Firefight," two soldiers are carrying the third to medical aid. Their expressions of strain and concern for their wounded comrade are familiar to anyone who has seen images from that time. The artist wants us to remember not only those who served, or fell, but how they took care of each other.

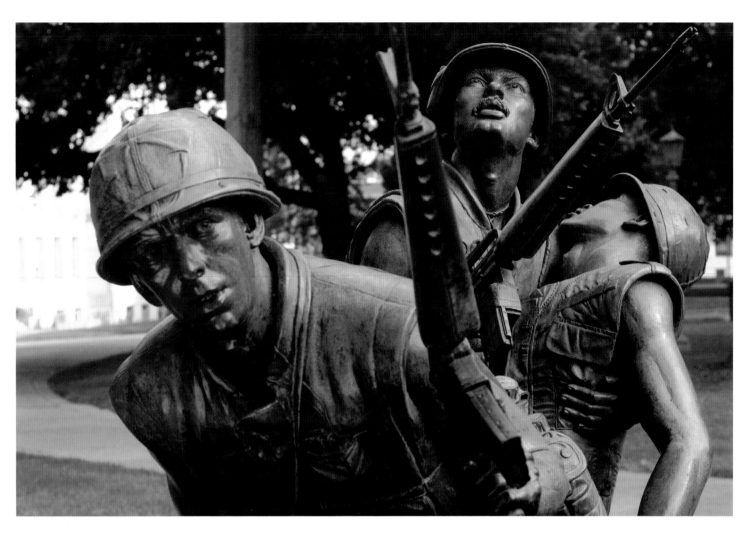

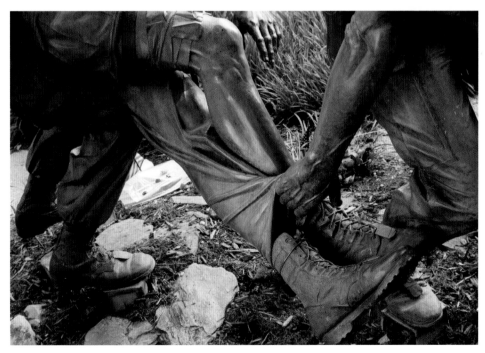

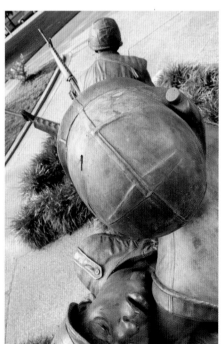

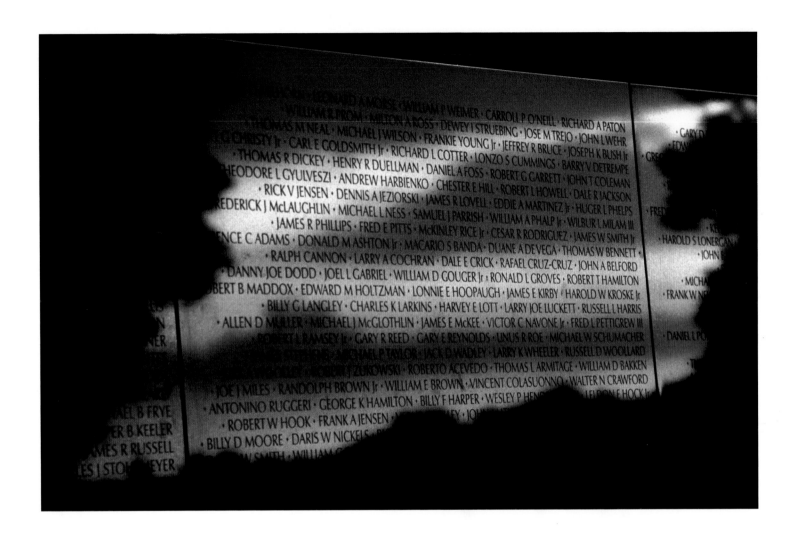

TALKING TO THE WALL

The Vietnam Veterans Memorial in Washington, D.C. was controversial when it was completed in 1982, but has been accepted and visited by millions. A stark angle of mirror-smooth granite, it blends with the landscape, in designer Maya Ying Lin's words, "a healing wound." Its simplicity contributes to the atmosphere, while the names personalize the monument for their loved ones. Thousands of items, from letters to medals, have been left at the memorial, so many that their collection has been institutionalized. As stark and bare as "The Wall" appears, those left behind remain close to those they've lost.

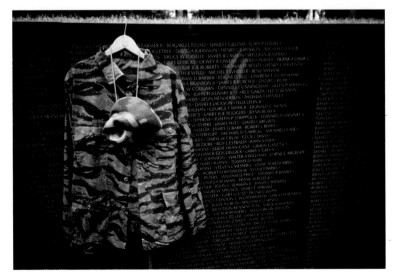

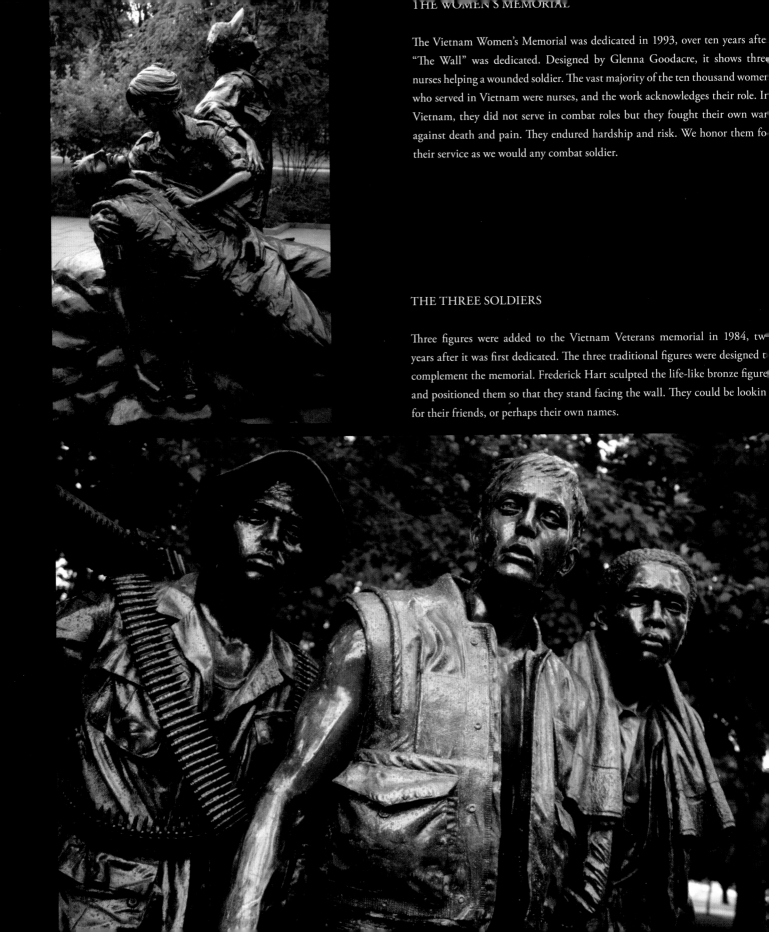

THE WOMEN'S MEMORIAL

The Vietnam Women's Memorial was dedicated in 1993, over ten years after "The Wall" was dedicated. Designed by Glenna Goodacre, it shows three nurses helping a wounded soldier. The vast majority of the ten thousand women who served in Vietnam were nurses, and the work acknowledges their role. In Vietnam, they did not serve in combat roles but they fought their own war against death and pain. They endured hardship and risk. We honor them for their service as we would any combat soldier.

THE THREE SOLDIERS

Three figures were added to the Vietnam Veterans memorial in 1984, two years after it was first dedicated. The three traditional figures were designed to complement the memorial. Frederick Hart sculpted the life-like bronze figures and positioned them so that they stand facing the wall. They could be looking for their friends, or perhaps their own names.

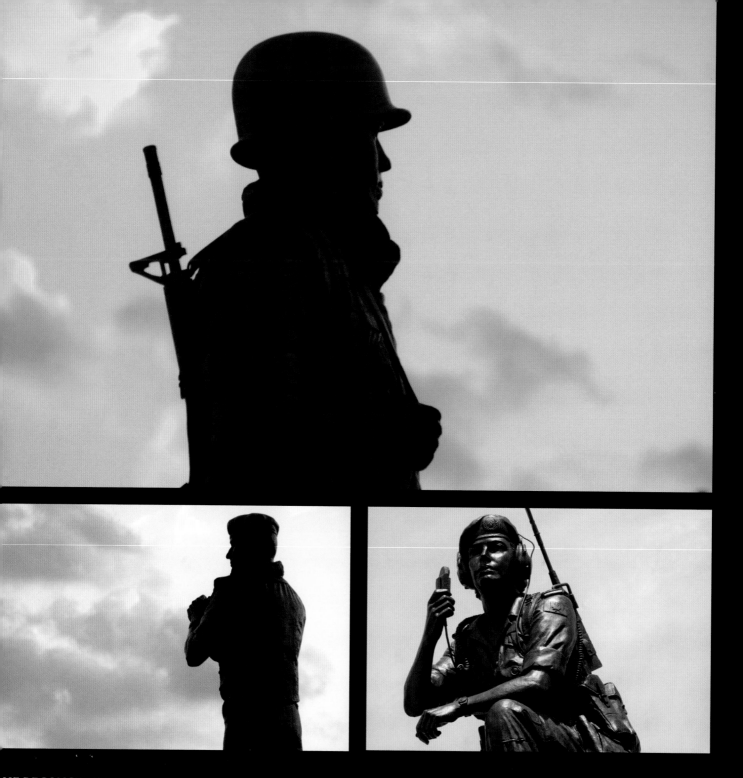

HE RECONCILIATION

anada's military heritage for the past fifty years has been in the service of the United Nations Peacekeeping Forces,
tablished in 1948. Over 125,000 Canadians have served on peacekeeping missions, which in spite of their name, have cost
er one hundred Canadians their lives. The Peacekeepers Memorial in Ottawa mixes sculpture and architecture to show
ree soldiers on the walls, rising above the debris of war. It was erected in 1992, and bears the word "Reconciliation." Many
onuments mention peace, the hope of all soldiers. This one honors that goal exclusively and those who serve it.

MEMORIAL TRADITION

Canada joined the nations honoring their unknowns in a solemn ceremony on May 28, 2000. Her National War Memorial, honoring Canada's WW I dead, was finished in 1939, with WW II and Korea included later. It is a solemn and beautiful monument in the center of Ottawa, Canada's capital city. For this new addition, a sarcophagus was placed in center front, and holds one of Canada's 27,500 unknowns, moved from a cemetery in Vimy, France. After the soldier was interred, onlookers immediately and spontaneously covered the grave with poppies, a symbol of remembrance. It started a tradition that has been continued each Remembrance Day and on other holidays.

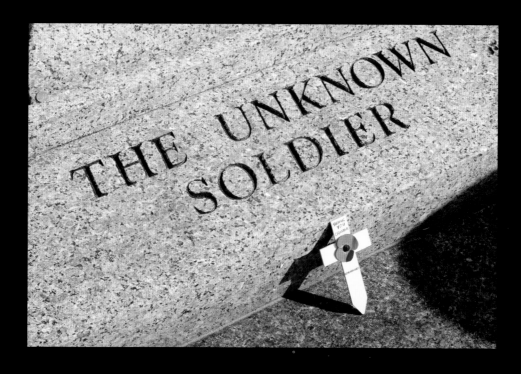

INDEX

INDEX

ACKNOWLEDGMENTS

Thanks to the many curators and communicators who helped me understand the history of these monuments. Keeping a memorial's message alive is a full-time job, requiring patience and a good memory. I also found grace and good humor and a willingness to do more than asked:

Mr. John Aarsen, Curator of the 82nd Airborne Museum, Fort Bragg, North Carolina; Mr. Ray Beck, North Carolina State Archivist; Mr. Bastian Bouma of the Chicago Architecture Foundation; Father Jacques du Plouy of the Church of Notre Dame de la Defense, Montréal; Ms. Melody Foote of the Fayette, North Carolina Tourism Bureau; Ms. Misty Hovey of the Ottawa Tourism Office; Ms. Sandy Klotz, Executive Director of the Airborne & Special Operations Museum Foundation; Ms. Helen Lovekin of the Ontario Tourism Office; Mr. Wendall A. Phillips; Mr. Mike Province of the Patton Society; Mr. Don Talbot of the Fayette, North Carolina Memorial Park Committee.

—Larry Bond

I would like to take a moment to thank people for their contributions to this book. Without question, the greatest thanks go to our nation's men and women who have served, frequently under duress of conflict, and especially those who made the ultimate sacrifice. Next are the tremendously talented sculptors, artists, architects and planners who had the vision to create these magnificent memorials of stone and metal.

My literary agent John Silbersack at Trident Media introduced me to co-author Larry Bond. Many thanks to Larry Bond for his support and knowledge, which is surpassed only by his kindness and sincerity. Encouragement from Gen. Colin Powell was important to the progress of this book as well. Our editor Donna Sanzone at Collins Reference was the one who found a niche in the Smithsonian Institution's prestigious publishing program; similar support at Collins Reference from Phil Friedman and Joe Tessitore was also invaluable. At the Smithsonian, Ellen Nanney and her group were a tremendous help throughout the editorial process, as was Jennifer L. Jones, Chair of Military History. My business partner Karen Jones helped me throughout the process. Designer David Perry completed a wonderful design and produced magnificent mechanicals. My old friend and photographic mentor Richard McCaffrey continues to help me understand technical demands far beyond my scope, especially with the new digital technology. All the folks at Renaissance Creative Imaging of Providence, Rhode Island were helpful, especially Judith Wilson, Kimberly Pinto, and Clyde Dunton-Gallagher. Photo assistants and researchers include Dr. John Keller, Dr. Camille Venti, Prof. Edward H. Foley III, Thomas J. Clark, Baba Lou Gross, and Desi Day. For their superb cameras, lenses and technical support, Nikon Professional Services, especially Bill Pekala and Deborah McQuade.

There were many individuals and concerns that helped me with research in locating memorials included in this book. For their logistical support and hospitality I would like to thank:

From New Orleans: Kelly Schulz, Communications and Public Relations Vice President, Convention & Visitors Bureau. *From North Carolina:* Walton Ferrell, Director of Public Relations, North Carolina Department of Commerce; Holiday Inn Brownstone Hotel & Conference Center in Raleigh; Martin Armes, Director of Communications and Marketing at Raleigh Convention & Visitors Bureau; Fayetteville-Bordeaux Holiday Inn; Ray Beck, historian and archivist for the State Capitol in Raleigh; and Melody Foote, Communications Manager, Fayetteville Area Convention & Visitors Bureau. *From Virginia:* Richard Lewis, National Public Relations Manager, Virginia Tourism Corporation; the Manassas Hampton Inn; Janene Charbeneau, Director of Communications, Richmond Metro Convention & Visitors Bureau; and the Richmond Comfort Inn Conference Center. *From Maryland:* Camila Clark, Public Relations and Promotions Manager, Maryland Office of Tourism Development; Kristin D. Zissel, Travel Media Manager, Baltimore Area Convention & Visitors Association. *From Boston:* Racheal O'Brien, Media Relations and Tourism Sales Coordinator, Greater Boston Convention & Visitors Bureau; Stephanie Moody, Reservations Manager, The Colonnade Hotel; Lauren Hayes of CM Communications, Inc.; and Michael P. Quinlin, President, Boston Irish Tourism Association. *From Vermont:* Paul A. Carnahan, Librarian, Vermont Historical Society; The Equinox in Manchester. *From Rhode Island:* Kristen Adamou, Director of Communications, Providence Warwick Convention & Visitors Bureau; Anne Marie McLaughlin, Communications Manager and Kathryn Farrington, V.P. of Marketing, Newport, Rhode Island Convention & Visitors Bureau. *From Philadelphia:* Donna Schorr, Media Relations Director of the Greater Philadelphia Tourism Marketing Corporation; and the Radisson Plaza-Warwick Hotel. *From Gettysburg:* Katie Lawhon, Public Affairs Specialist, Gettysburg National Military Park; Stacey Fox, Director of Marketing at the Gettysburg Convention & Visitors Bureau; and the Gettysburg Hotel. *From Washington, D.C.:* Rebecca Pawlowski, Media Relations Manager, Washington, D.C. Convention & Tourism Corporation; The Washington Plaza Hotel; Ama Blankson-Wood, Sales and Marketing Coordinator, and Cynthia Scherer at The Fairmont; and Heather Freeman Media & Public Relations. *From Canada:* Helen Lovekin, Media Relations Coordinator, North America, Ontario Tourism Marketing Partnership Corp.; Toronto Sheraton Centre Hotel; Fairmont Chateau Laurier; Deneen Perrin at the Fairmont Royal York; Misty Wade Hovey at Ottawa Tourism; Pierre LeDuc at the Canadian War Museum; Marie José Pinsonnault, Media Relations Director, and Ruby Roy, tour guide for Montréal Tourism.

And finally, to my wife Judith, and my children Genni and Weston, who stood by at our first viewing of the Vietnam Wall, wondering why I was in tears—that was the very beginning of this journey.

I dedicate this book to all those members of my family who have served—Grandpa Diego M., Uncles Peter M., Richard M., Dominic V., and Joseph V., my brother-in-law Norman L., and my cousins Richard L., Michael L., Joseph L., Sammy V. and Sam V., Richard V., Dominic V., and Anthony V.

—f-stop Fitzgerald

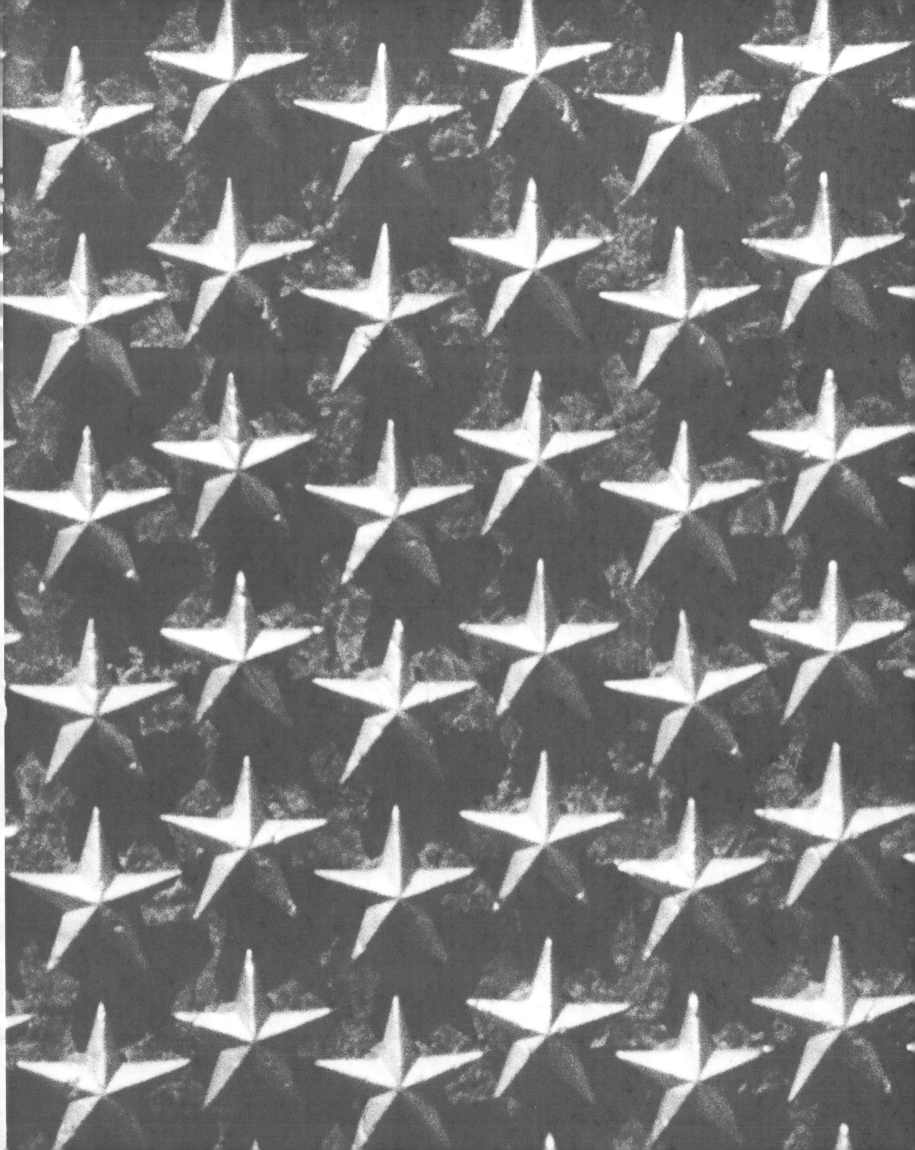